Packaging9 Graphis Mission Statement: *Graphis* is committed to presenting exceptional work in international design, advertising, illustration and photography. Since 1944, we have presented individuals and companies in the visual communications industry who have consistently demonstrated excellence and determination in overcoming economic, cultural and creative hurdles to produce true brilliance.

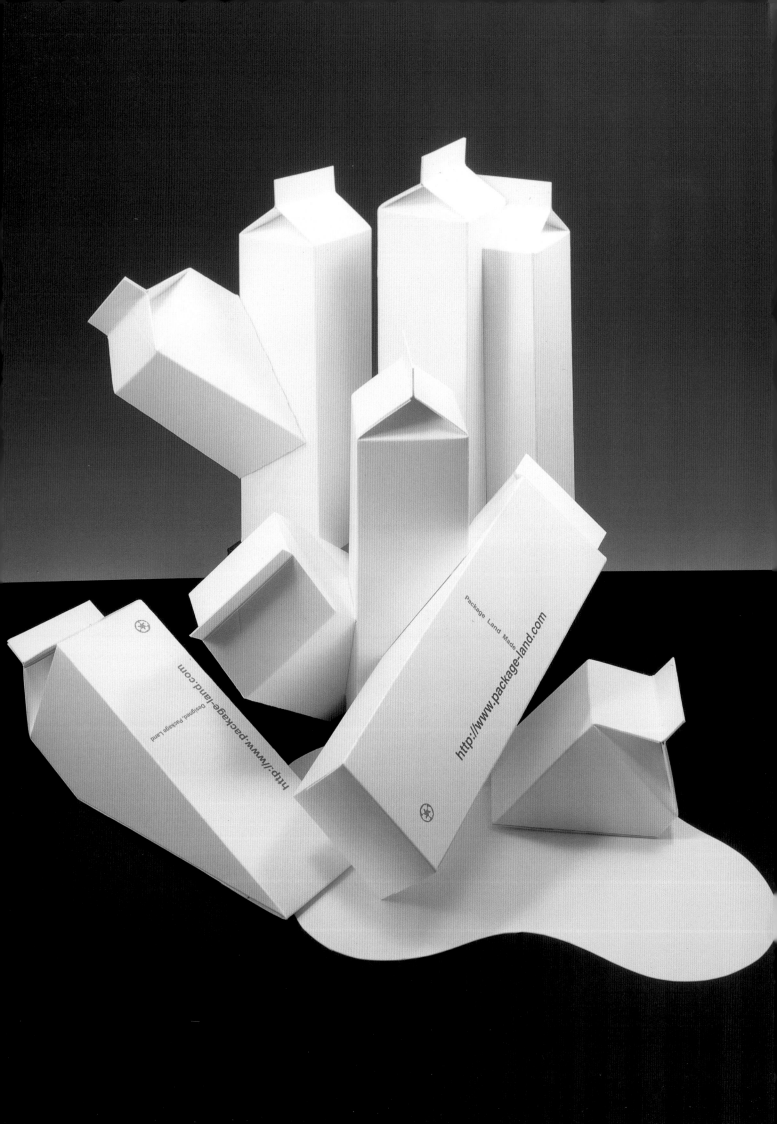

Package Land Made

http://www.package-land.com

designed Package Land

http://www.package-land.com

Packaging 9

CEO & Creative Director: B. Martin Pedersen

Front Matter Editor: Lætitia Wolff
Managing Editor: Ryan Brunette
Designers: Lauren Prigozen, Jennah Synnestvedt
Production: Luis Diaz

Published by Graphis Inc.

(opposite) Experimental milk packaging. Design: Yasuo Tanaka/Package Land. (Pg.4) Apple G4 Packaging carton box. Design: Apple Computers.

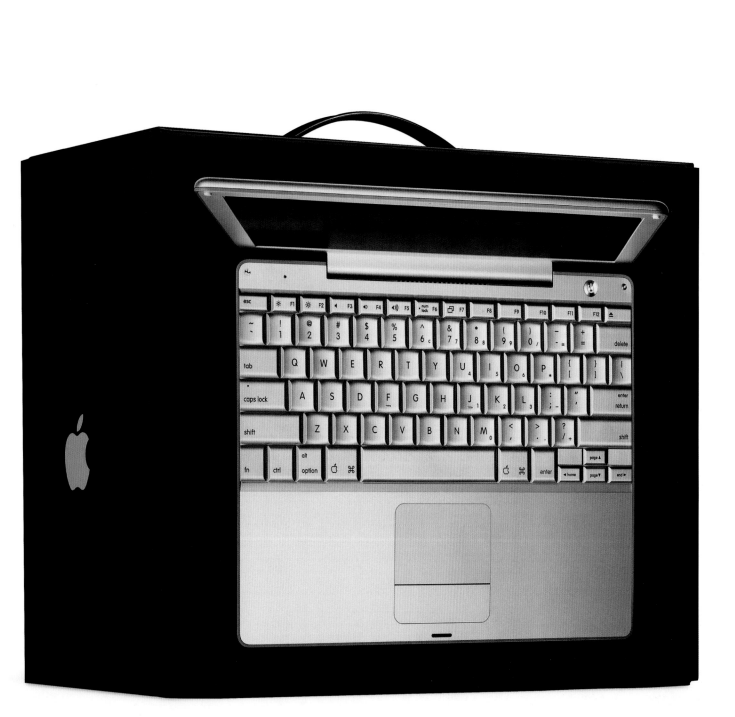

Contents Inhalt Sommaire

Remarks: We extend our heartfelt thanks to contributors throughout the world who have made it possible to publish a wide and international spectrum of the best work in this field. Entry instructions for all Graphis Books may be requested from: **Graphis Inc.**, 307 Fifth Avenue, Tenth Floor, New York, New York 10016, or visit our Web site at www.graphis.com.

Anmerkungen: Unser Dank gilt den Einsendern aus aller Welt, die es uns ermöglicht haben, ein breites, internationales Spektrum der besten Arbeiten zu veröffentlichen. Teilnahmebedingungen für die Graphis-Bücher sind erhältlich bei: **Graphis Inc.**, 307 Fifth Avenue, Tenth Floor, New York, New York 10016. Besuchen Sie uns im World Wide Web, www.graphis.com.

Remerciements: Nous remercions les participants du monde entier qui ont rendu possible la publication de cet ouvrage offrant un panorama complet des meilleurs travaux. Les modalités d'inscription peuvent être obtenues auprès de: **Graphis Inc.**, 307 Fifth Avenue, Tenth Floor, New York, New York 10016. Rendez-nous visite sur notre site web: www.graphis.com.

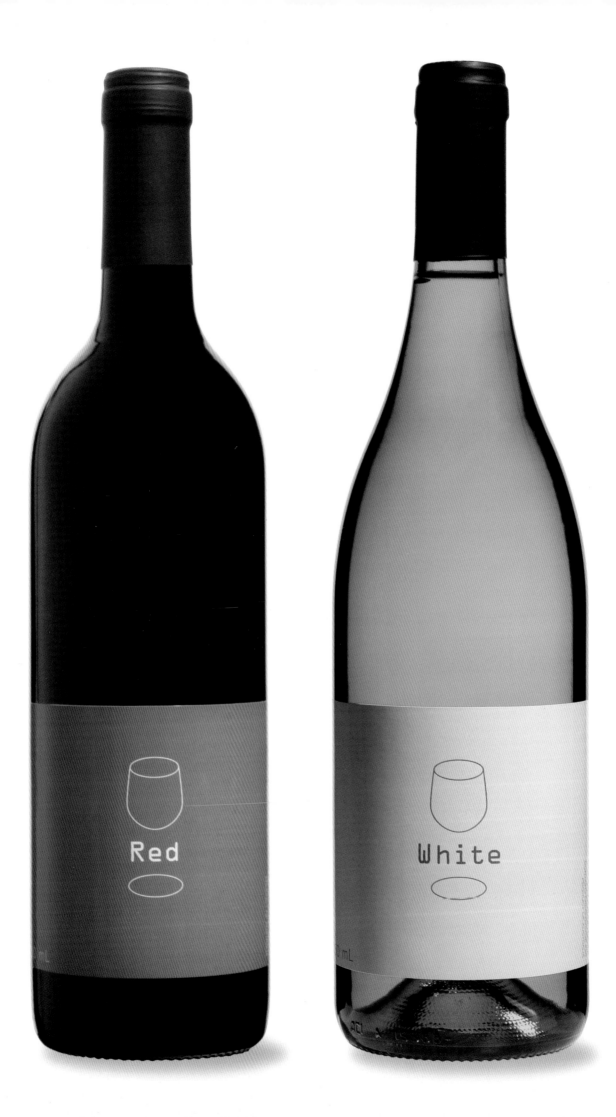

CommentaryKommentarCommentaire

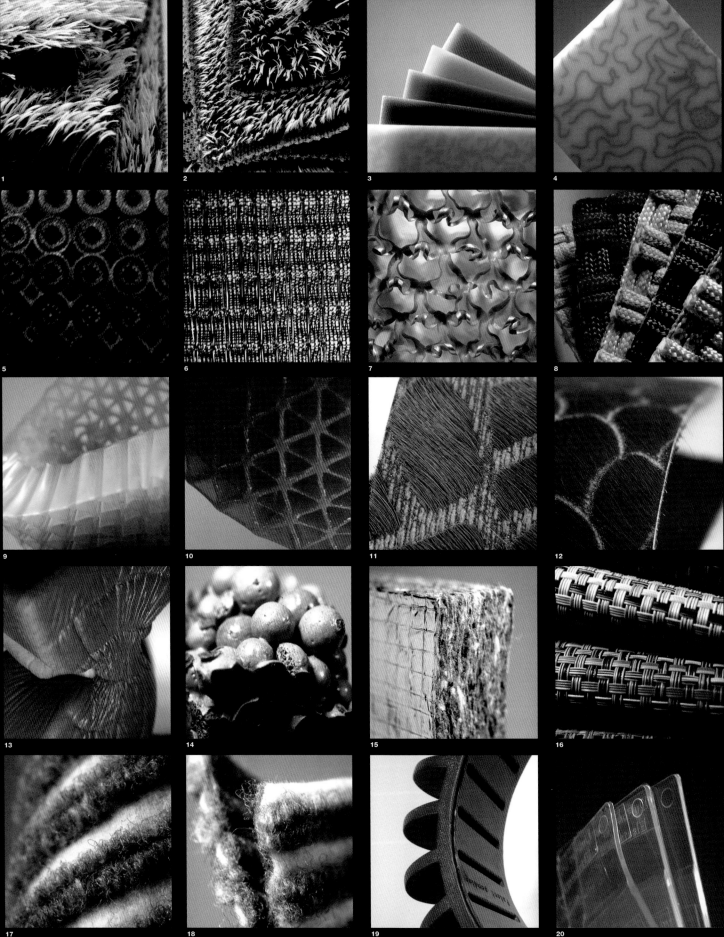

1

2

3

4

5

6

7

8

9

10

11

12

13

14

15

16

17

18

19

20

Material ConneXion: "A selection of Innovative Materials for Innovative Packaging Design"

With the expertise of Andrew H. Dent, Director of Library and Materials Research at Material ConneXion, Graphis selected innovative materials, for their potential packaging applications, and general inspiration for new forms and textures. Organized into the Material ConneXion's eight main categories (polymers, glasses, ceramics, cement-based, carbon based, metals, naturals, natural material derivatives, and processes) these materials offer a wide range of treatments both as printable surfaces with original textures, as well as for 3-D purposes, as containers, envelopes, or structures for display systems—presenting challenging solutions to how the products can utilize three-dimensionality. Founded by George M. Beylerian in 1997, Material ConneXion® is the world's most extensive resource for new, innovative materials and processes. Material ConneXion provides architects, engineers, industrial and interior designers access to the latest and most exciting materials from a broad range of industries that are often overlooked or inaccessible to specifiers. Its library houses over 3,000 material samples in eight categories: ceramics, glass, metals, polymers, carbon-based materials, cement-based materials, natural materials and nature-based derivatives. Complete access to the library is available through the Material ConneXion database via the Internet at www.material-connexion.com. In addition to the library, Material ConneXion offers membership, marketing and consulting services to retailers and manufacturers on all material-related matters, including research, trend forecasting and product development. Material ConneXion has offices in New York and Milan.

Credits (from left to right, top to bottom)

1. and 2. MC#4689 Acid-tipped Mohair
Decorative textile for upholstery applications. 100% mohair fibers that have been burned and melded using acid to produce lighter colored "tips" attached to a cotton backing. The textile is available in 30 m (98.2 ft) lengths and 1.4 m (4.6 ft) widths; custom colors are available with a very small minimum order as well as customization of the nap length and color. Past applications include interior design and teddy bear fabrication.

3. and 4. MC#0091-09 Diafos (rigid sheet)
Translucent laminate sheets (51 in x 120 in; 129.54 cm x 304.8 cm) with three-dimensional decorations, created with translucent paper and melamine resin; available in 5 colors and 21 different patterns. Used as decorative dividers or to camouflage overhead lighting, and when coupled with phenolic backing for desktops or other horizontal applications.

5. MC#3398 07 Virtual Reality Collection
Thin gage films that incorporate textures and simulated holography merged with lenticular imagery. Available in 60 contemporary design styles with the option of five metalized color finishes. Each collection measures 17" (43.2cm) wide by 16" (40.6cm) in length and in a roll format with 248 identical image repeats; approximately 100 yards (100m) in length.

6. MC#2060-01 Pyramat
Patented, open three-dimensional woven geotextile that is strong and durable, composed of ultraviolet radiation (UV) stabilized polypropylene monofilament yarns woven into a dimensionally stable (all yarns are locked in place) uniform configuration of resilient pyramid-like projections; used as a high performance turf reinforcement mat to stabilize soils and reinforce vegetation. Minimum order is for 500 yds (457 m).

7. MC#4608-01 Custom design silicone coated fabrics
Silicone coated fabrics. Custom designed in small runs of up to 20 yds, with a minimum of 1 yd. These very creative silicone treated fabrics can be designed using almost any color, scale, texture and fabric. Silicone is applied to the fabric using different application methods in order to best achieve the desired custom look. Applications are mainly for theater, dance and film costumes, as well as for visual merchandising and window displays. Custom fabrics have been used in films such as Ghostbusters, Star Trek and the Flinstone's Movie.

8. MC#4282-02 Mat Twist
Mats and seating surfaces from woven rope. High tenacity climbing rope, comprising a stranded nylon core and a rubber/nylon protective sheath, is woven to produce distinct matting and seating surfaces. This woven mat is easily washable, anti-fungal, anti-bacterial UV resistant and very durable. The mats are available in five color-ways: red/pink, blue/blue, black/gray, red/orange and white/white and in 200 x 200 cm, 200 x 350 cm and 200 x 400 cm (78.75 x 78.75 in, 78.75 x 138 in, 78.75 x 157.5 in). These mats are currently used for interior high traffic areas.

9. and 10. MC#4056-02 Intelli-Gel™/Gellycomb™
A unique cushioning material that is made of a highly elastomeric materials in a column construction. A wide variety of properties can be engineered by changing the formulation of the elastomer and also the dimensions of the column walls and cells. As the body sinks in, the columns buckle to allow a contoured support. Applications include commercial and medical cushioning, vibration isolation, and impact absorption.

11. and 12. MC#0071-02 Laser Cavallo
Decorative textured leather. 100% horse-hide is laser cut into decorative patterns on the hair side. Four laser cut patterns are available each with a set single color. The maximum sheet size is approximately 3x6 ft; 91x183 cm. Custom colors are available with a minimum order of 200ft.

13. MC#3652-01 Alova
Odorless, molded polyurethane foam for medical products such as cushions, pillows, and mattresses, that conforms to the shape of the body and after use returns to its original form. Available in 3 color-coded densities: soft (yellow); medium (orange); and firm (green).

14. MC#1480-01 Porocom
A porous construction material for sound-proofing that is lightweight, strong, fire-retardant, and recyclable. It is composed of two residue products: granular material such as fly ash and glass granules from recycled glass, combined with a thermosetting powder that is a residue of the metal coating industry; available in various colors for applications such as sound-absorbent and chemical-resistant wall and ceiling panels, and combined with rockwool as highway noise abatement barriers.

15. MC#4598 01 Ultra Touch
Insulation made from recycled, recyclable natural fibers. Composed of post-industrial denim and cotton fibers treated with a boron-based flame retardant, that also serves as an anti-fungal agent, this is an alternative to fiberglass insulation as it does not irritate the skin, and has superior thermal and acoustical properties. The insulation has a Class A fire rating and smoke developed index and is manufactured in 16.50 in and 24.50 in widths (0.4191 m and 0.6223 m), compared with standard 15 in and 23 in fiberglass widths. It may be custom die cut into specific shapes and sizes and is also available in 2, and 3 ply layers with carpet padding backings or aluminum backings. It is used as building and automotive insulation, sound insulation, and decorative accents.

16. MC#1494-05 Phifertex
Vinyl-coated polyester fabrics with good tensile and tear strength that are flame, abrasion, and mildew-resistant, colorfast, and washable; applications include cushions and umbrellas for outdoor furniture, banners and outdoor structures, curtain dividers.

17. and 18. MC#3873 01 Hydrotex
Needle-punched felt made from either polypropylene or polyether sulfone for improving drainage in landfills and also for roofing. When used for roofing, a thinner version is sandwiched between sheeting material and impregnated with resin to enhance its impermeable properties. The felt is supplied in different grades, and also with channels to enhance the flow of water and act as a filter.

19. and 20. MC#2166 01 Engage
Polyolefin elastomer resin. An elastomer, based upon polyolefin chemistry that, when added to low cost polymers, improves texture, impact resistance, low temperature resistance and flexibility. The resin has the flexibility of rubber and the ease of processing of a thermoplastic. Although the resin may be used exclusively (in some household items and toys), it has poor high temperature resistance so is normally blended with another polyolefin, such as polypropylene or polyethylene. The resins may be colored or clear. Applications are currently mainly in the automotive industry such as fenders and interior trim, though the resin is also added to molded household products and also some sports equipment such as snowboard bindings.
—Selection made by Laetitia Wolff

Material ConneXion® 127 West 25th Street, 2nd Floor
New York NY 10001. Tel. 212.842.1040; Fax 212 842 1090
www.materialconnexion.com

Q+A with Tamar Cohen: "My Candy Life"

The daughter of Arthur A. Cohen and Elaine Lustig Cohen, graphic artist Tamar Cohen was born with the collector's gene. Having grown up in her parents' Manhattan cabinet of curiosities, a famous gallery and bookshop called Ex Libris that specialized in printed books and ephemera of the European avant-garde, Cohen continues the tradition. She, however, prefers the world of "low art" raising the status of the quotidian. As a graphic designer, Tamar Cohen has bridged the worlds of illustration, drawing, collage and graphics by separating her commercial client assignments from her own polka dotted digital canvases— which exist thanks to her museum-quality candy packaging collection.

How/when did you start collecting?
As a kid, I collected magazines, trading cards, stickers and dolls, I still even have my bus passes. When I was in college, I started seriously collecting ephemera (such as fruit wrappers, food labels, printed napkins, matchbooks, and postcards). When I spent a year abroad in Paris, I started saving candy wrappers like the Car en Sac licorice box for instance. I was attracted to color, typefaces and, I guess, I have to admit I have a boundless love for candy and sugar.

How did your collection evolve?
By the mid '90s I had collected so much stuff from trips abroad and flea markets that I had no more room to store it. I accumulated piles of children's books, cigar labels, and Indian fireworks posters. From a trip to Morocco, the only thing I brought back as a souvenir was $5

Chicklets mini boxes, and American Juicy Fruit). I often think of myself as a documenter of sugar-coated vernacular. Then I scan them all, archive them, and in Photoshop I start adding layers of polka dots, lines, and dotted lines, sometimes completely covering up the original packaging in the background. I then add and take away layers until I feel the balance is right.

What are the art formats you've been working in?
I have always done collage but the applications have been different: 3-D objects, paintings, photography and now digitally. The first works in this series using candy wrappers, found packaging and dots were more formal and controlled, now they're more expressive. It's almost as if I were drawing on the computer. Then I output them onto canvas and stretch them. I am thrilled with how far technology has improved since the photocopy machine.

What is your model of inspiration?
Not sure I have one in particular. It is about a mix of influences, high and low, ethnic and Western, Christian and Hindu, antique and modern, maybe '60s Pop. I grew up surrounded by art and had a great role model, my Mom was a graphic designer and then became an artist. I feel proud to be following in her footsteps. What you see here on my fireplace mantel illustrates my diverse inspirations: a painting on glass from Bali, an old Mexican retablo, a Herbert Bayer collage and one of my Mom's photo collages.

worth of bubblegum. I became so overwhelmed with material that I decided I would only collect what I could use in my artwork.

What do you find inspiring in the candy packaging design?
I am inspired by the variety of size, shape and forms of candy packages, by the beautiful bright colors, the rich imagery which often feature cartoon characters, and of course as a designer I love the array of typographic solutions. Admittedly that part of my obsession comes from a boundless love for candy and sugar. Ironically, I began this body of work after having given up sweets for a year—I guess my sugar fixation was substituted with a visual one.

Has making art always been part of your life?
Yes, as a child I was obsessed by fashion and would draw my own issues of *Vogue* magazine, in college I studied art history and studio art and have continued making my own art while being a graphic designer. Working in the commercial world it is essential for me to have an outlet where I don't have to compromise my creativity. I have always been drawn to collage. I love juxtaposing unrelated images, putting them in new contexts, making them mine. In the late '80s I did this with photocopies. I would Xerox on tissue paper, overlapping multiple layers on top of each other, using cartoons, found ephemera, gold leaf, oil pastels and paint. I've always been interested in layering, it creates great depth, and forces the viewer to look below the surface. I even bought myself an expensive Xerox machine, a real dinosaur. I had to give it away because it took up too much space. This was prior to the computer, remember!

Can you describe the design process from collecting to printing?
In this body of work, I try to keep the selection of candy packaging very eclectic and culturally diverse, a mix of Eastern and Western pop influences (here for instance, you have Israeli gum wrappers, Mexican

How do you foresee your work process will evolve?
For now, I want to continue with this series, I feel like there is more I want to explore. I would also like to blow them up larger and possibly do some kind of installation piece. I also take photographs which I would like to try and integrate as well.

What do you want to do with this body of work?
Ideally I would love to show this body of work in a gallery. I would like to get it off the walls of my studio and out there into the world so other people can see it. In the meantime I will continue making new stuff, it sounds corny but making art just keeps me alive and happy.
—*Interview by Laetitia Wolff*

Tamar Cohen. *After graduating from Oberlin College with a degree in art history and studio art, Tamar got a crash course in graphic design at Vignelli Associates, later moving on to the more experimental studio Doublespace, where she met her future partner David Slatoff. They formed Slatoff + Cohen Partners in 1992 and established a broad roster of clients including: Cinemax, Chronicle Books, ESPN, Gap, Lincoln Center Theater, MTV, Nickelodeon, Nick at Nite, Swatch, Tribeca Film Center and VH1. In 2001, Tamar opened her own studio, Tamarco. She has received awards from the AIGA, the Art Directors Club, the Broadcast Designers Association and the Society of Publication Designers. Additionally her work is in the permanent collection of The Cooper Hewitt. Tamar has taught at Pratt Institute and is a guest critic at Yale.*
Tamar Cohen, Tamarco, 357 West 22nd Street, #4, New York, NY 10011
E: tamarcohen@nyc.rr.com

(opposite page) Pumkin by Tamar Cohen, 2003. Inkjet on canvas (28.75"x36)

(this page) View of the candy collection at Tamarco Studio. Photo by Tamar Cohen.

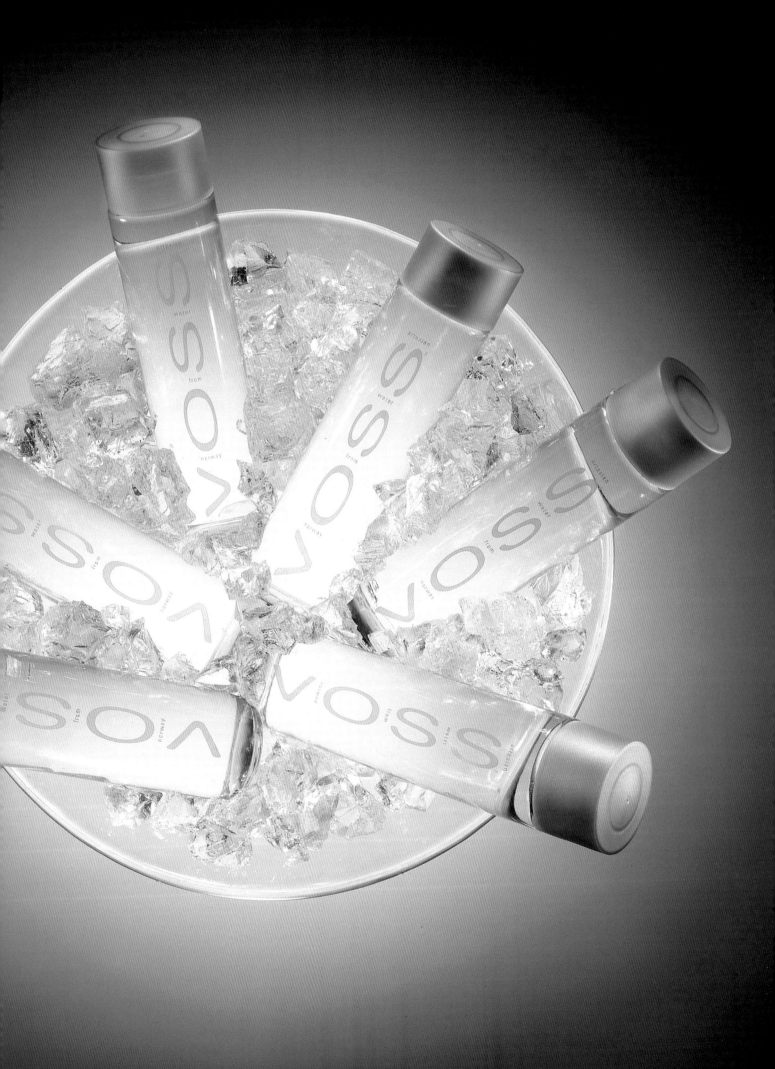

Voss Water: Water for all your Senses

Natural. Cool. Is this describing the packaging or the content of VOSS water? This exclusive artesian water from the fjords of Norway has been alternately praised for being sexy and pure. Similarly, it is reputedly simple and yet complicated enough to have wine connoisseurs buzzing. The fact is that water sales are reaching new heights, and VOSS—which means "waterfall" in old Norwegian—has found a few ways to make a tasteless, odorless, and nearly formless substance into a trendy and profitable product.

VOSS cylindrical bottle is 'artless,' and appeals to consumers with a sense of fashion and an eye for the sleek and simple. But while the stylish crowd falls for VOSS packaging, the content—tapped from a virgin aquifer in a location as pure as the ice that isolates it—has been heralded as "the purest water on earth," an appraisal that captures the attention of the health-conscious consumer who seeks shelter from a fast-food nation.

Ole Christian Sandberg, VOSS's founder and chairman, discusses the business of launching a clear water on a saturated beverage market that has been conspicuously dominated by the concept of ultra-premium brands. He explains how a careful marriage of design, engineering, and content can give birth to a lucrative business and how VOSS brought to water what premium Vodka brands brought to the hard liquor category.

What's your professional background?

I am an entrepreneur and the founder of Sophie Faroh, one of the leading women's fashion labels in Norway. Since 1998 I was involved in several Internet startups until the dot.com collapse in 2001. I am now working on a new venture, Maisy Bloom, a new bedding line (packaging and distribution strategy) to be introduced in Norway this fall.

When and how did you come up with the business idea of VOSS Water?

VOSS of Norway was founded in 1998; distribution started in the first quarter of 2001. VOSS was originally created by myself and Christopher Harlem, we were two young entrepreneurs who started the venture in our mid-twenties. Christopher is no longer active at VOSS (he remains a shareholder) and currently works in his family business (one of the largest food wholesaler in Norway). While Norway is a small country, its fjords and glaciers produce the best artesian water on earth. We've enjoyed this wonderful water all our lives. We thought it would be a thrill to be able to export and share this pure and delicious water with the rest of the world.

Why do you think bottled water is an interesting market?

It's actually the fastest growing segment of the beverage industry. Consumers are becoming increasingly more health conscious and water is a big part of that healthy lifestyle. There were no other ultra-premium water category on the market until now—we saw a niche market and an opportunity to create something really different.

Who designed the bottle?

Neil Kraft, creative director and founder of the New York agency KraftWorks. After interviewing several agencies, we really felt we connected with Neil. Three weeks after our preliminary conversation in NYC, Neil showed up in Oslo to present some of his ideas. He came up with the initial design concept and had already thought about the shape of the bottle.

What kind of design brief did you give the designer (technical information and aesthetic directions)?

No technical information was provided to the agency—they were presented with the challenge of helping us create an ultra-premium water brand. The packaging should stand out and be different as an on-premise product, but still be instantly recognized as a classic. We wanted to create a new, contemporary bottled water that would primarily be distributed in restaurants and hotels.

How has the packaging evolved?

The shape of the bottle has changed in order to make it more practical to manufacture and transport. The in-house adjustments we made to the packaging were mostly done for technical reasons. We changed the small print on the back of the bottle from horizontal to vertical on the side to improve its look and appearance. We altered the safety seal to ensure tamper evidence and the ring finish to enable perfect seal.

Do you manage to keep your high standards of specifications cost-effective?

The bottle is actually lighter than standard water bottles. We have spent a lot of time with different manufacturers to explore who could come up with a light-weight bottle, meeting our design and quality specifications. Using the most modern glass manufacturing techniques and the newest production methods, from our point of view we think we succeeded. For instance, we are using vacuum, blow/blow and push/blow to improve glass distribution in the bottle as well as ensure pressure resistance in the shoulder for carbonization. We are constantly challenging our suppliers to see what other detail can be improved.

Describe the glass manufacturing process of the bottle.

There are continuous small adjustments made to the design of the bottle and cap to improve the functionality of the packaging without affecting its aesthetic value. In the beginning we worked with Irish glass manufacturer Quinn to try to perfect the shape of the bottle, especially focusing on the weight, glass quality, shoulders and ring finish. We have seen numerous trials fail over the years, but with good glass manufacturing consultants on our side we were able to challenge first Quinn and later BSN to create the bottle we wanted. After a year with Quinn we took the concept to French glass company BSN's German outpost (a European leader in glass bottling manufacturers) who created the more delicate bottle made of lighter glass—the current shape the VOSS bottle has today.

And what about the design of the cap?

For the initial concept Neil Kraft suggested a metal cap, but that cap turned out to be impractical and not cost-efficient. Finn Karlsen of FK Engineering and Bosse Nilsson at Emballator Vaxjøplasti took the concept and developed the cap into the current bottle cap we have today. They sized the bottle spout to allow for the right pressure to match the right plastic cap, and selected the right plastic to work with the glass. Swedish cap manufacturer Emballator (Absolut Vodka Corks) was the only company willing to produce the final product, responsible for producing the caps today.

How do you position VOSS compared to other spring waters?

VOSS comes from an artesian source and is sold exclusively in high-end, on-premise accounts (hotel and restaurants) and at very limited gourmet retail. As volume is really experienced at the retail level most brands only sell on-premise for image and awareness building, and make most of their money in retail. We, on the contrary, have turned retail business away to keep our positioning and brand image intact and pure. We target consumers who frequent high-end hotel and restaurant establishments. These, gourmet shops and select wine stores are the only places where Voss can be found, other than online at www.vosswaterstore.com

How many bottles have been sold since its inception?

We have produced 1.3 cases (23.4 millions bottles) since 2001.

What is the reception of the product in the U.S. vs. Europe?

Overall the product has had very positive feedback, but due to its limited availability and being that the distribution is most developed in the U.S., awareness is paradoxically highest in the U.S. We dare to say that the success of VOSS is due to a solid distribution system, word of mouth, great design, and incredible water.

What's your budget spent on marketing/advertising since 2001?

$2.5 million since the first launch. No advertising dollars were spent in strategic positioning. For promotional purposes, we spent money on public relations, sales support, product donations, charity and sponsored events presenting the product.

Do you think drinking water is a fashionable trend?

No, water is a commodity in our society. As clean water sources get more scarce the demand for bottled water increases. In addition, people are becoming more and more health conscious and water is a big part of a healthy lifestyle. *Interview by Laetitia Wolff*

Pg.6 (opener page) Zaleti, house white and red whine labels.
Design: David Lancashire Design, Richmond, Australia.

Pg.12 Chilling VOSS water bottles, Photo: Brian Klutch.
Pg.14 VOSS water bottle, front view. Photo: Courtesy of VOSS Water.

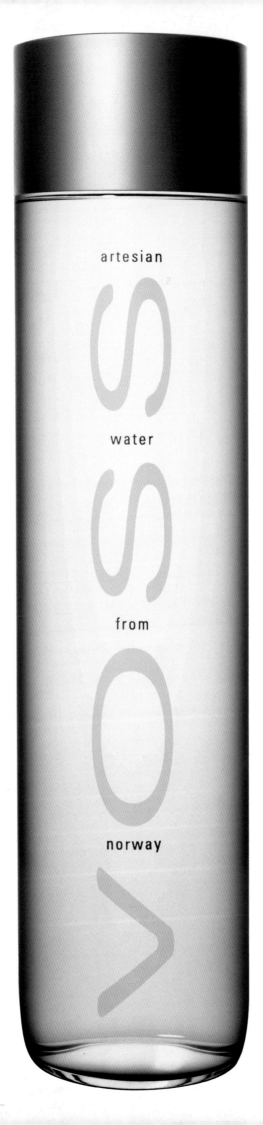

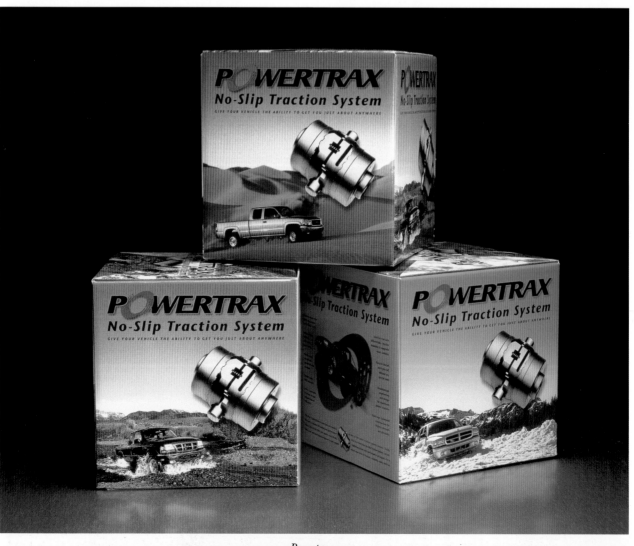

Powertrax

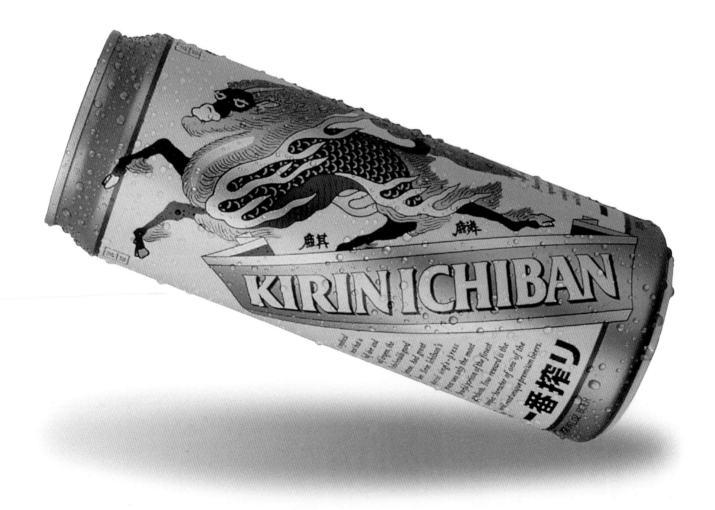

(this page) Bright Strategic Design/Kirin Brewery of America, (opposite) Hornall Anderson Design Works Inc./Widmer Brothers

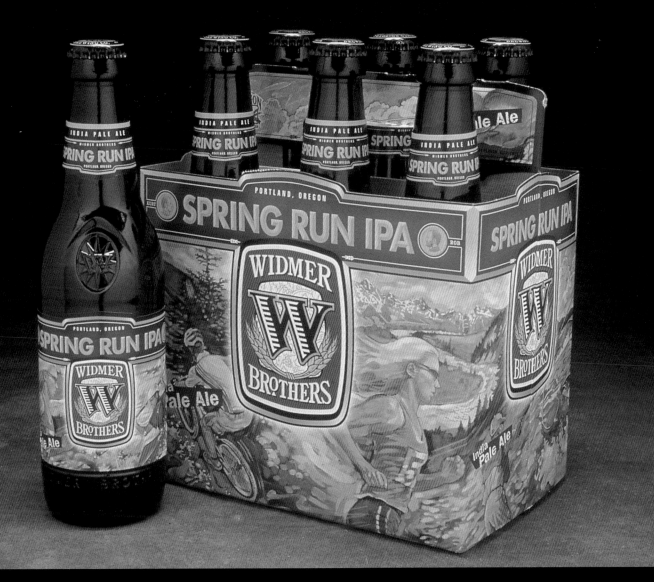

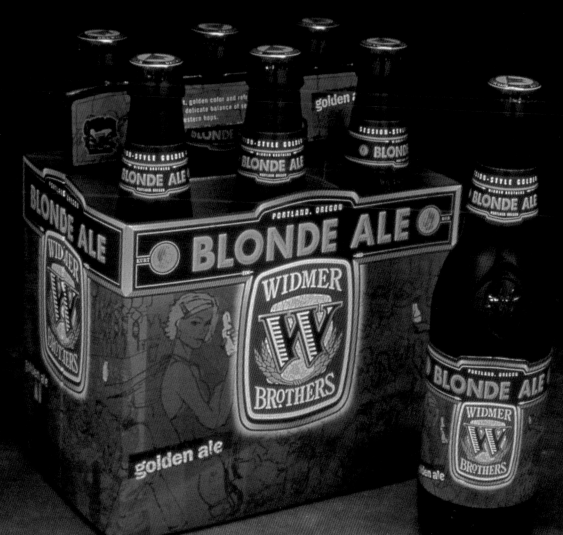

Deutsch Design Works/AB Image Development

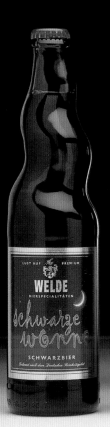
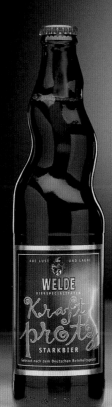
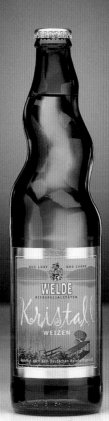
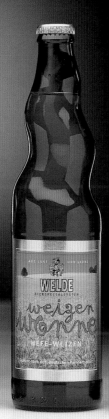

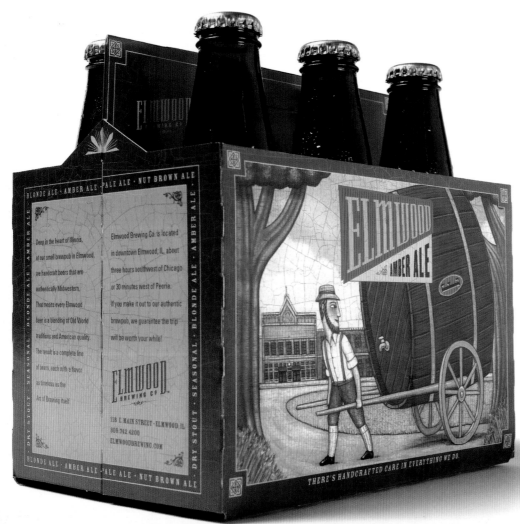

Ross Creative & Strategy/Elmwood Brewing Co.

Williams Murray Hamm/Interbrew UK, (opposite) WORK and Hailey Johnson Design/Work Beer

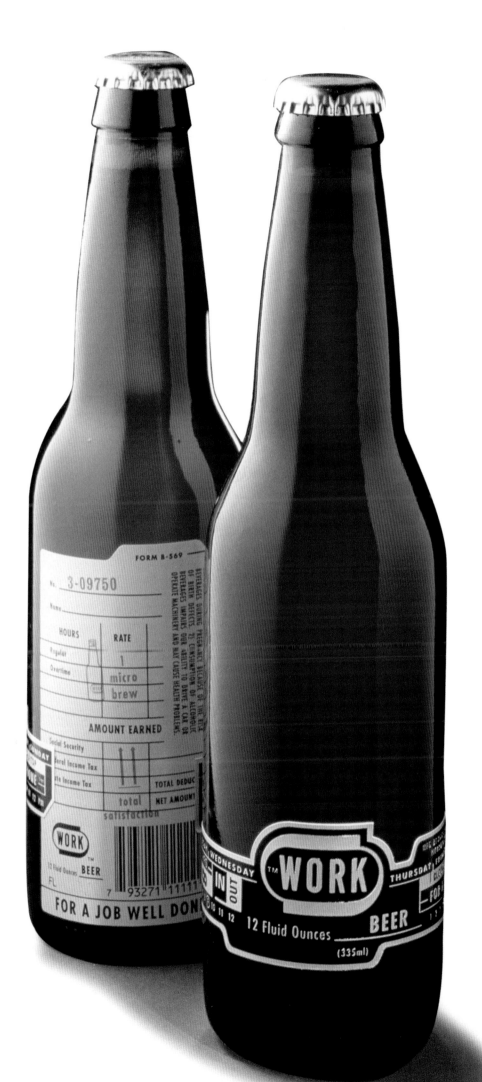

Hornall Anderson Design Works Inc./KAZI Beverage Company, (opposite) Wega Werbeagentur/Oldenwald Quelle

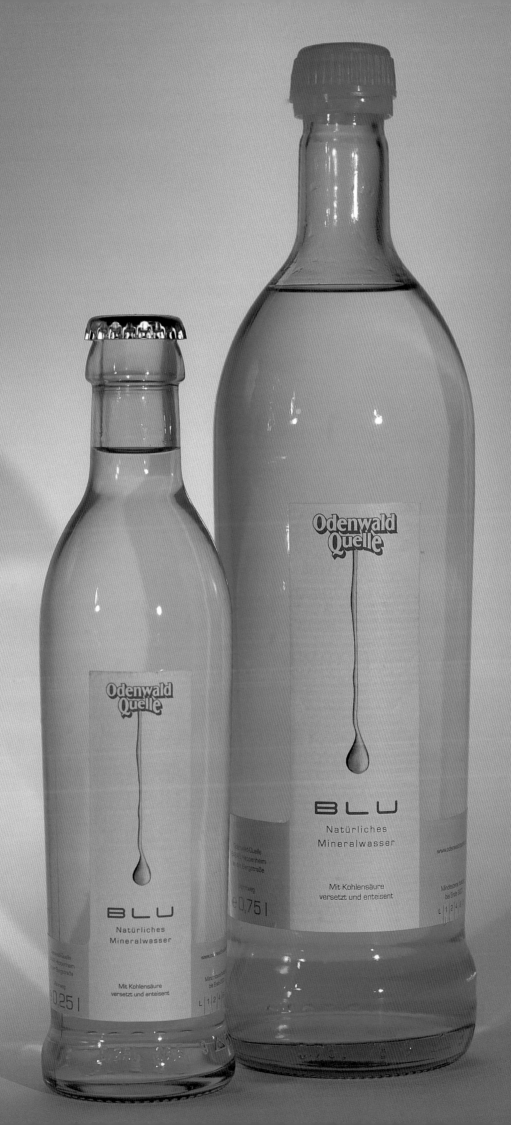

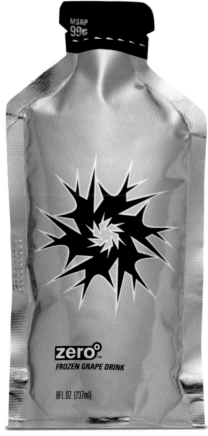

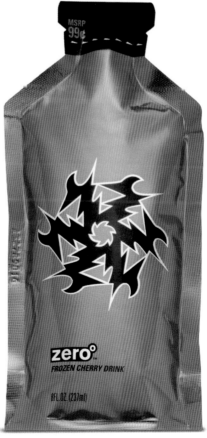

Turner Duckworth Design/McKenzie River

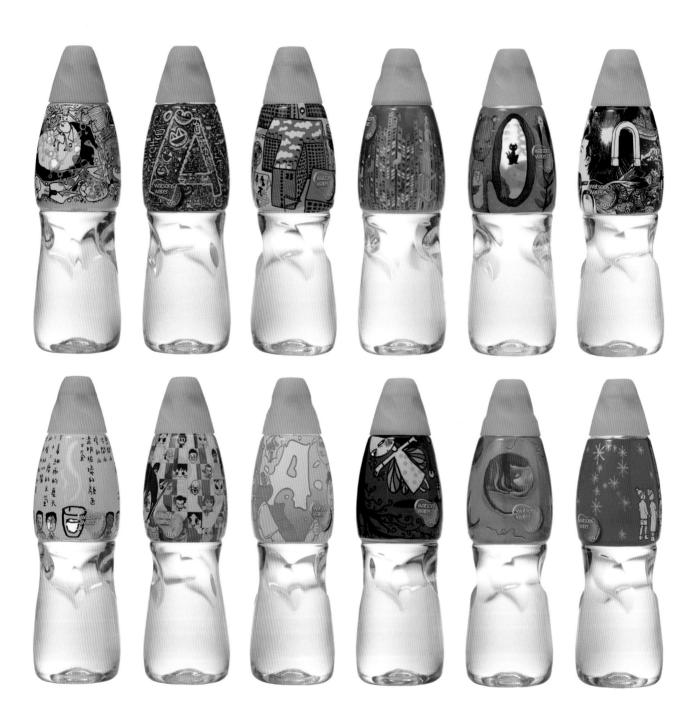

Kan and Lau/Watson Distill Water, (opposite) Out Of The Box/Batch Beverage

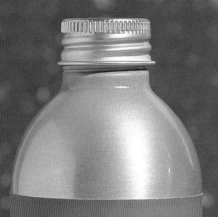
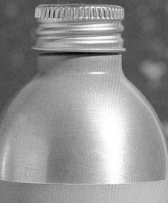

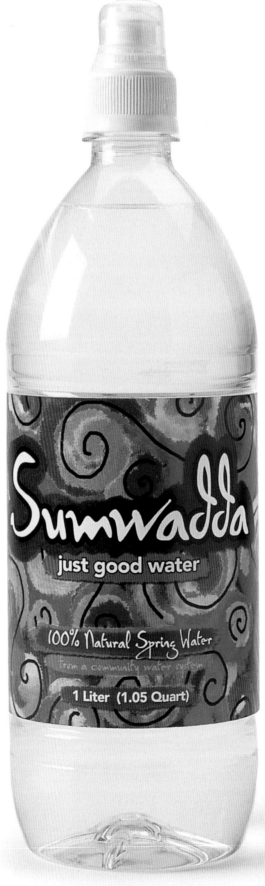

I.VOX Design/The Sweetwater Co.

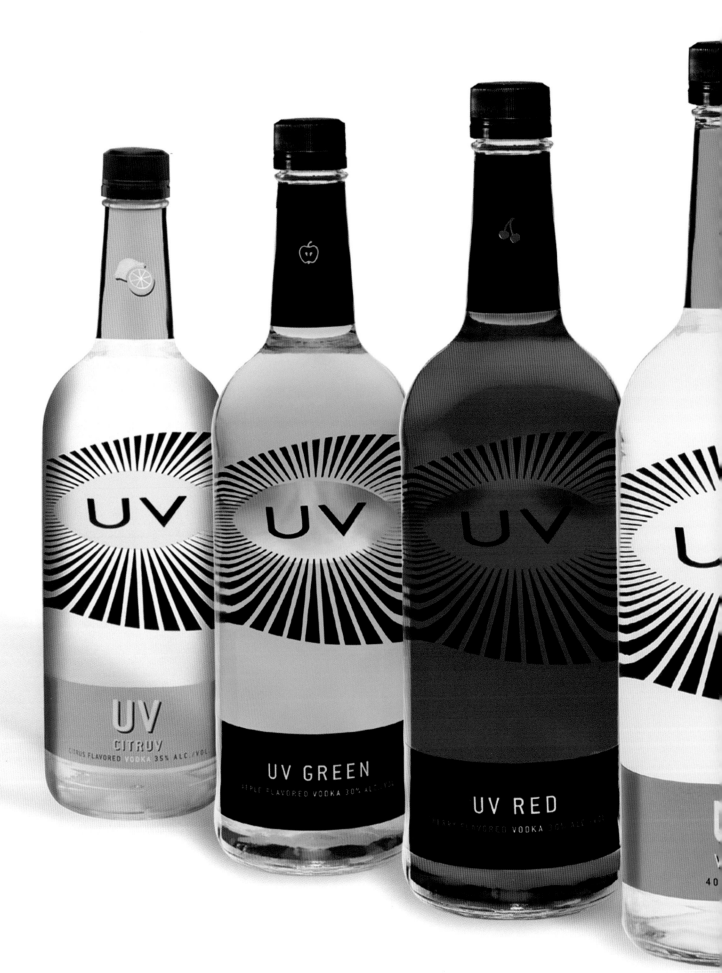

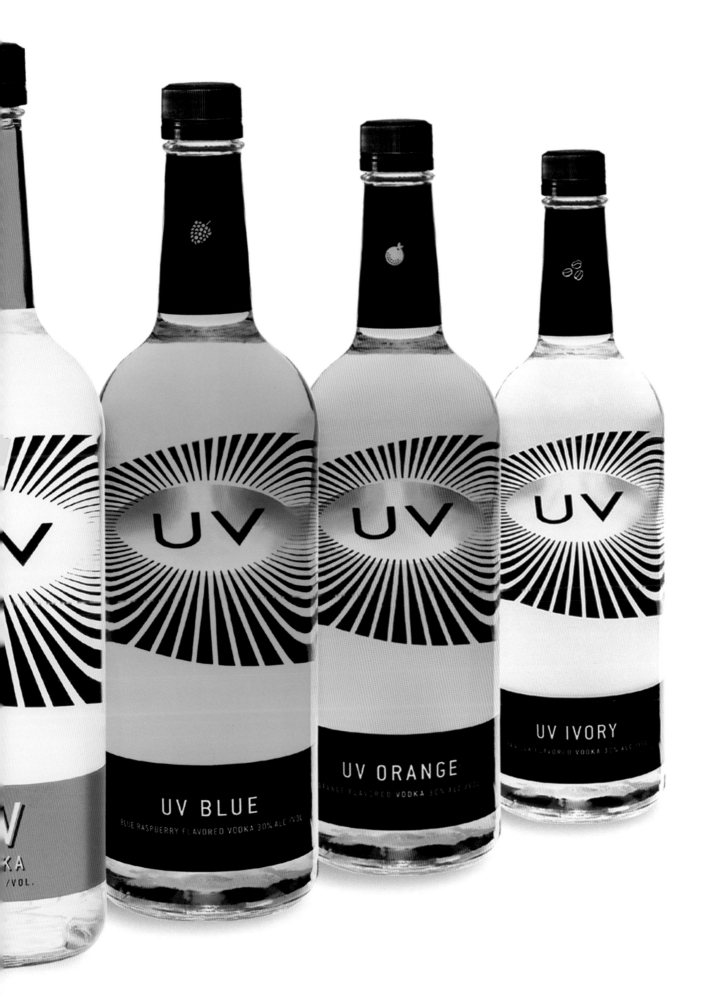

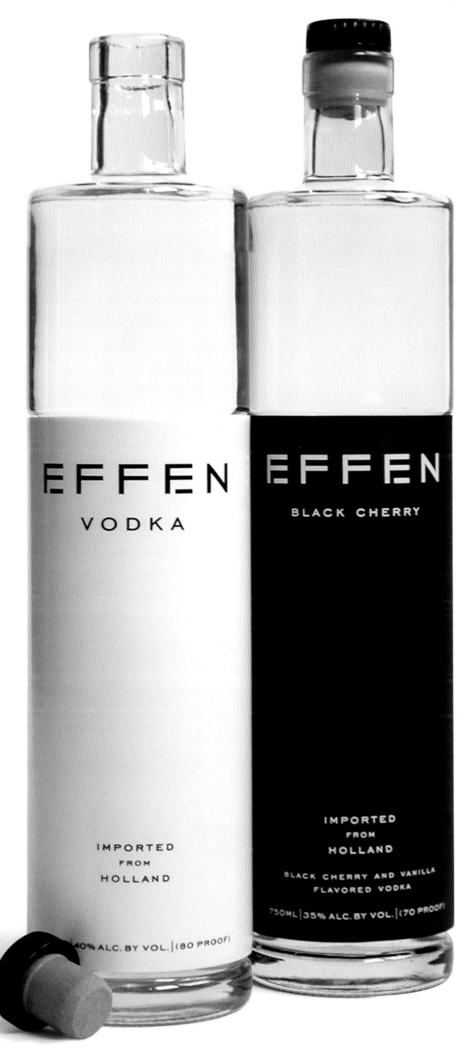

Cahan & Associates/jstar Brands

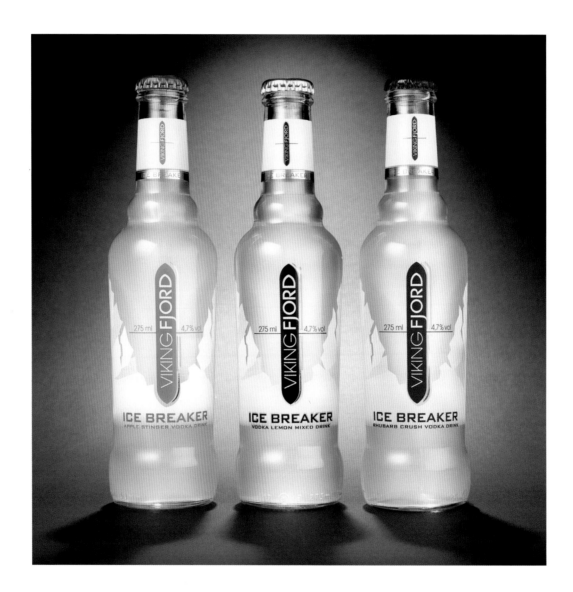

Design Bridge/Arcus, (opposite) Underberg

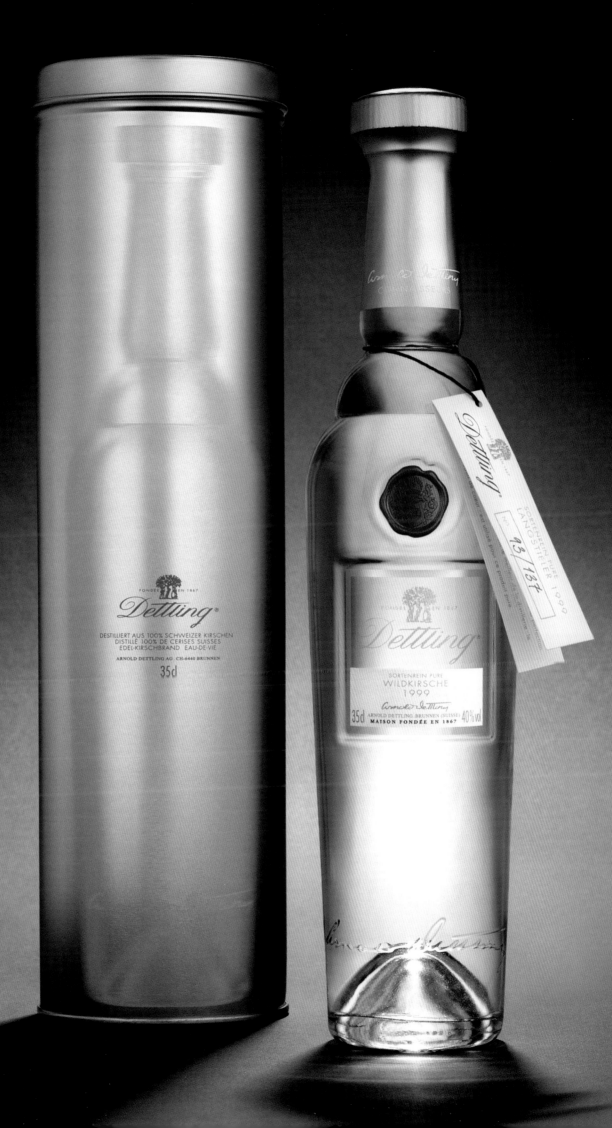

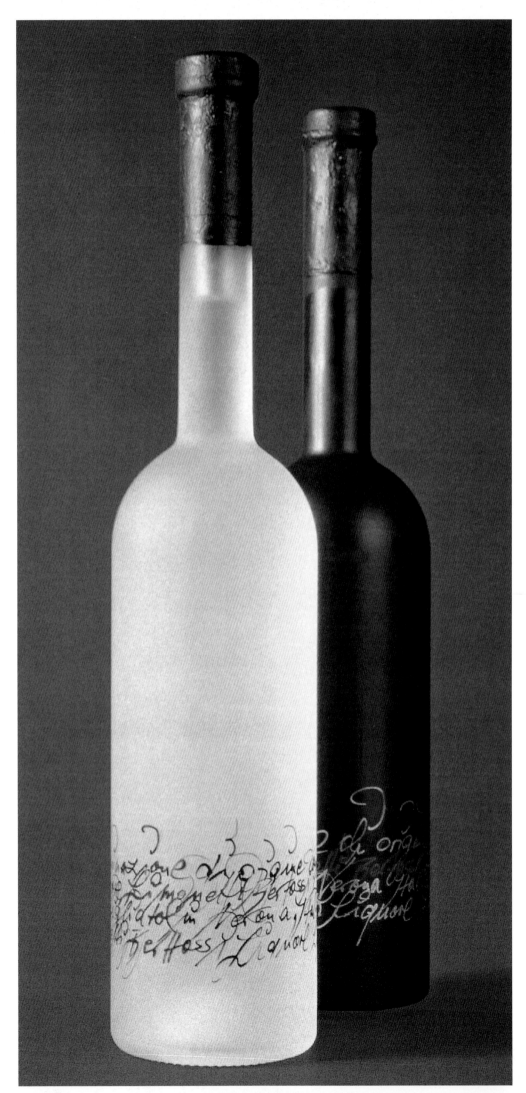

Aidalos Design/Bertossi

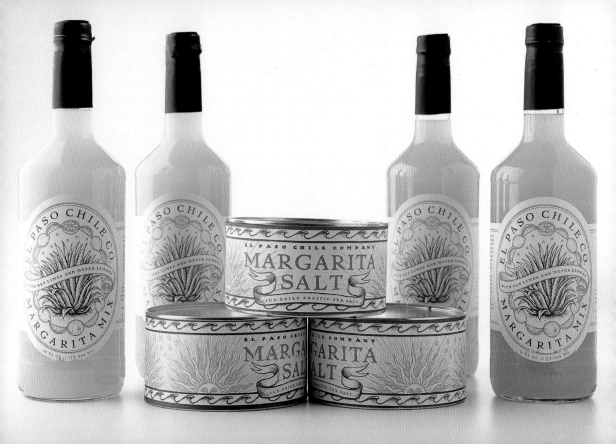

Poagi ®/Old Vines Co.

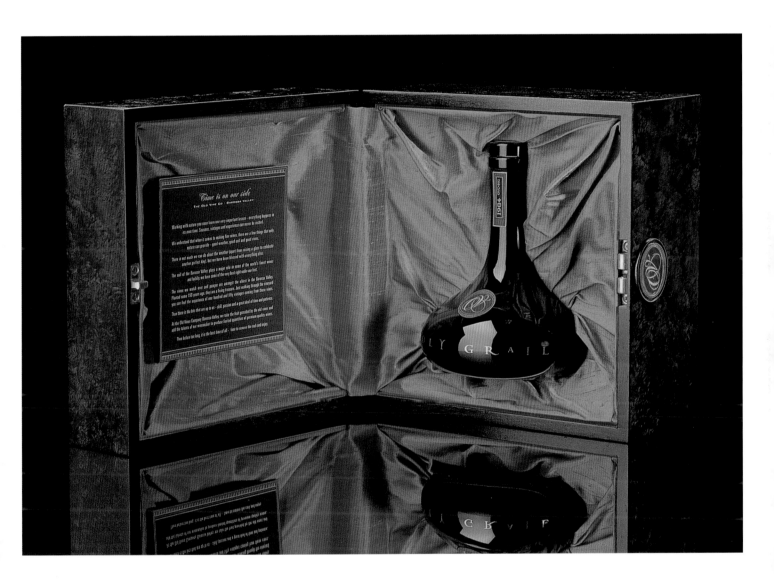

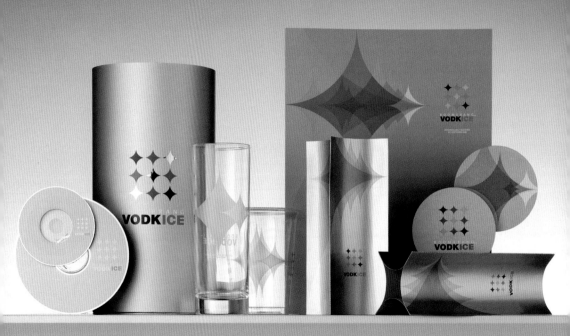

ULTR
REMI

Christiania

ULTRA PREMIUM
V O D K A

I M P O R T E D
FROM NORWAY

40% ALC/VOL (80 PROOF) 750ml

MAESTRO TEQUILERO®
TEQUILA REPOSADO
CLÁSICO

100% DE AGAVE
HECHO EN MEXICO

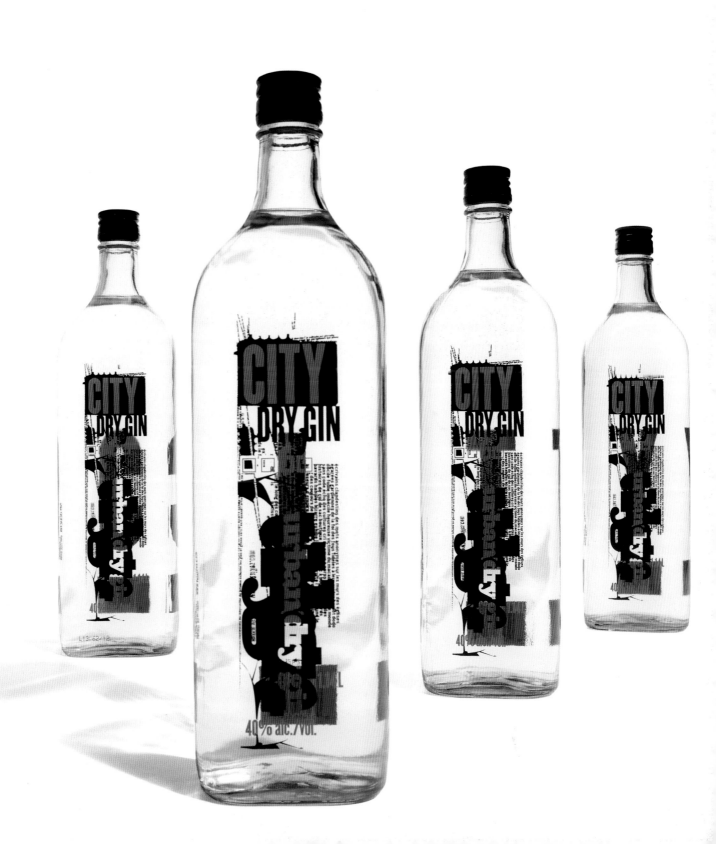

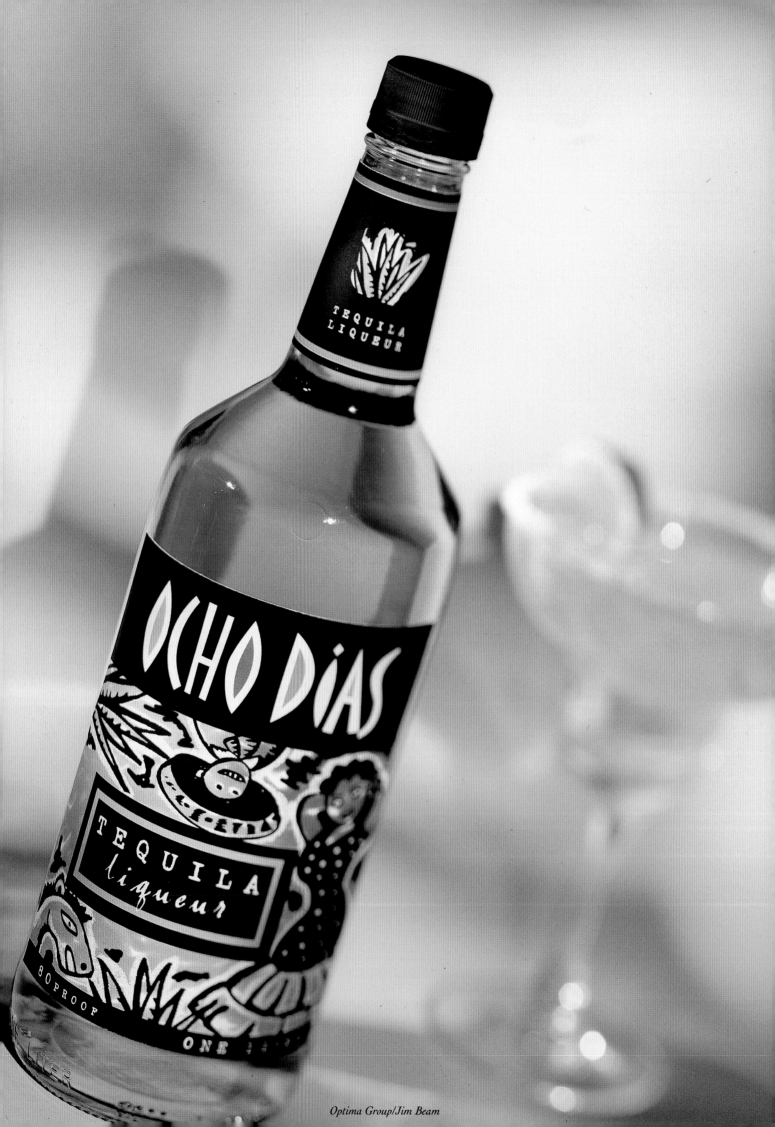

Optima Group/Jim Beam

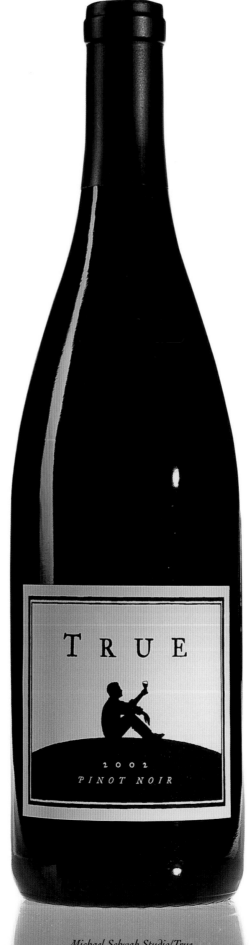

Michael Schwab Studio/True

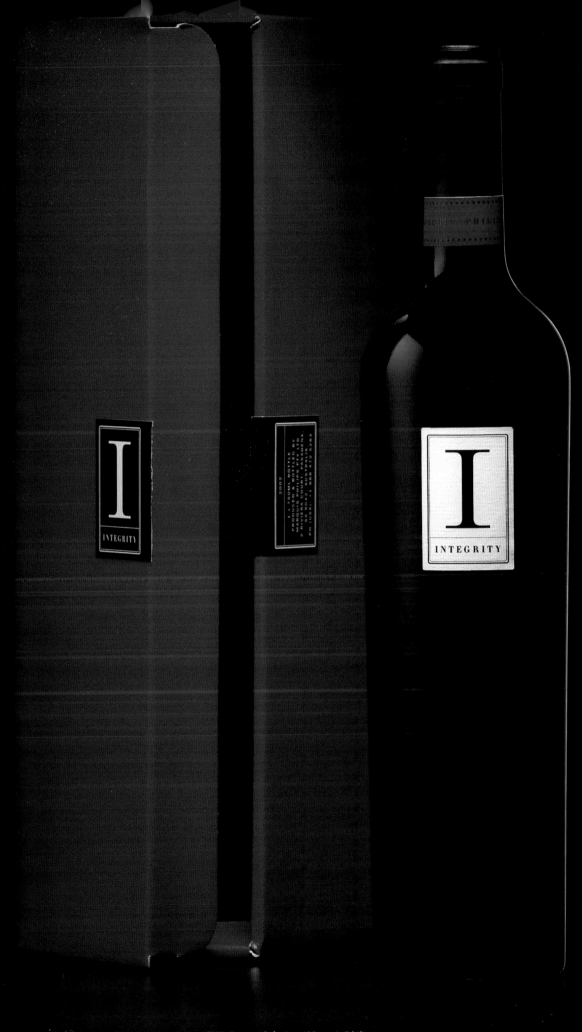

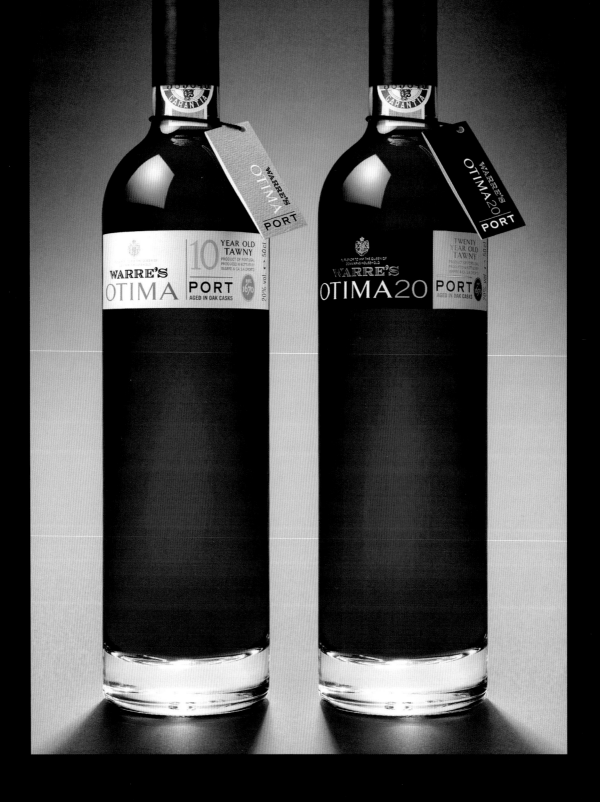

Design Bridge/Symington Family

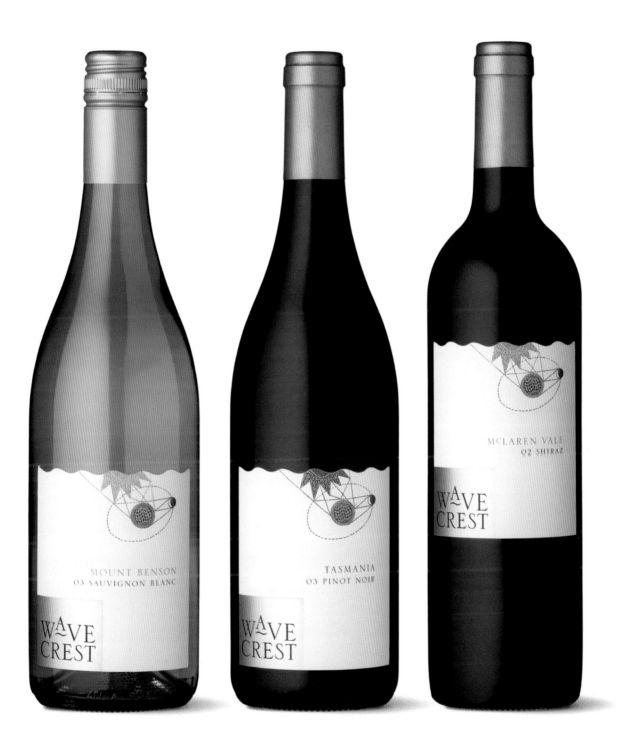

Harcus Design/Kreglinger Wine Estates

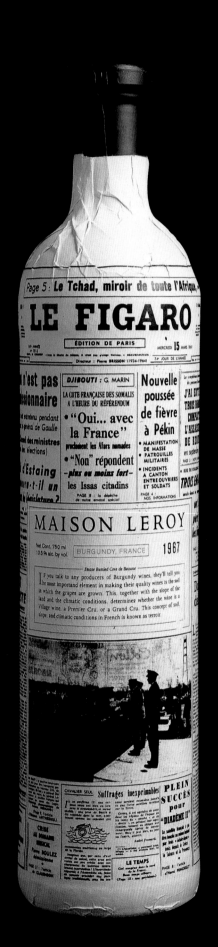

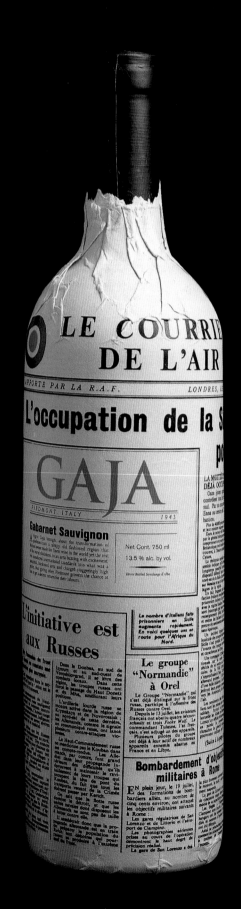

Marina Drukman

Tawny Porto
LIMITED EDITION

40 FORTY YEARS OLD

SANDEMAN
EST 1790

THIS BOTTLE CERTIFIED AS No.
4512

20%vol 75cl

MA
247135
02

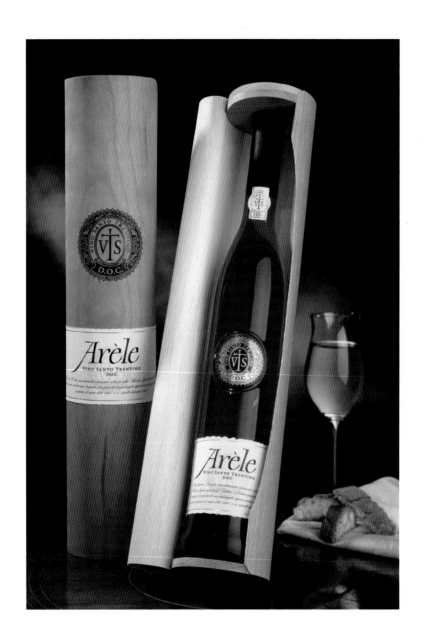

BLACK&WHITE
TOPANGA
VINEYARDS
CABERNET SAUVIGNON
NAPA VALLEY
1999

ALCOHOL 13.5% BY VOLUME
PRODUCED AND BOTTLED BY
TOPANGA VINEYARDS
ST. HELENA. NAPA COUNTY. CA
310 455 1287

GOVERNMENT WARNING
1) ACCORDING TO THE SURGEON GENERAL WOMEN
SHOULD NOT DRINK ALCOHOLIC BEVERAGES
DURING PREGNANCY BECAUSE OF THE RISK OF
BIRTH DEFECTS.
2) CONSUMPTION OF ALCOHOLIC BEVERAGES
IMPAIRS YOUR ABILITY TO DRIVE A CAR OR OPERATE
MACHINERY, AND MAY CAUSE HEALTH PROBLEMS.

CONTAINS SULFITES

Germ/Black & White

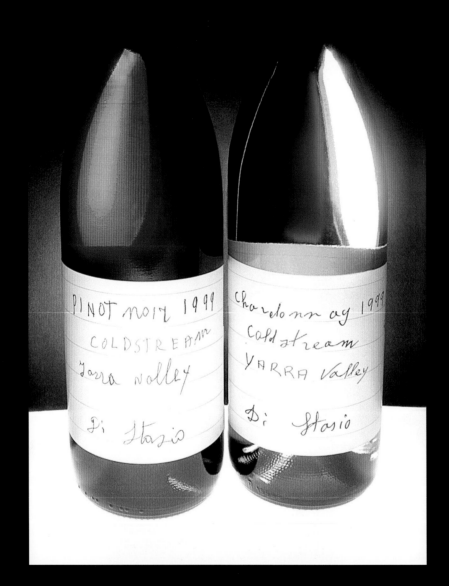

On the bottle labels (handwritten):

PINOT noir 1999
COLDSTREAM
Yarra Valley

Di Stasio

Chardonnay 1999
Coldstream
YARRA Valley

Di Stasio

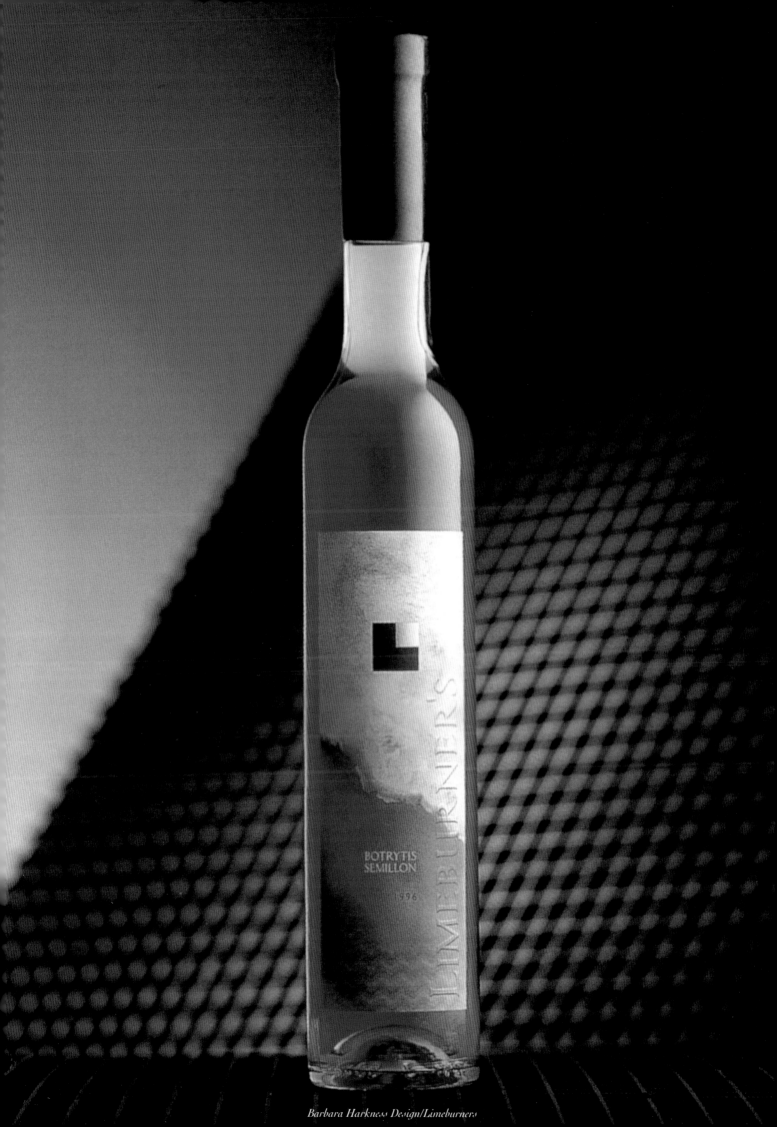

Barbara Harkness Design/Limeburners

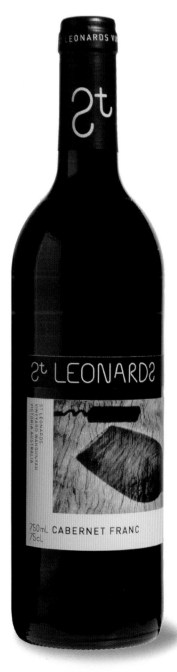

David Lancashire/St. Leonard's Vineyard

Buena Vista

LIMITED RELEASE · CARNEROS ZINFANDEL ROSÉ · 1998

Sterling Cross Creative/Buena Vista

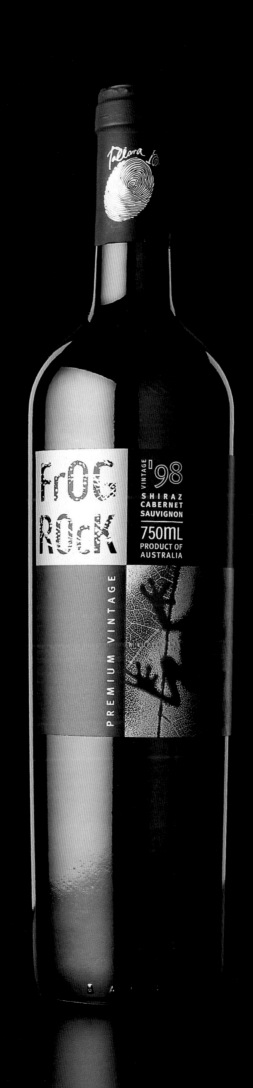

Harcus Design/Frog Rock

SFIDA
NEGROAMARO 40%
PRIMITIVO 30%
AGLIANICO 30%
PUGLIA
INDICAZIONE GEOGRAFICA TIPICA
ROSSO

Louise Fili Ltd/Matt Brothers

1998

STEPPING
STONE

BY CORNERSTONE

CABERNET SAUVIGNON

MILL RACE VINEYARD~NAPA VALLEY

14.2% ALCOHOL BY VOLUME 750 ML

Shiraz/1998

PRODUCE OF AUSTRALIA

ALCVOL 13.5%

750ML

Chardonnay
Barossa Valley

2001

BEER BROTHERS WINE: farmshop@maggiebeer.com.au

The 2001 Chardonnay has been fermented and partly
matured in French oak. The colour is pale straw, with
citrus and peach aromas. The palate is creamy with
peaches, figs and nutty oak characters with a citrus
freshness on the finish
Visit our cellar door at Maggie Beer's Farm Shop off
Samuel Road Nuriootpa to taste our full range of wines
and sample the famous Maggie Beer gourmet foods.

COLIN & BRUCE BEER

APPROX 8.0 STANDARD DRINKS. PRESERVATIVE (220)
AND ANTIOXIDANT (300) ADDED

"The boys could always be found on the beach at Pt Parham,
persuading a few crabs to come home for supper by the bonfire".

Beer
Bros.

Beer
Bros.

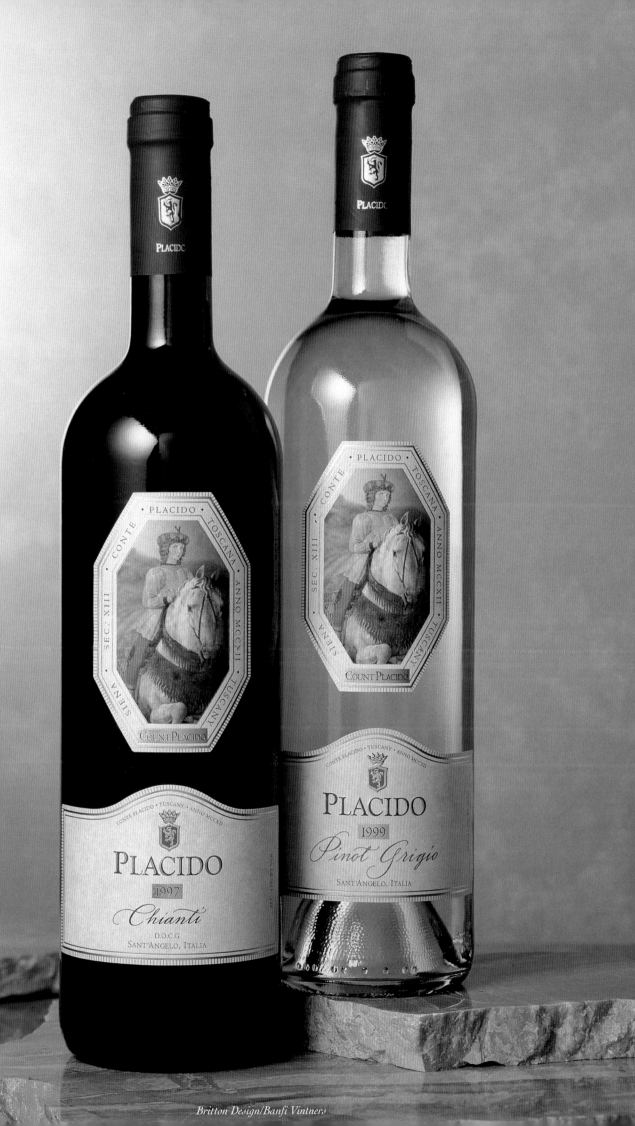

Emer
~Chardonnay~
ADELAIDE HILLS

Speckled House
~Riesling~
ADELAIDE HILLS

Cuchulain
~Shiraz~
ADELAIDE HILLS

Black Sanglain
Cabernet Sauvignon
ADELAIDE HILLS

(this spread) IKD Design Solutions/Talunga Ridge, (opposite) Marquis Philips

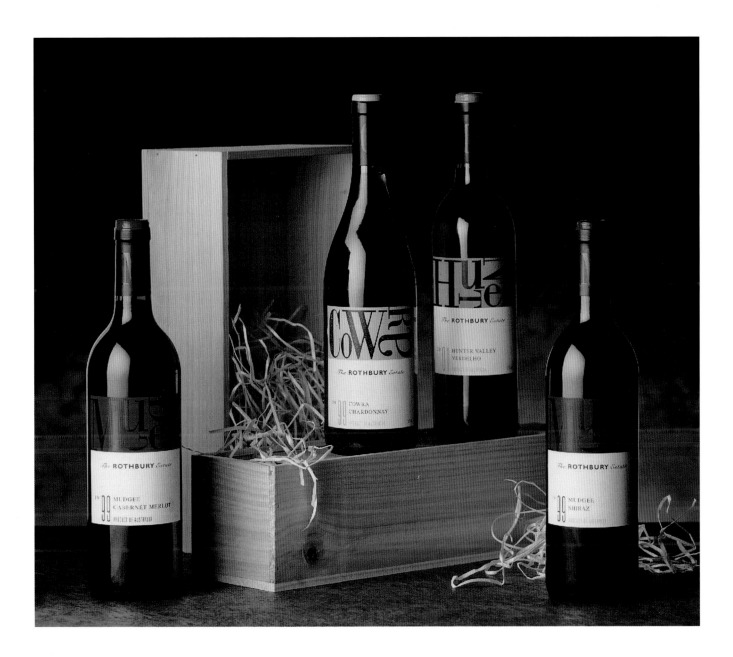

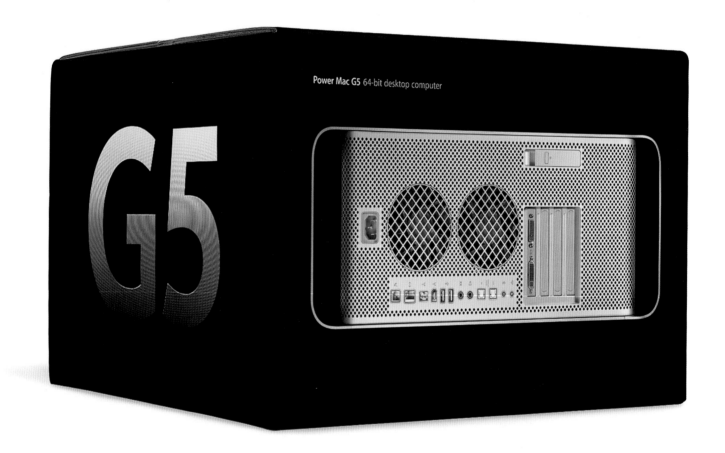

Power Mac G5 64-bit desktop computer

(this spread) Apple Computers

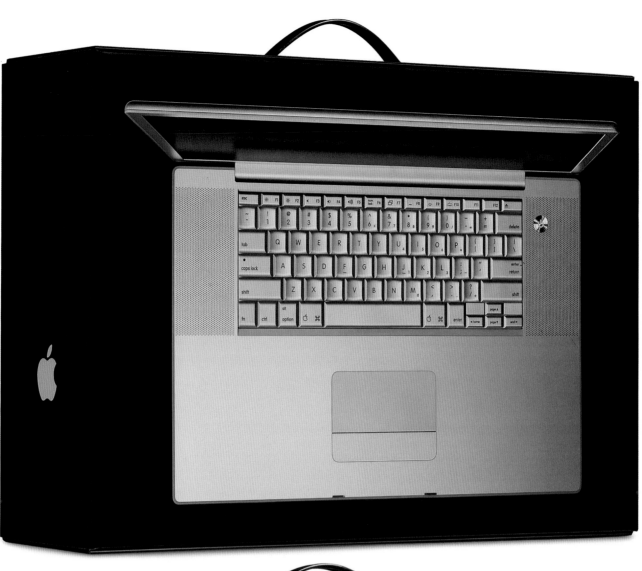

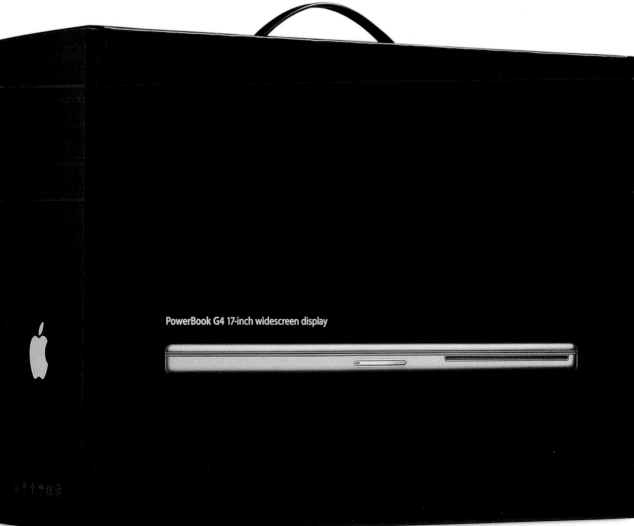

PowerBook G4 17-inch widescreen display

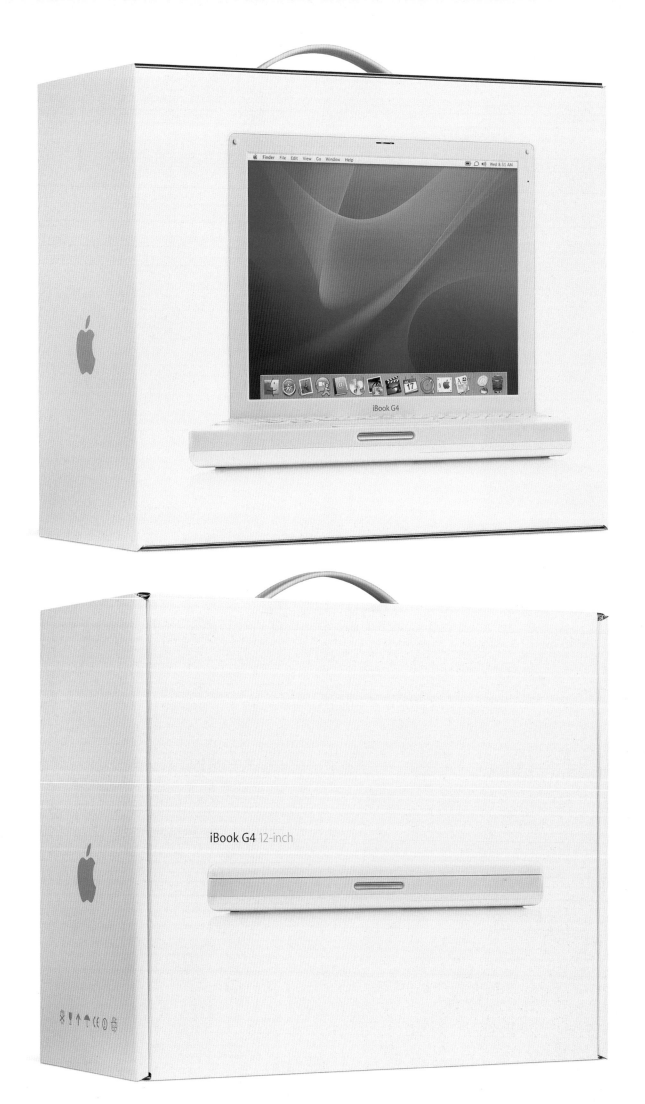

(this spread) Apple Computers

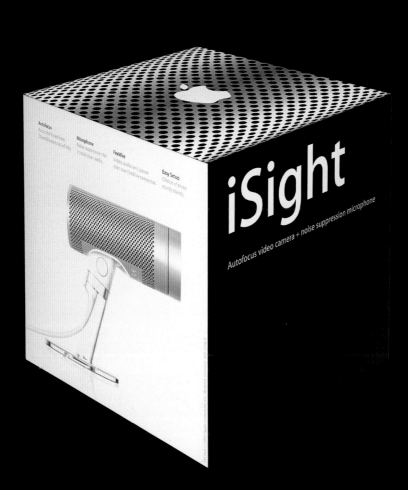

Autofocus
Accurate focus from
50 millimeters to infinity.

Microphone
Noise suppression for
crystal-clear audio.

FireWire
Video, audio, and power
over one FireWire connector.

Easy Setup
Choice of three
sturdy stands.

iSight

Autofocus video camera + noise suppression microphone

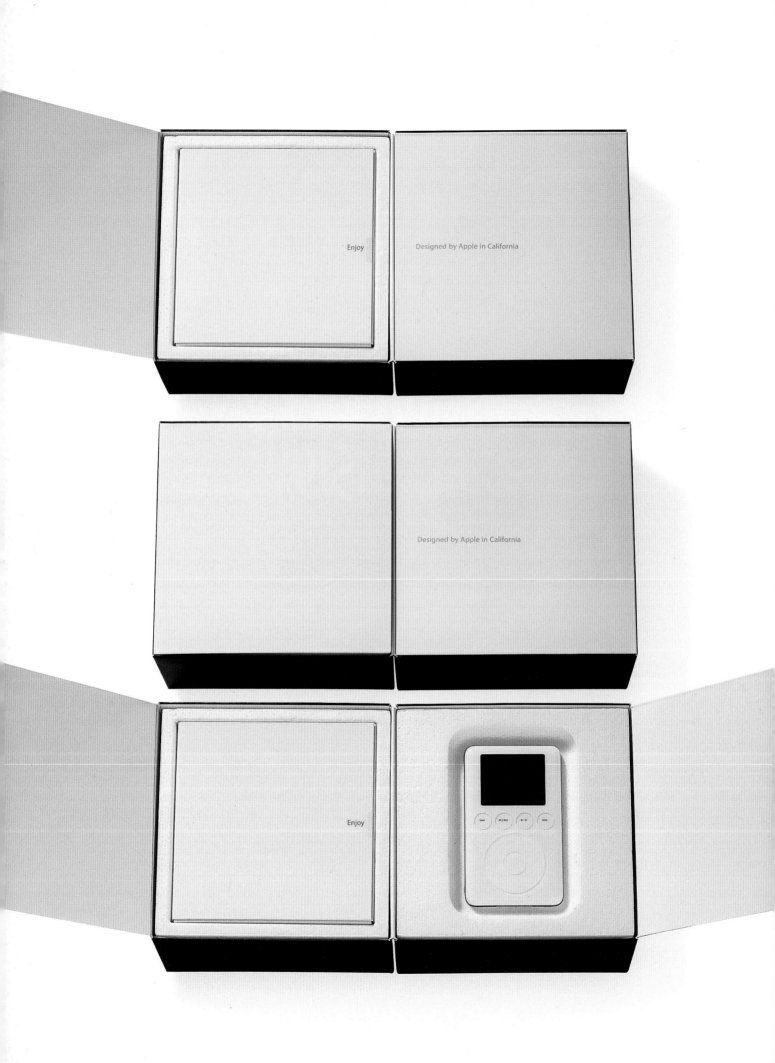

(this spread) Apple Computers

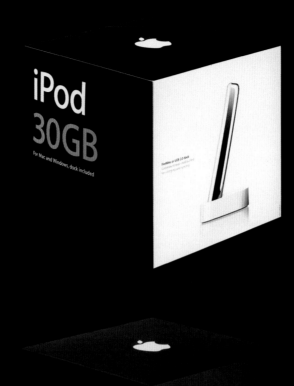

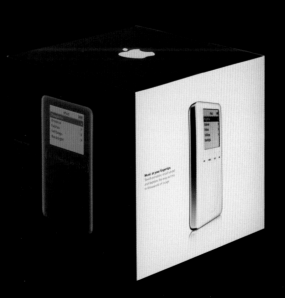

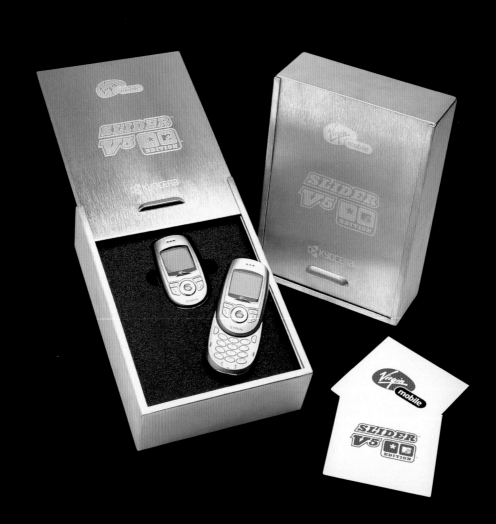

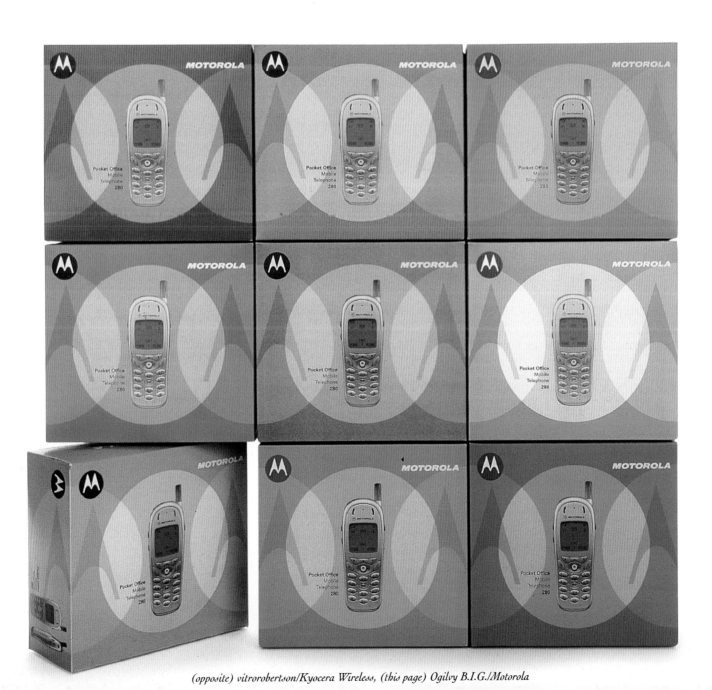

(opposite) vitrorobertson/Kyocera Wireless, (this page) Ogilvy B.I.G./Motorola

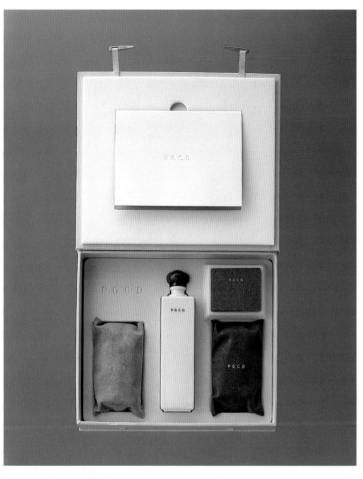

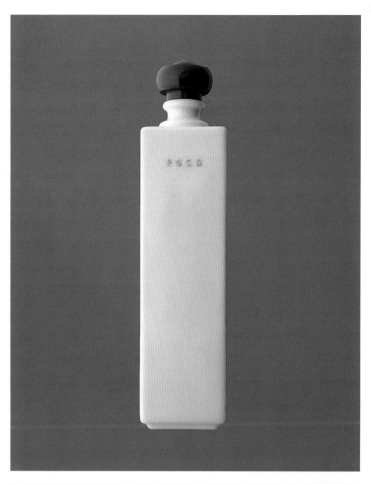

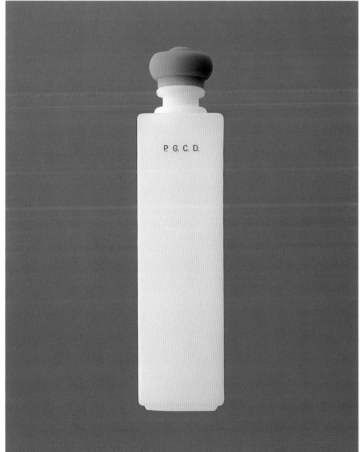

Taku Satoh Design Office Inc.

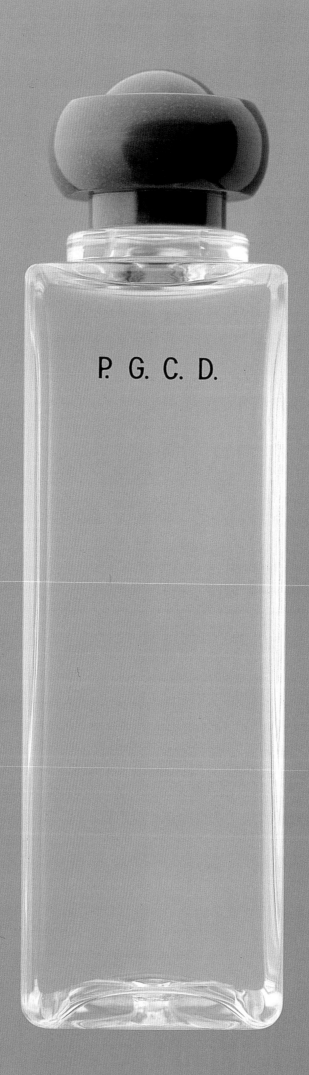

(this spread) Taku Satoh Design Office Inc.

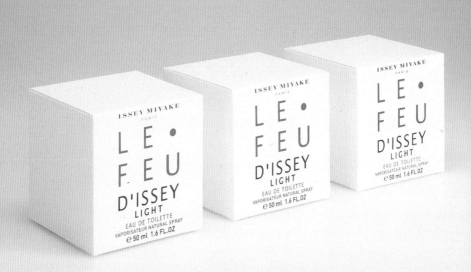

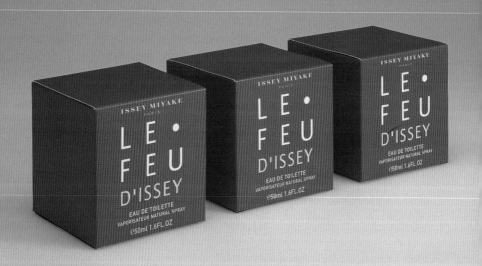

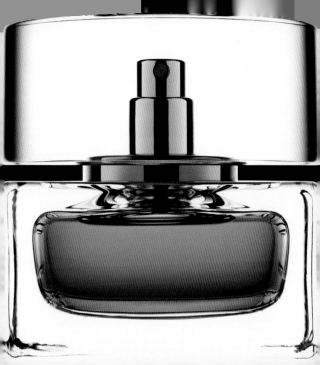

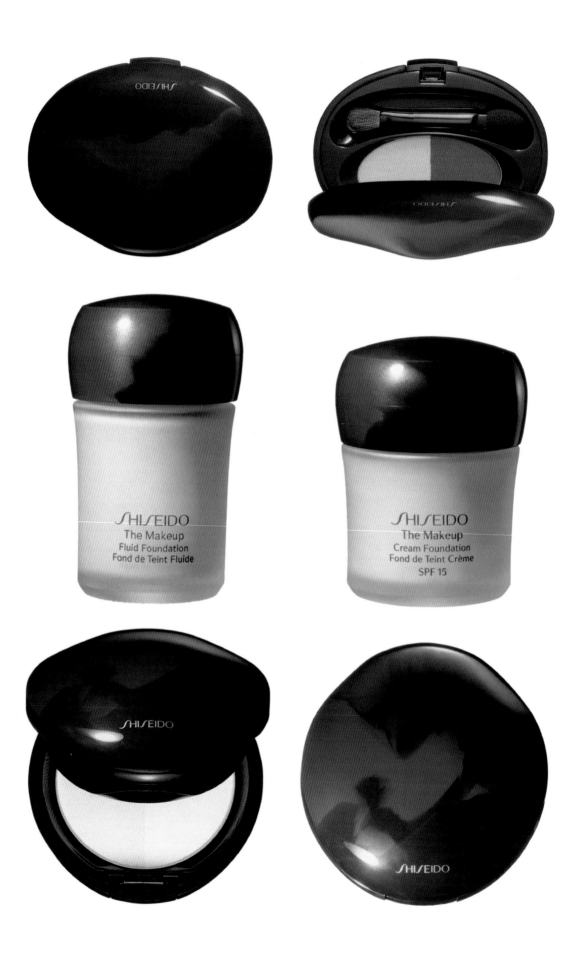

EAU DE
TOILETTE

DÉODORANT SANS ALCOOL
ALCOHOL FREE DEODORANT

EAU DE
TOILETTE

LOTION APRES RASAGE
AFTER-SHAVE LOTION

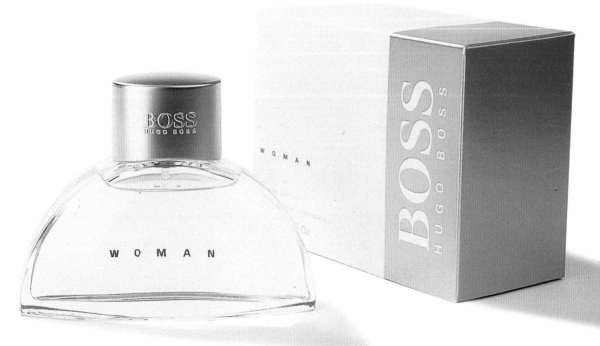

Peter Schmidt Studios/Procter & Gamble

RUSK

Shine™

IR

Shine Spray
Laque Brilliante

Rusk Shine™ is a superfine myst
spray that imparts brilliant gloss,
reflective shine and an invisible
shield to protect the hair. Its light
weight formula even leaves fine hair
with movement and manageability.

Rusk Shine™ est une laque à jet
ultra-fin qui rend les cheveux très
brillants et forme une barrière invisible
pour les protéger. Sa formule légère
rend même les cheveux fins souples
et faciles à coiffer.

Cont. Net 125 G Net Wt. 4.4 oz

Nestor-Stermole VCG/Rusk

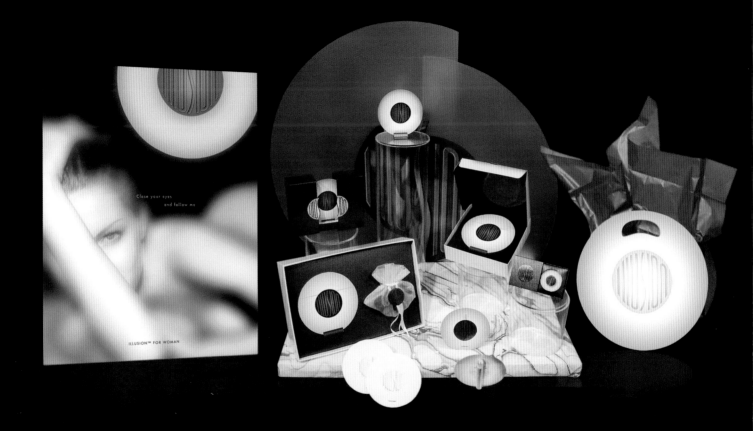

Priska-d

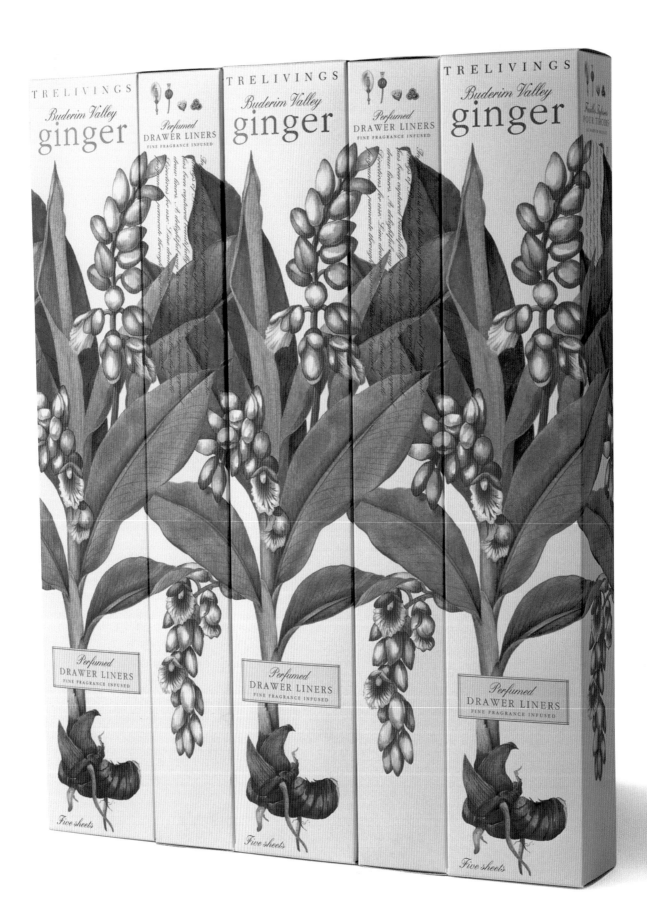

(this spread) Harcus Design/The Trelivings Company

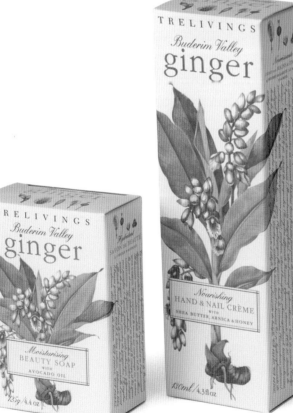
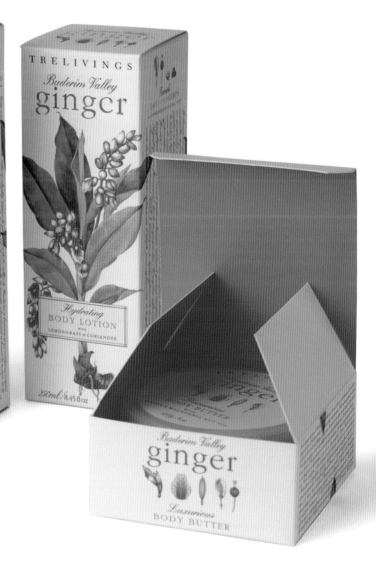

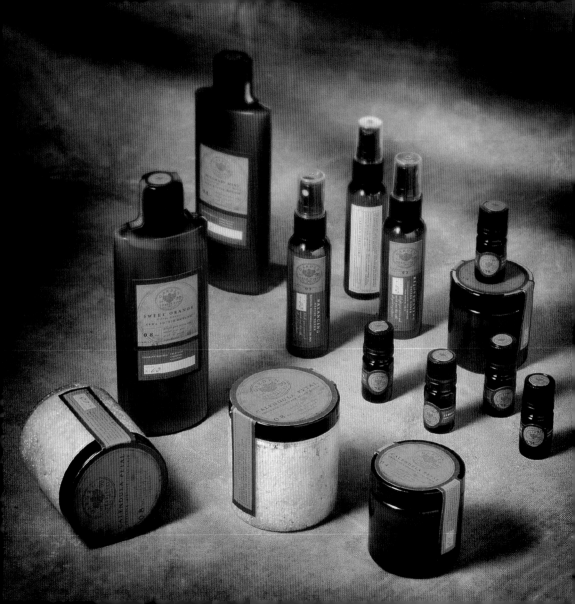

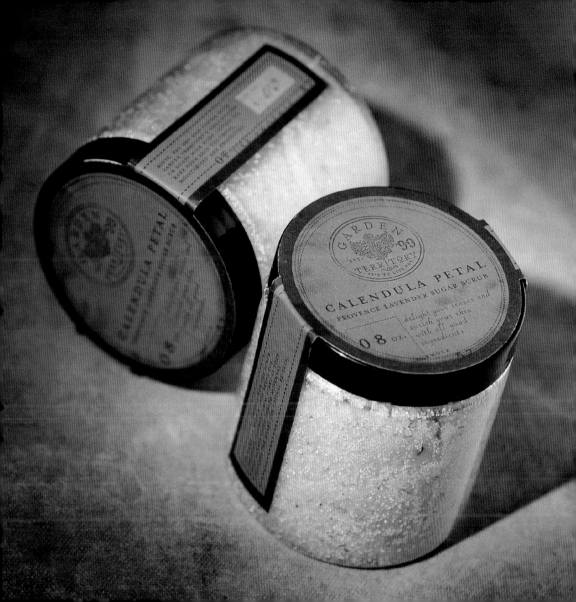

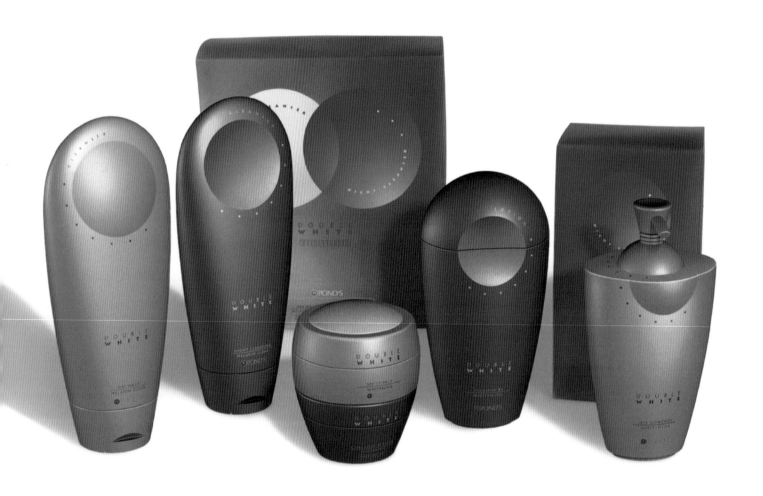

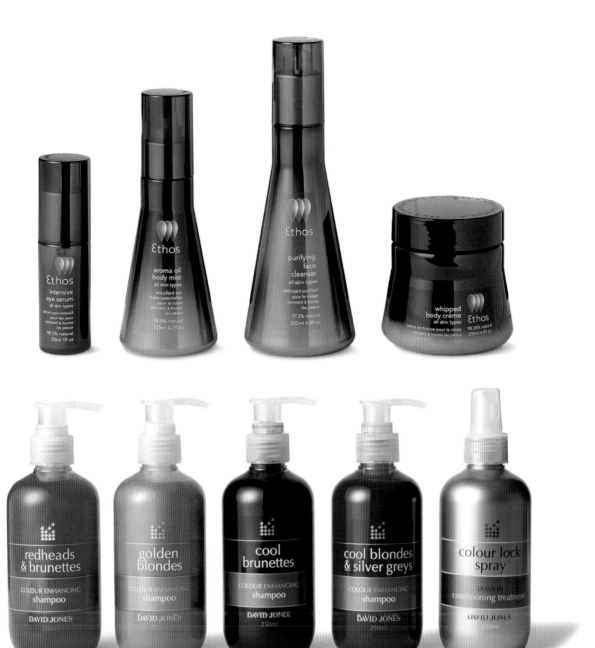

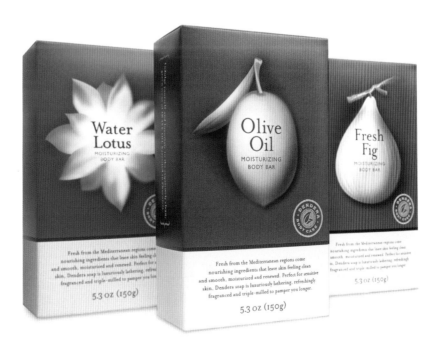

Harcus Design/The Trelivings Company
Harcus Design/Rauxel Pty Ltd
Wallace Church Inc./Bradford Soaps

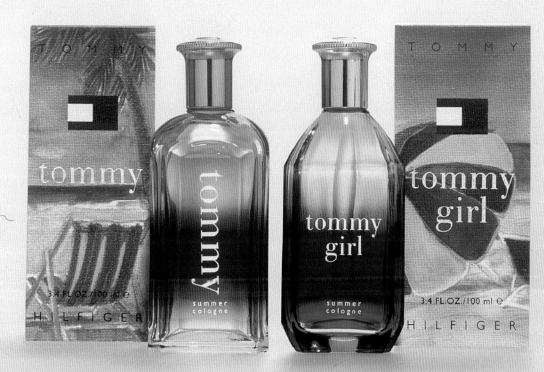

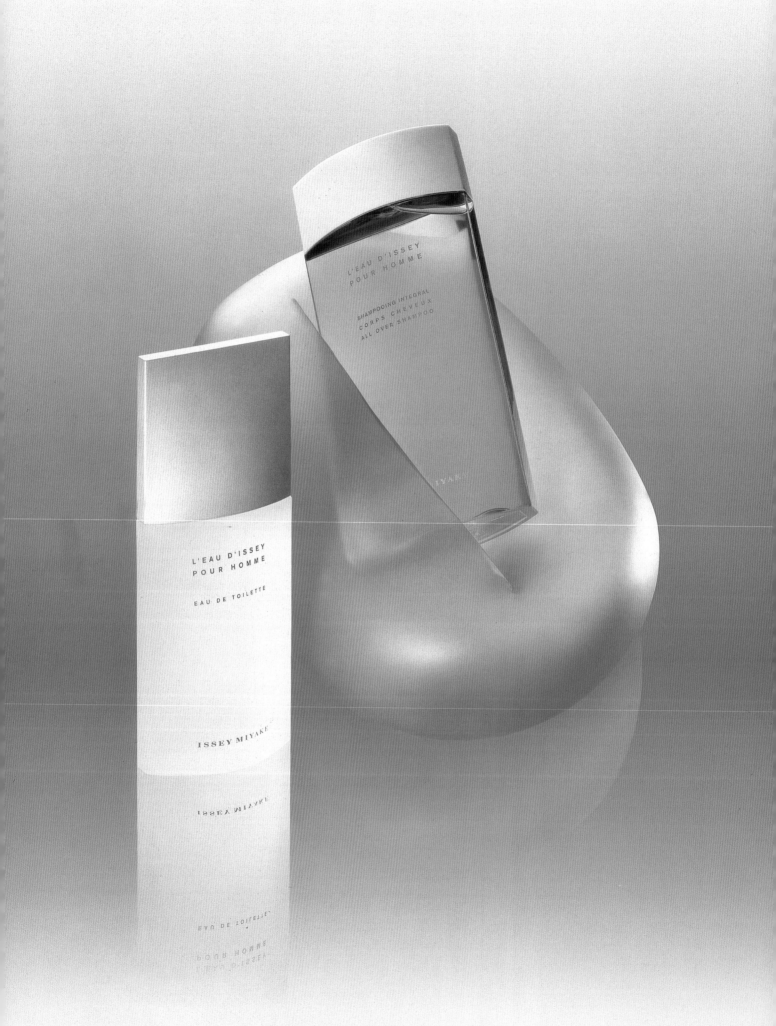

Karim Rashid Inc./BPI Perfumes, Issey Miyake

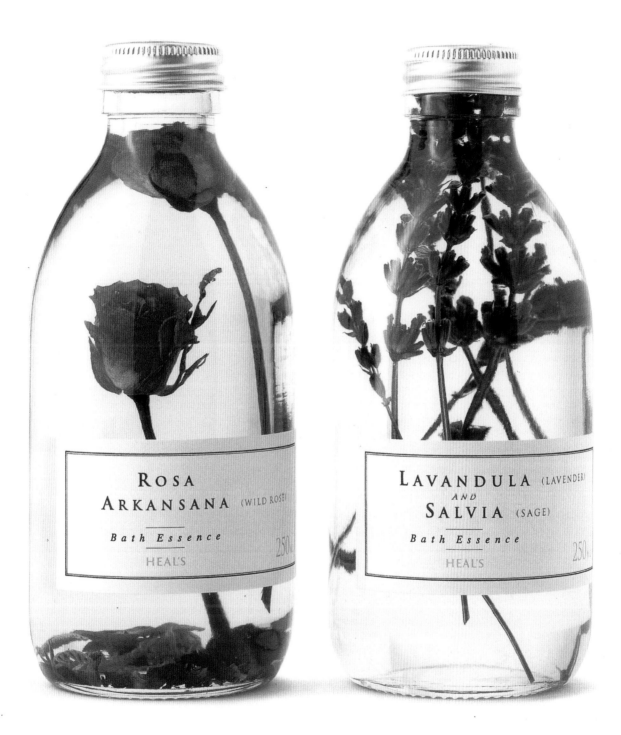

terra bella
ROOM SPRAY

terra bella

terra bella
BATH SALTS

cliniderm™

ALL DAY SUN
PROTECTION

FACTOR
16

WATER PROOF
SWEAT PROOF
RUB PROOF
UVA–UVB PROTECTION

cliniderm™

AFTER SUN CARE

WITH ALOE VERA,
VITAMIN-E
AND ACTIVE LIPOSOMES

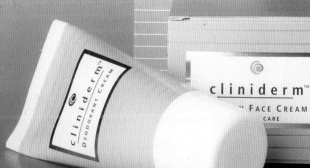

cliniderm™

DEODORANT CREAM

cliniderm™

FACE CREAM
CARE

cliniderm

NIGHT CREAM
WITH AHA

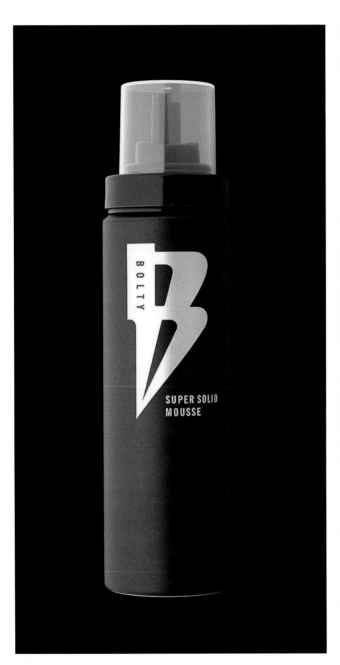

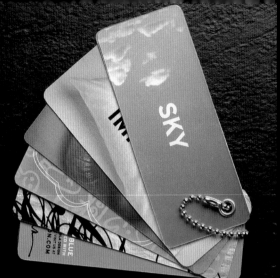

Morla Design/Express Jeans; (opposite) Turner Duckworth Design/Levi Strauss & Co.

Turner Duckworth Design/Levi Strauss & Co.

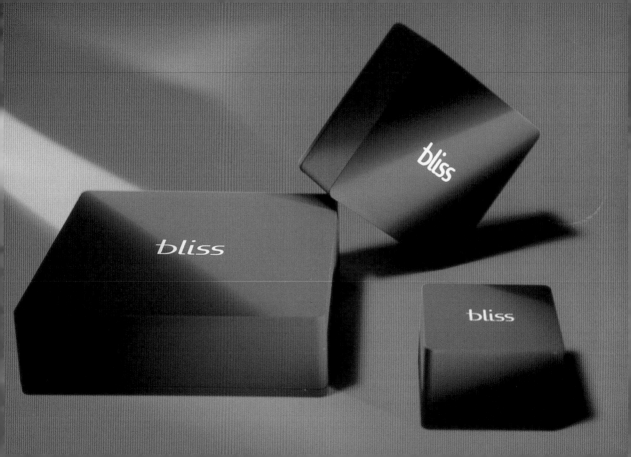

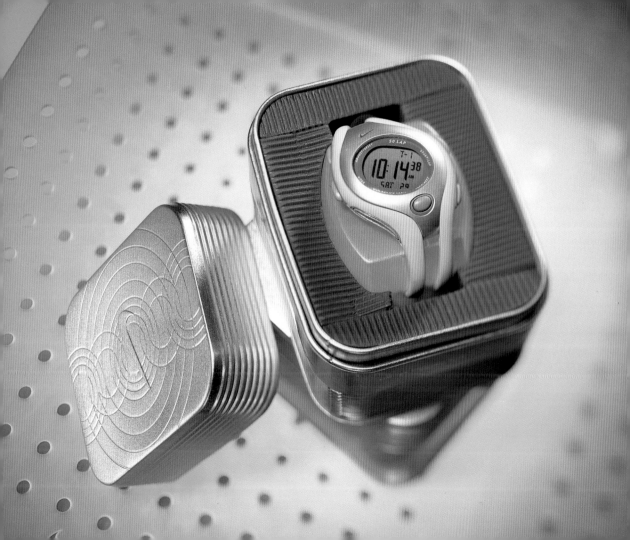

(this spread) Fossil

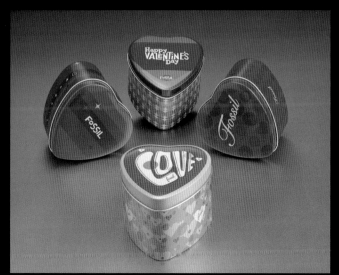

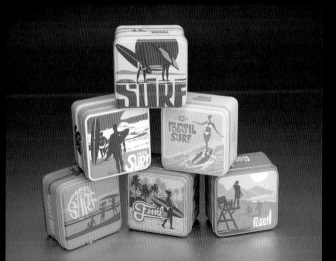

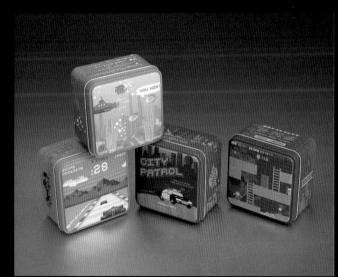

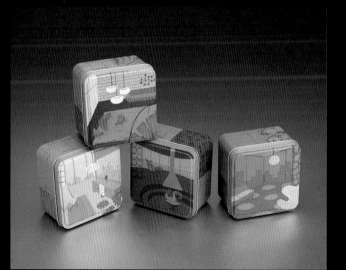

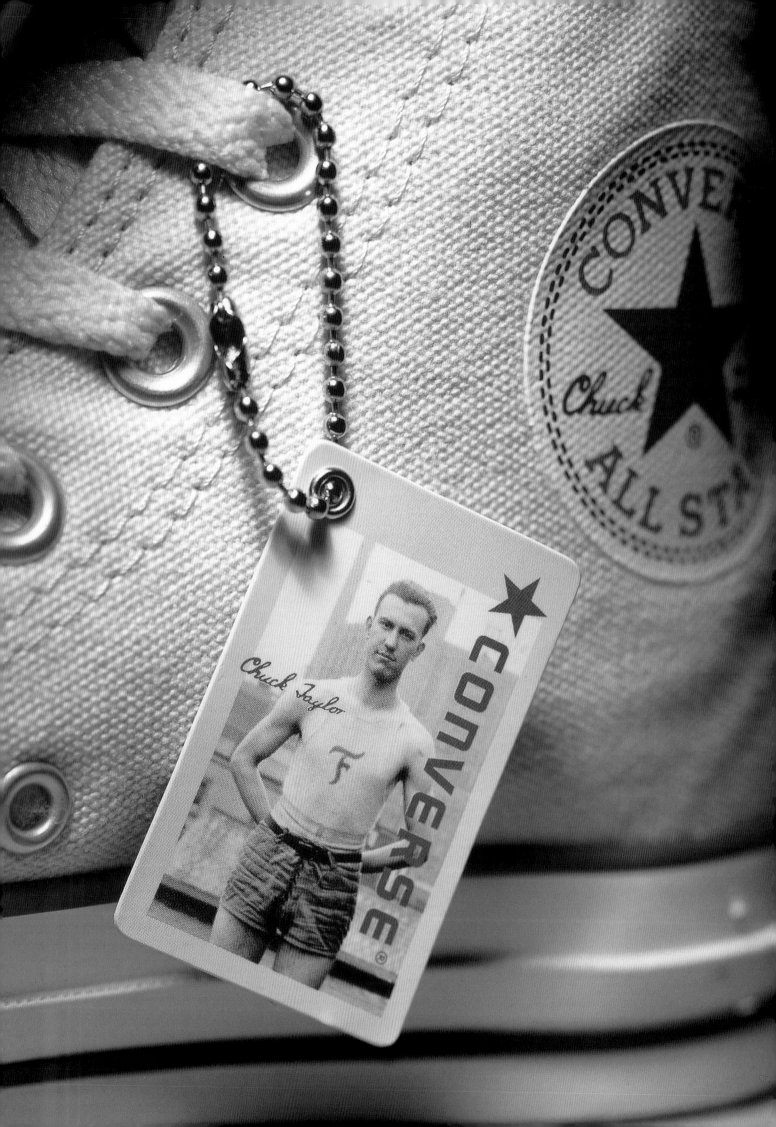

WAITROSE
DIVA
PRESS-ON
TOWELS

20 REGULAR

WAITROSE
DIVA
PRESS-ON
TOWELS

18 SUPER

WAITROSE
DIVA
NIGHT TIME
TOWELS

10 SUPER PLUS

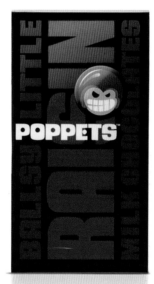
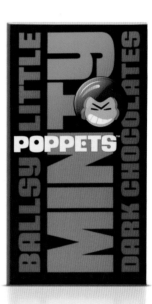

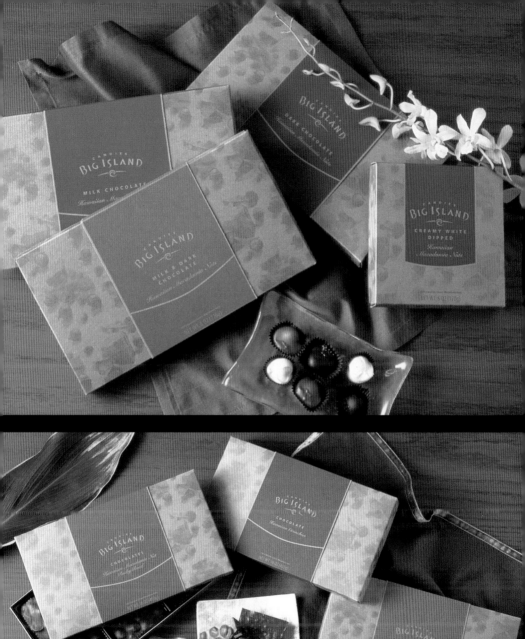
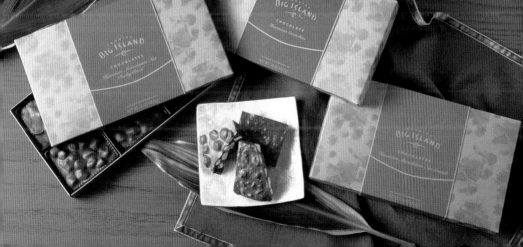

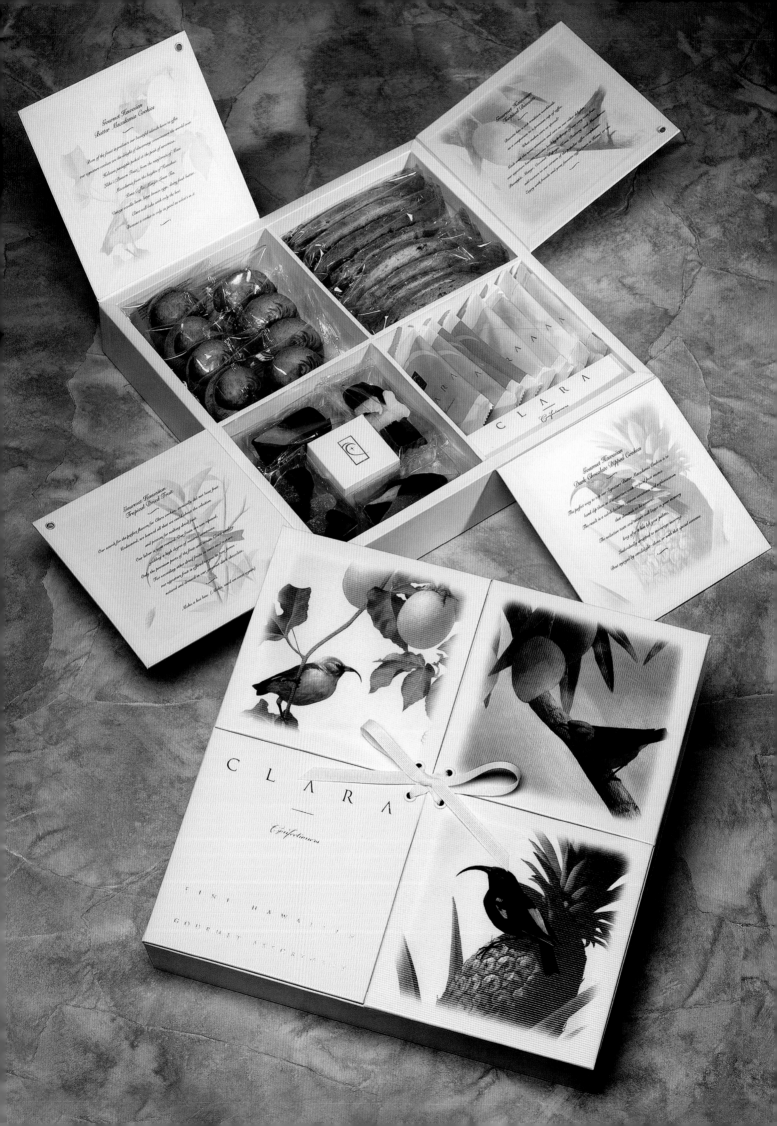

(opposite) Studio Ignition/Clara Confectioners, (this page) Sabingrafik Inc./Tamansari Beverage, Seafarer Baking Company

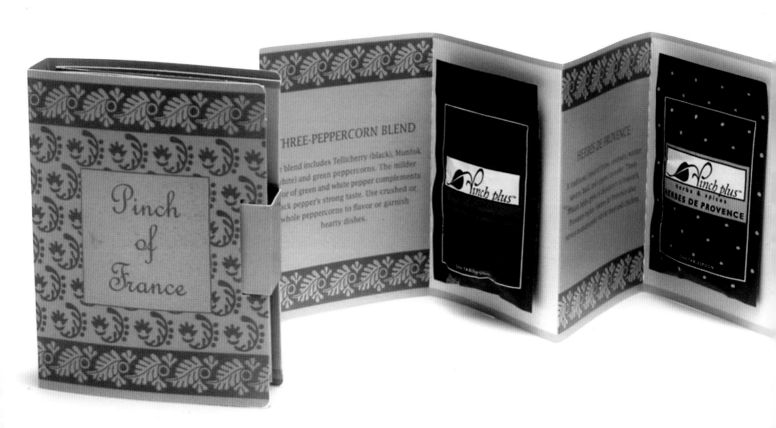

Pinch
of
France

THREE-PEPPERCORN BLEND

blend includes Tellicherry (black), Muntok
white) and green peppercorns. The milder
or of green and white pepper complements
ack pepper's strong taste. Use crushed or
whole peppercorns to flavor or garnish
hearty dishes.

Pinch plus™

HERBES DE PROVENCE

Pinch plus™
herbs & spices
HERBES DE PROVENCE

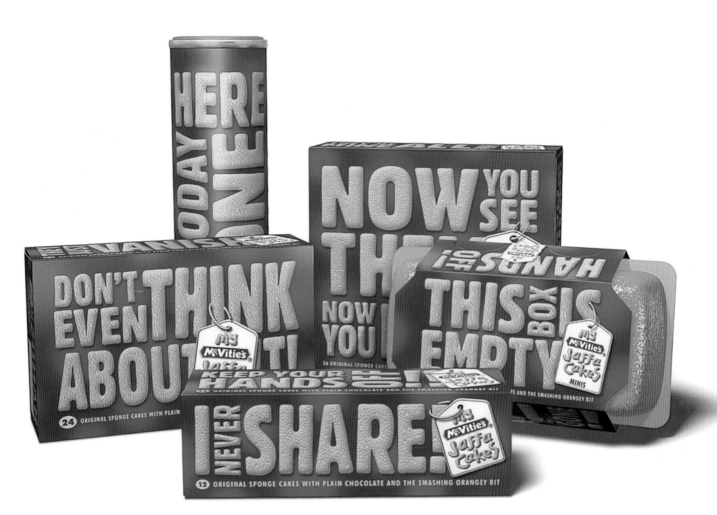

東京
あずき
グラッセ

(this page) Mark Oliver Inc./Kellogg Company, (opposite) Graphics & Designing Inc./Will Planning Inc.

CAVIAR

CAVIAR BAR
NINJA AKASAKA

SEVRUGA

NET WEIGHT: 50g
KEEP COOL

CAVIAR

CAVIAR BAR
NINJA AKASAKA

ASETRA

NET WEIGHT: 50g
KEEP COOL

CAVIAR

CAVIAR BAR
NINJA AKASAKA

ASETRA

NET WEIGHT: 50g
KEEP COOL

CAVIAR

CAVIAR BAR
NINJA AKASAKA

BELUGA

NET WEIGHT: 50g
KEEP COOL

CAVIAR

CAVIAR BAR
NINJA AKASAKA

SEVRUGA

NET WEIGHT: 50g
KEEP COOL

CAVIAR

CAVIAR BAR
NINJA AKASAKA

BELUGA

NET WEIGHT: 50g
KEEP COOL

CAVIAR

CAVIAR BAR
NINJA AKASAKA

ASETRA

NET WEIGHT: 50g
KEEP COOL

CAVIAR

CAVIAR BAR
NINJA AKASAKA

Turner Duckworth Design/La Tempesta

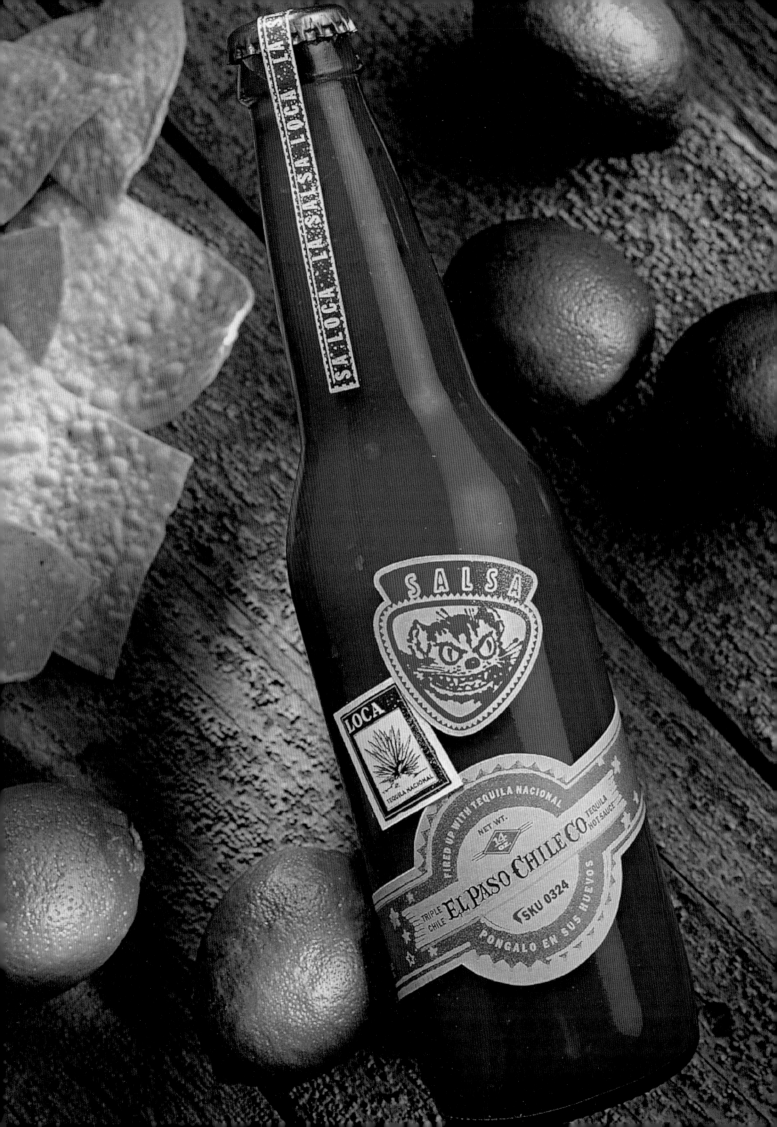

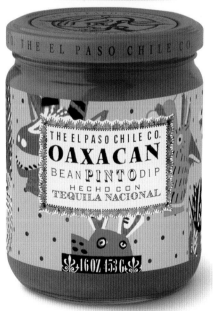

(this spread) RBMM/El Paso Chile Co.

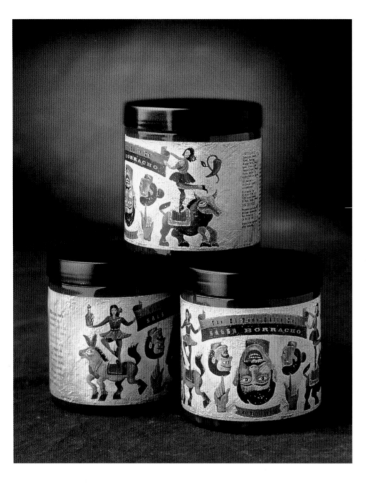

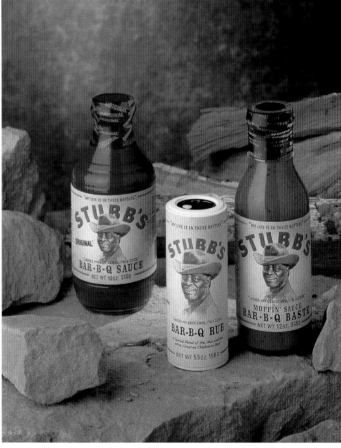

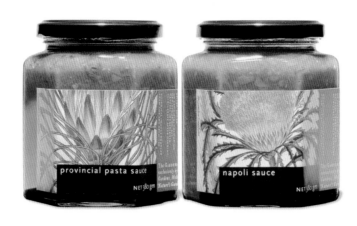

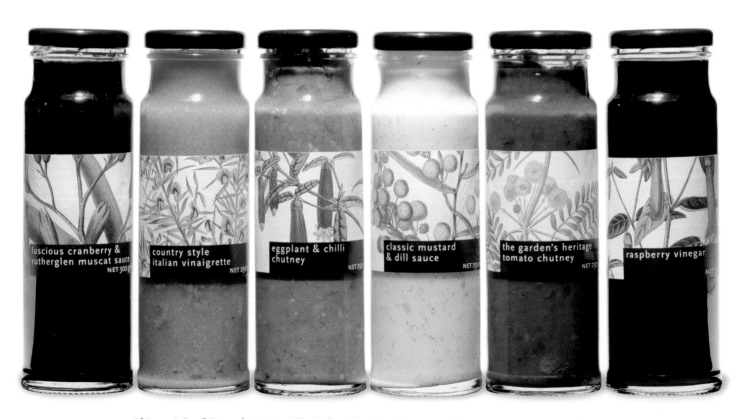

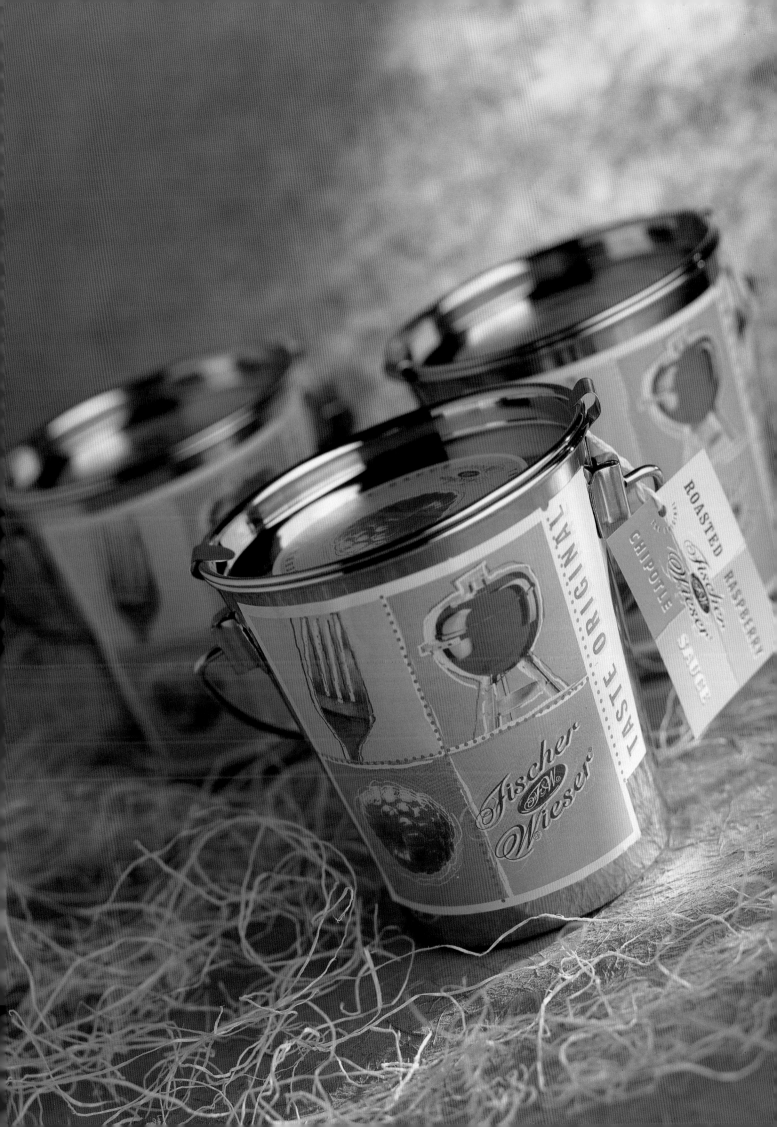

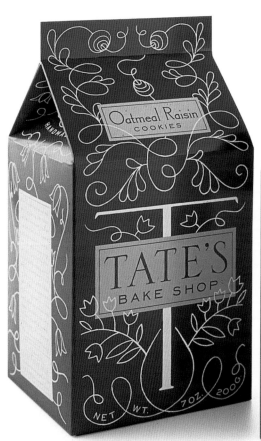
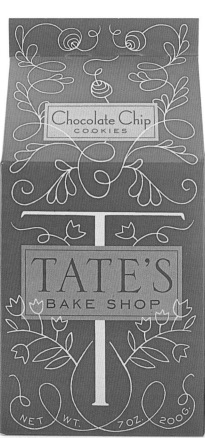
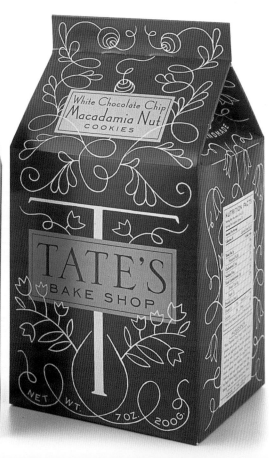

Louise Fili Ltd/Tate's

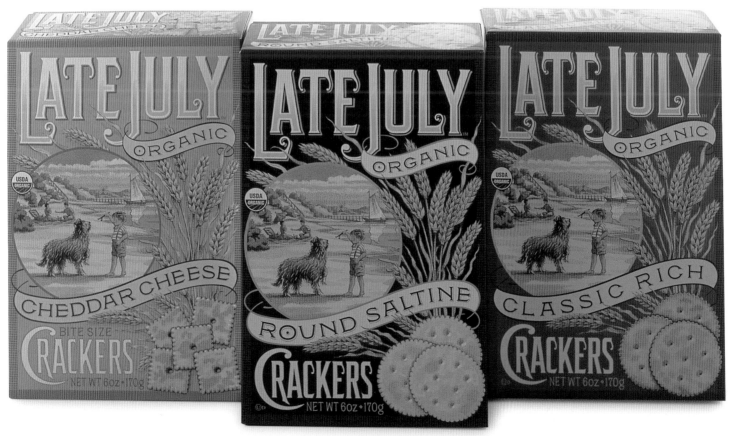

Louise Fili Ltd/Late July

Travers Collins & Company/Di Camillo Bakery

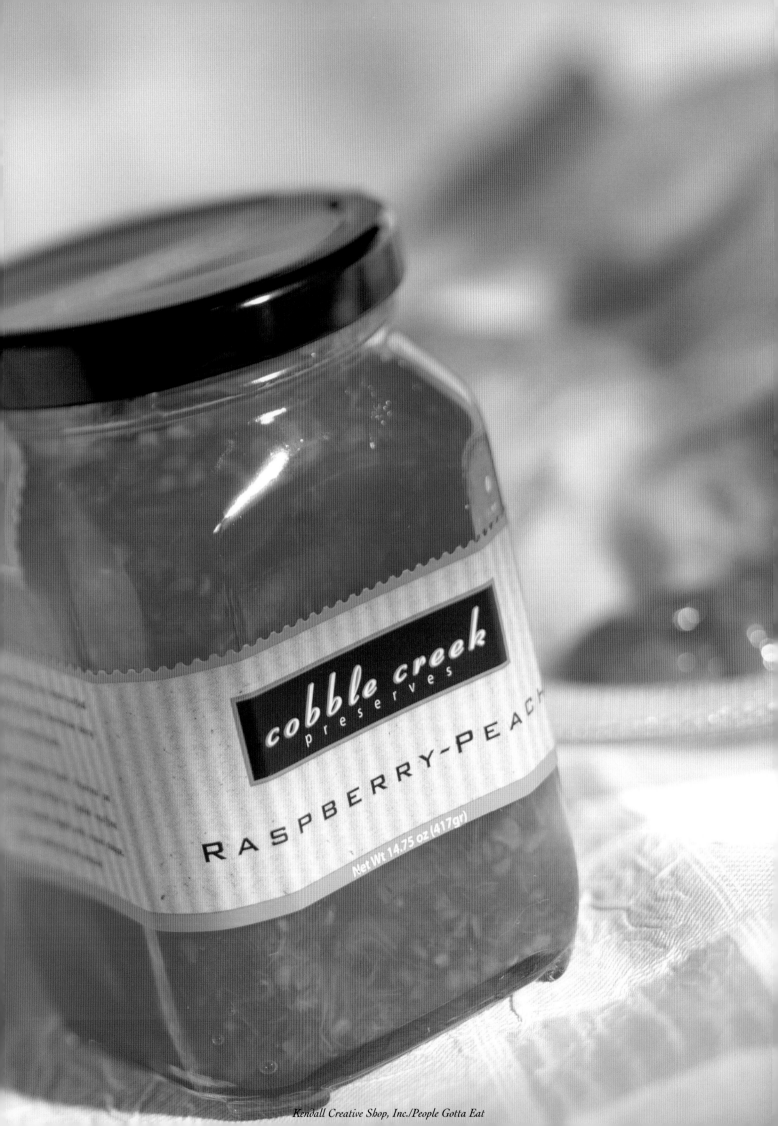

cobble creek
preserves

RASPBERRY-PEACH

Net Wt 14.75 oz (417gr)

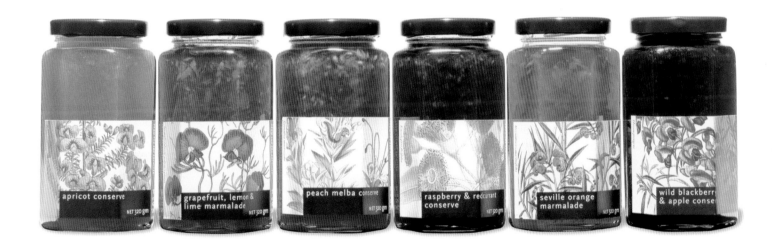

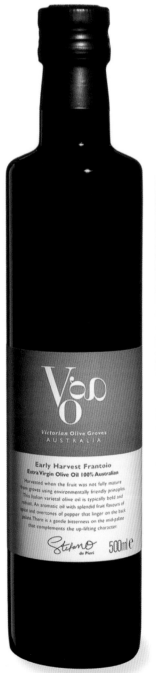
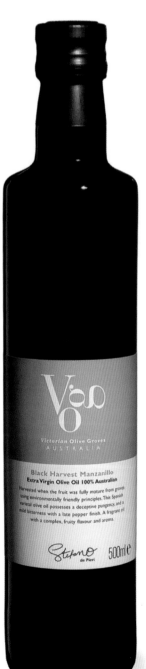
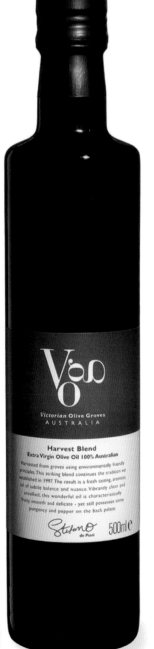
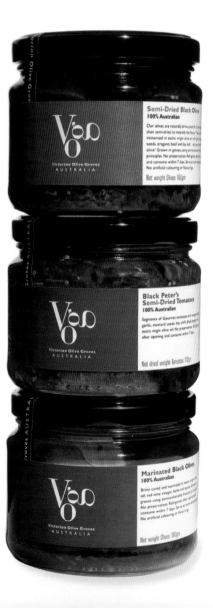

David Lancashire Design/Victorian Olive Groves

Sibley Peteet Design/The Bellagio Resort Las Vegas

MUSTAPHA'S
FINE FOODS OF MOROCCO
ARGAN
OIL
ORGANIC
NET WT 100 ML (3.4 FL. OZ)

MUSTAPHA'S
MOROCCAN FINE FOODS
ARGAN OIL
ORGANIC
NET WT 100 ML (3.4 FL. OZ)

BALSAMIC

VINEGAR

200ML

(this spread) Williams Murray Hamm/Heal and Son

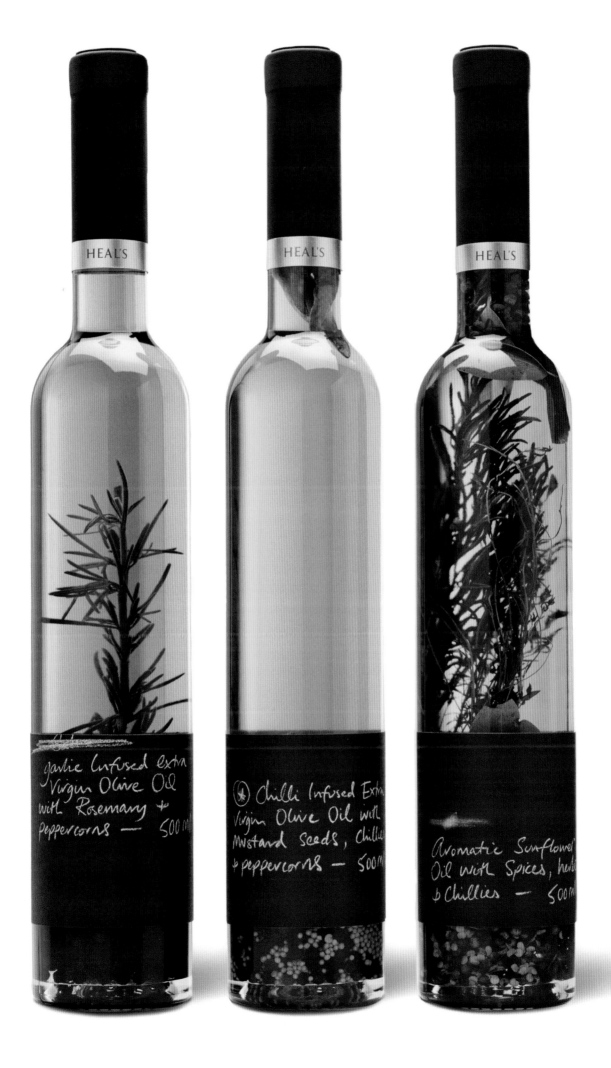

CALIFORNIA
GRAPESEED OIL

with

HERBS DE PROVENCE

HARVESTED AND PRODUCED
IN THE SAN JOAQUIN VALLEY
AND OTHER FINE VINEYARDS

30.4 FL OZ · 900 ML

CALIFORNIA
GRAPESEED OIL

HARVESTED AND PRODUCED
IN THE SAN JOAQUIN VALLEY
AND OTHER FINE VINEYARDS.
CHOICE OF FOUR-STAR CHEFS

30.4 FL OZ · 900 ML

CALIFORNIA
GRAPESEED OIL

with

ITALIAN HERBS

HARVESTED AND PRODUCED
IN THE SAN JOAQUIN VALLEY
AND OTHER FINE VINEYARDS

30.4 FL OZ · 900 ML

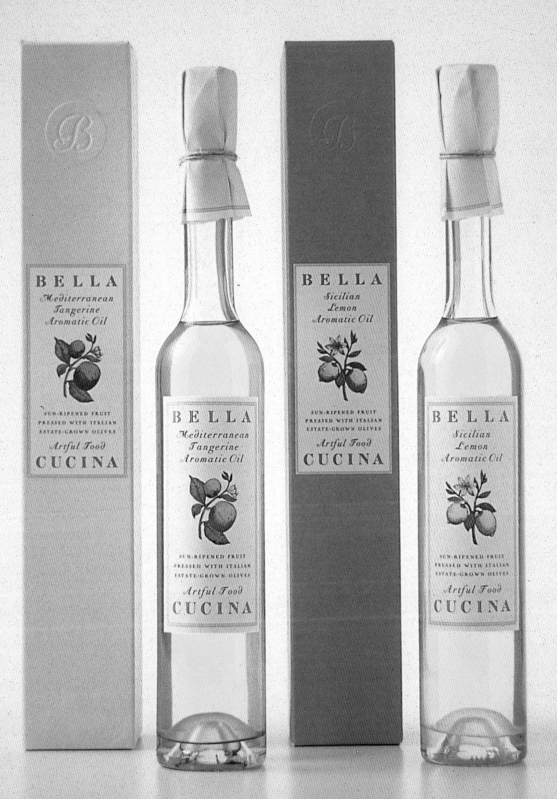

Louise Fili Ltd/Bella Cucina

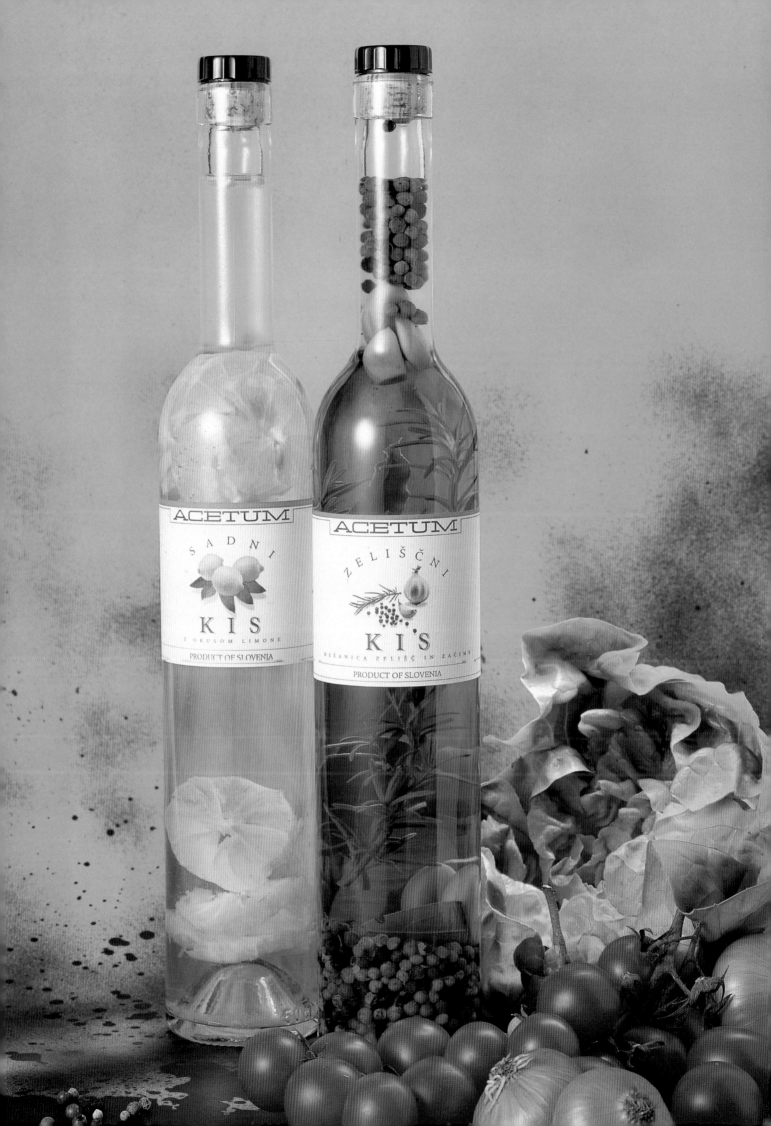

PREMIUM MIXED NUTS
A FEW GOOD NUTS
less than 50% peanuts

N NUTTY NET WT. 9.0 OZ HOLLYWOOD VIDEO

HONEY ROASTED PEANUTS
the Color of Honey

N NUTTY NET WT. 10 OZ HOLLYWOOD VIDEO

CASHEW PIECES
CASHEWBLANCA

N NUTTY NET WT. 9.0 OZ HOLLYWOOD VIDEO

PARTY PEANUTS
THE ENGLISH PEANUT

N NUTTY NET WT. 10 OZ HOLLYWOOD VIDEO

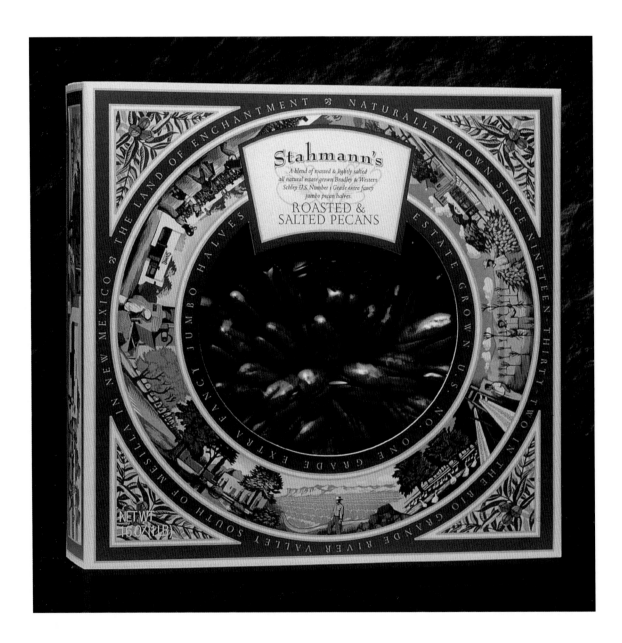

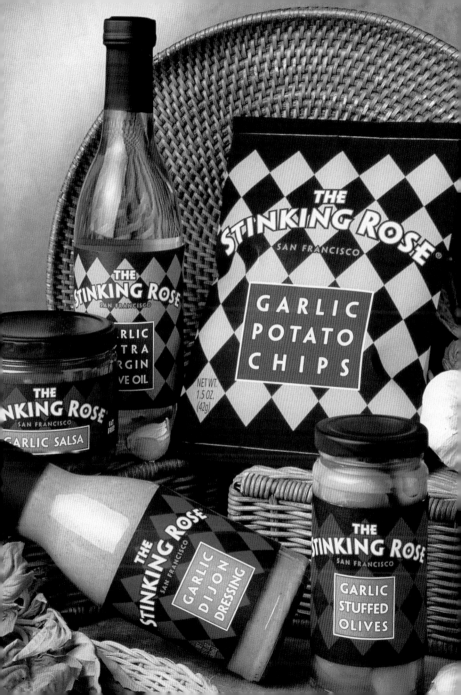

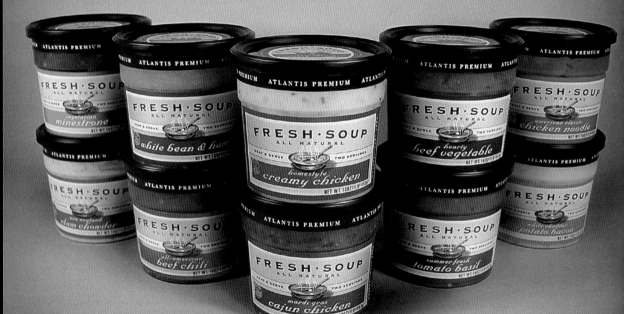

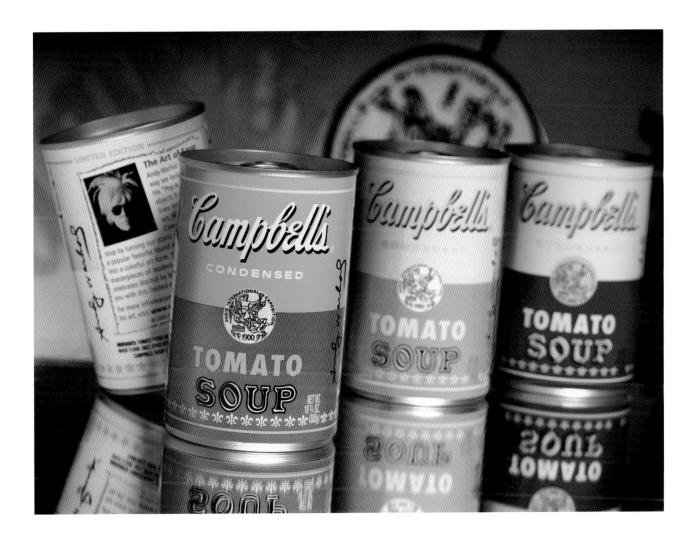

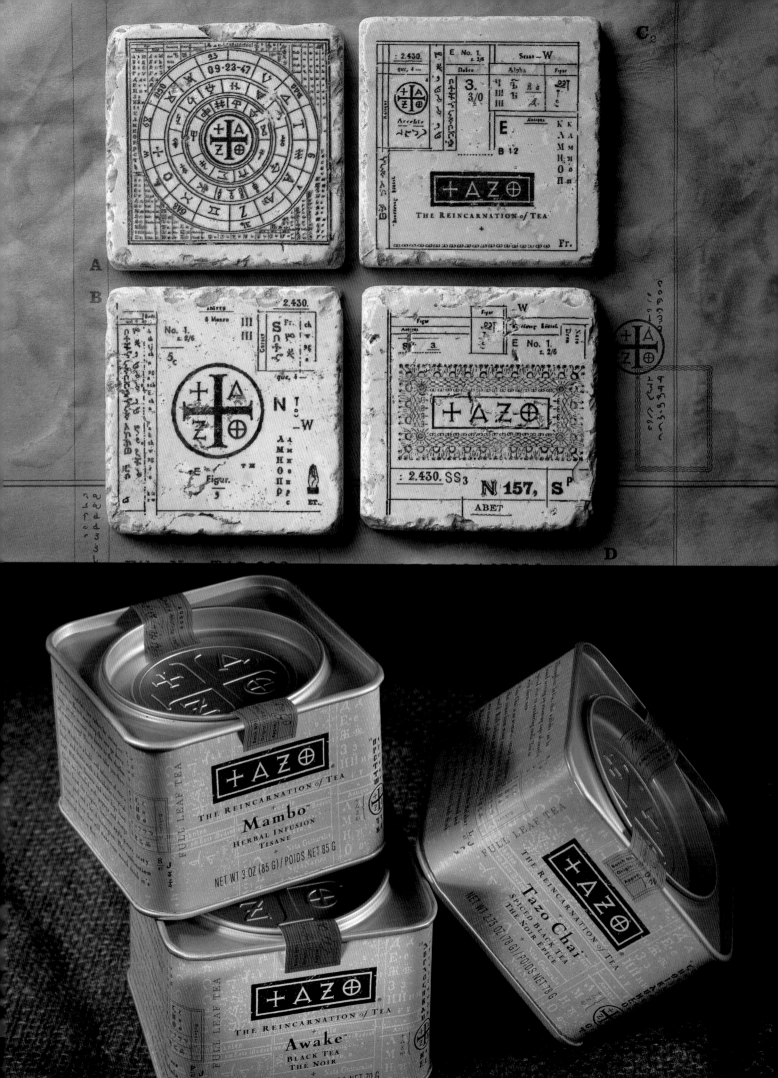

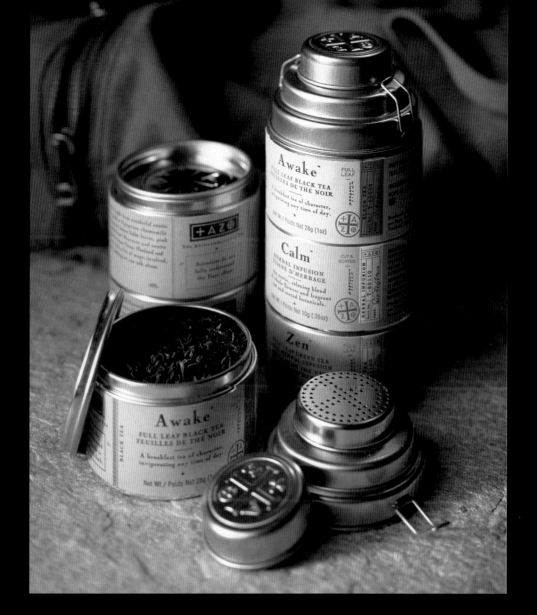

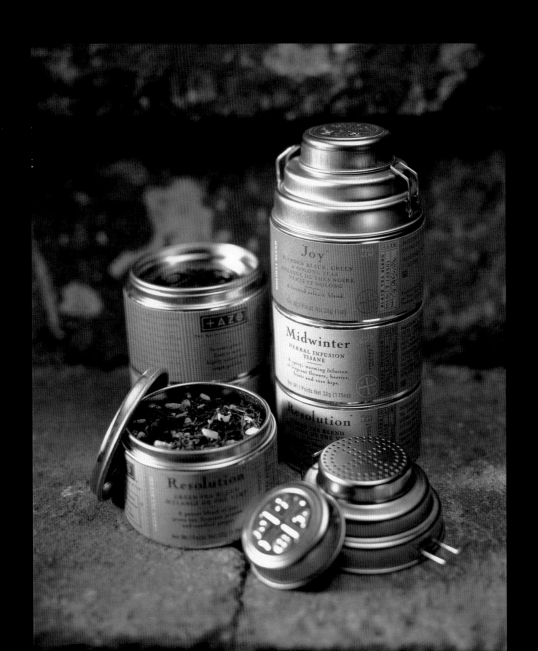

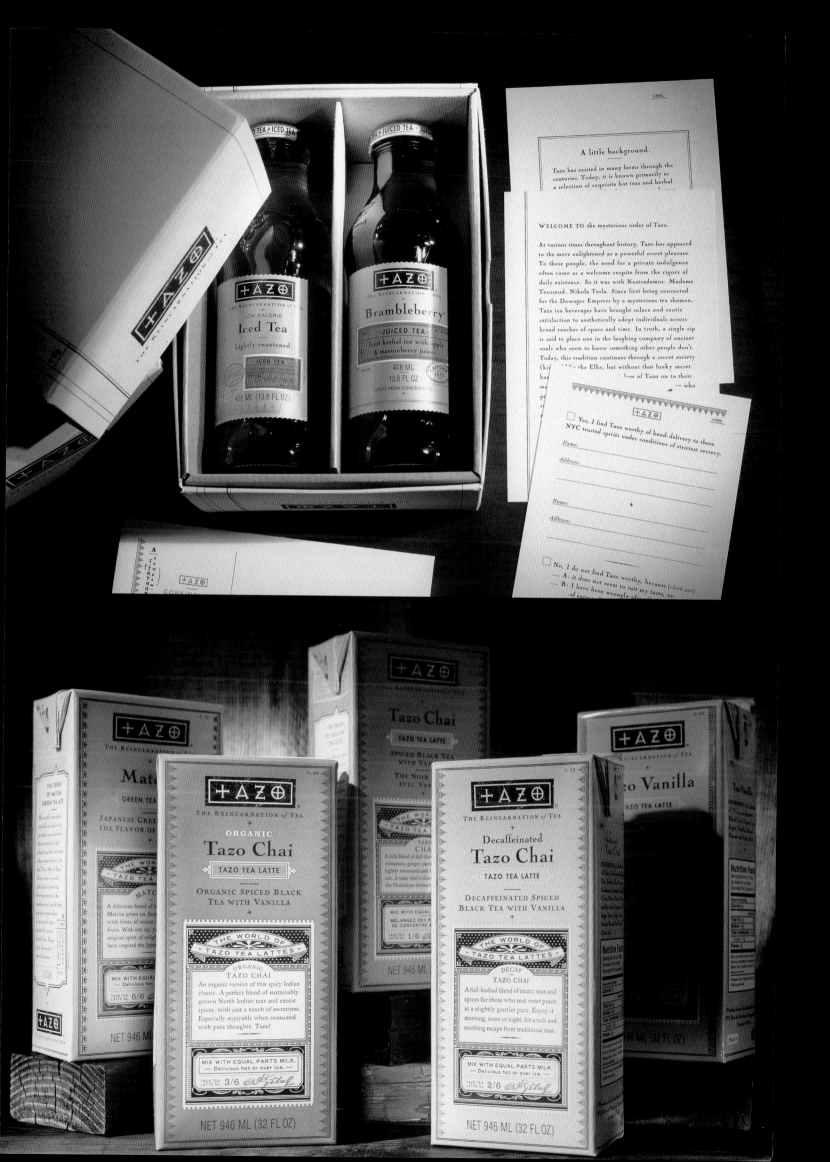

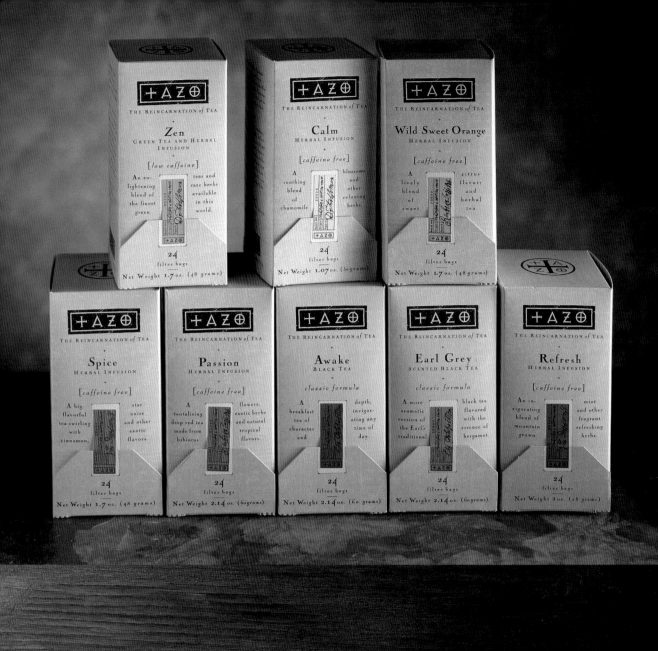

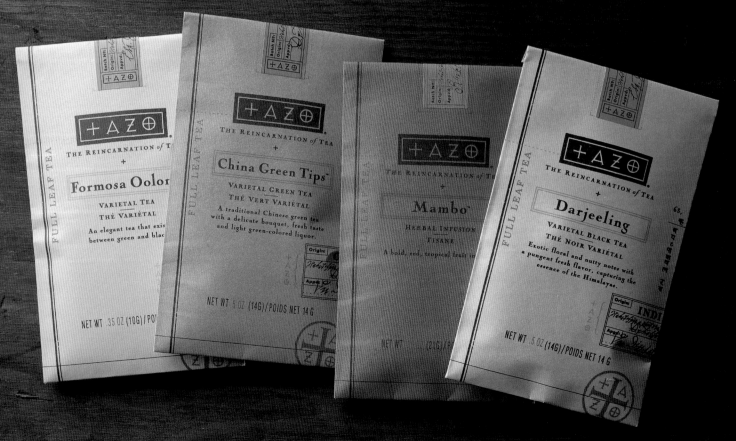

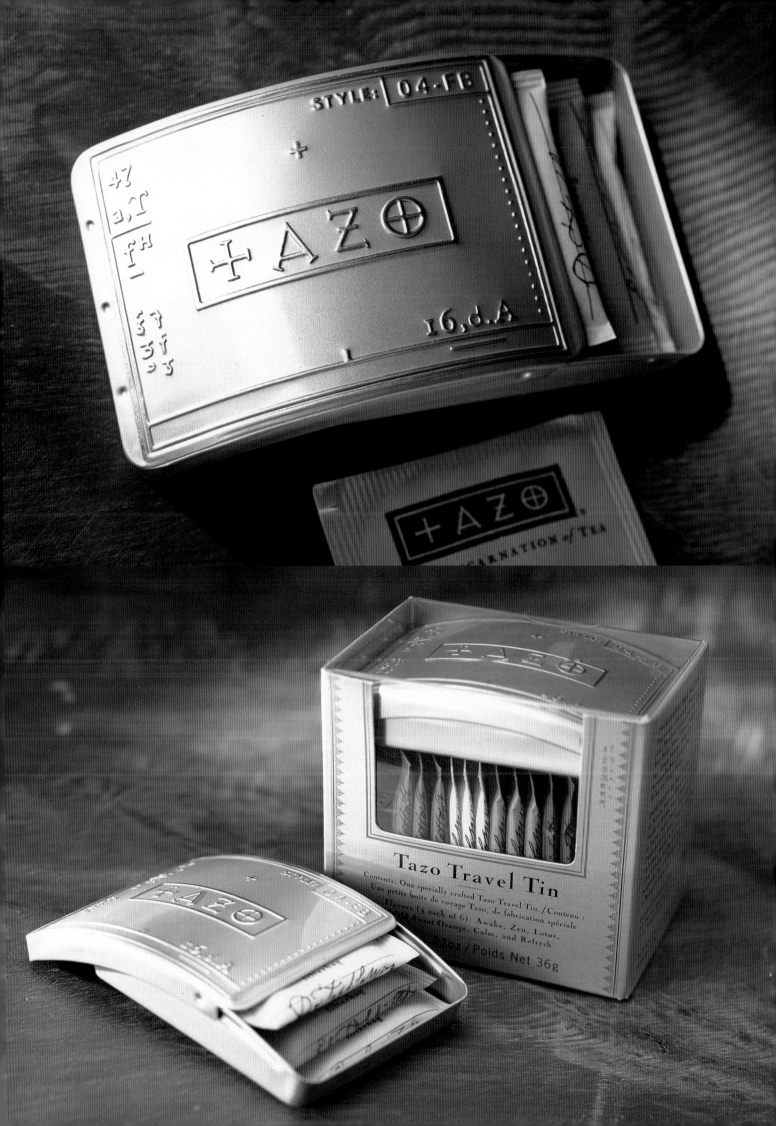

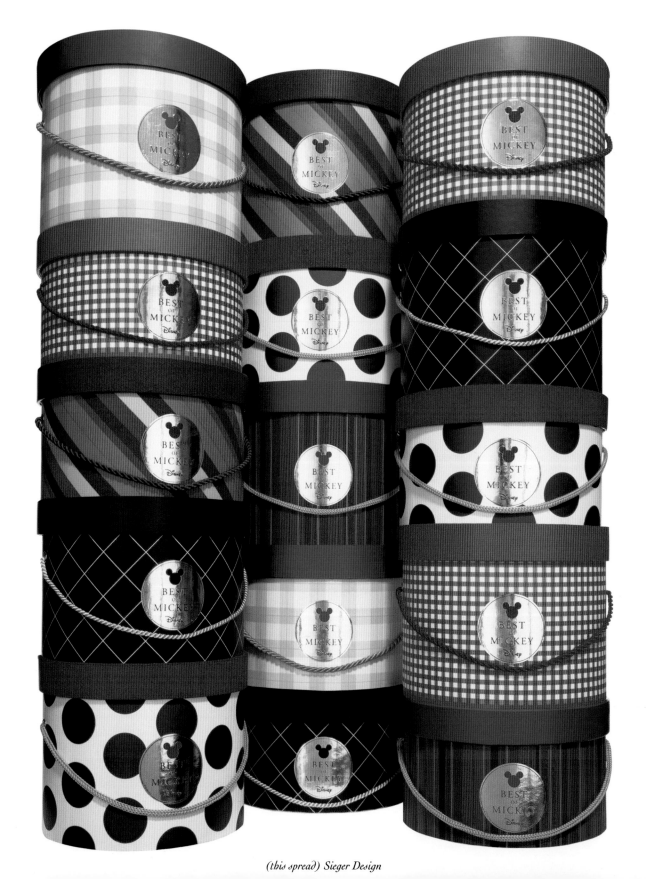

(this spread) Sieger Design

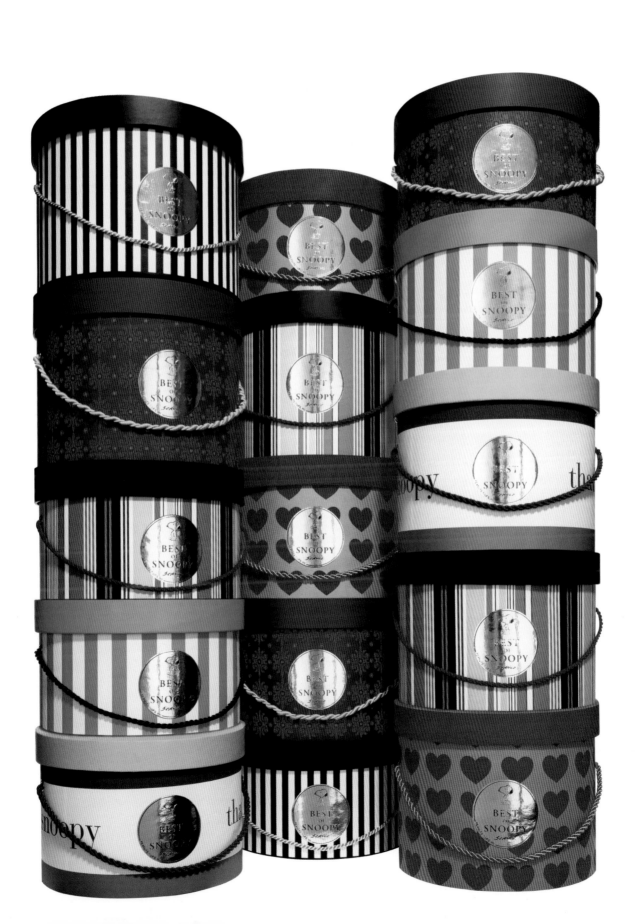

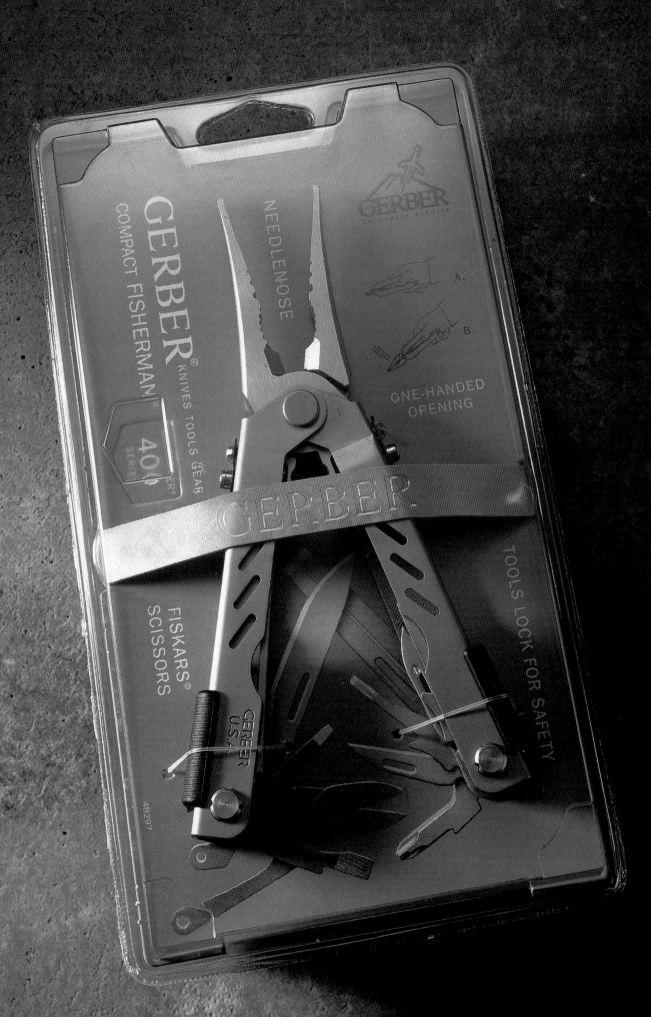

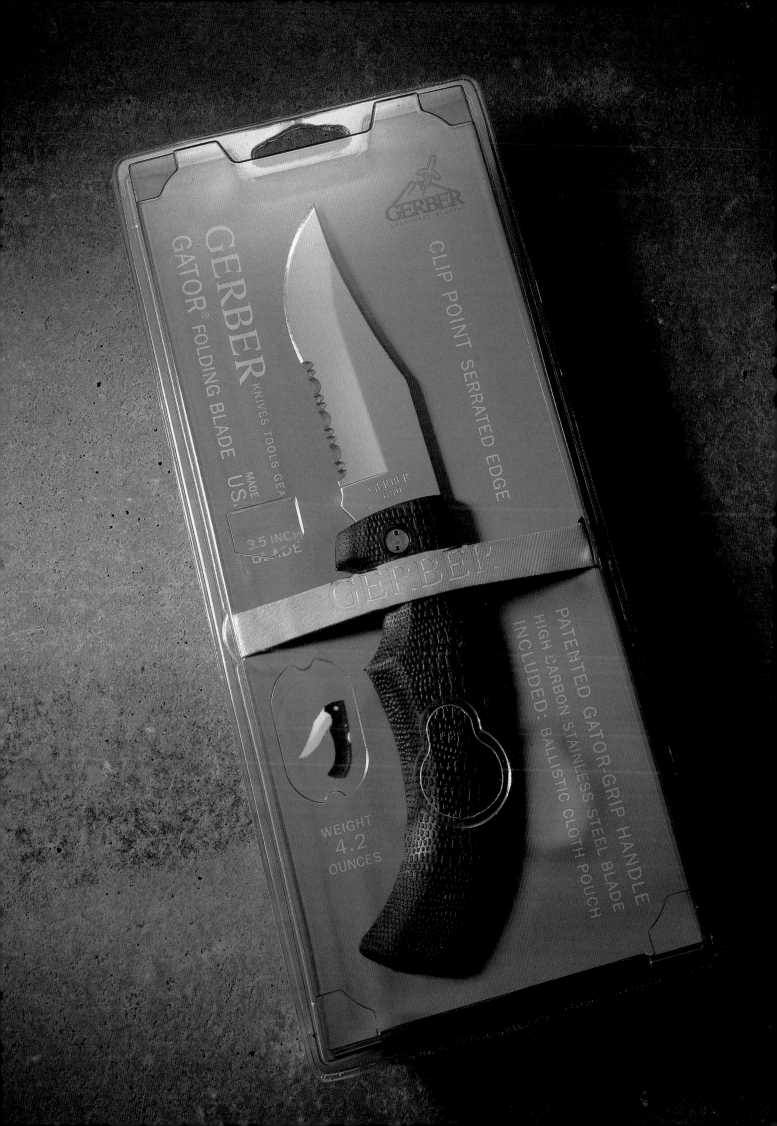

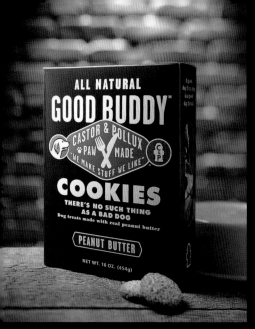

ALL NATURAL
GOOD BUDDY™

CASTOR & POLLUX
PAW MADE
"WE MAKE STUFF WE LIKE"

COOKIES

THERE'S NO SUCH THING AS A BAD DOG

Dog treats made with real peanut butter

PEANUT BUTTER

NET WT. 16 OZ. (454g)

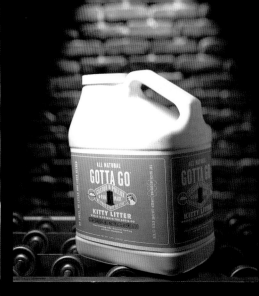

ALL NATURAL
GOTTA GO

CASTOR & POLLUX
PAW MADE

KITTY LITTER

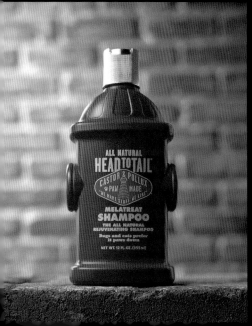

ALL NATURAL
HEAD TO TAIL™

CASTOR & POLLUX
PAW MADE
"WE MAKE STUFF WE LIKE"

MELATREAT
SHAMPOO

THE ALL NATURAL REJUVENATING SHAMPOO

Dogs and cats prefer it paws down

NET WT. 12 FL. OZ. (355 ml)

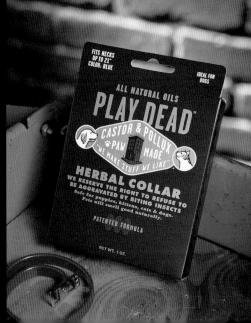

FITS NECKS
UP TO 21"
COLOR: BLUE

IDEAL FOR
DOGS

ALL NATURAL OILS
PLAY DEAD™

CASTOR & POLLUX
PAW MADE
"WE MAKE STUFF WE LIKE"

HERBAL COLLAR

WE RESERVE THE RIGHT TO REFUSE TO BE AGGRAVATED BY BITING INSECTS

Safe for puppies, kittens, cats & dogs.
Pets will smell good naturally.

PATENTED FORMULA

NET WT. 1 OZ.

PRESSED

WET NOSE™

CASTOR & POLLUX
PAW C&P MADE
"WE MAKE STUFF WE LIKE"™

RAWHIDE

TREAT YOUR DOG RIGHT

7-PAK

CONVENIENT SEVEN DAY PAK

Be a dog's best friend
every day of the week.

SEVEN 4.5" PRESSED
SUN-DRIED RAWHIDE BONES

280 - 315 gm

KNOTTED

WET NOSE™

CASTOR & POLLUX
PAW C&P MADE
"WE MAKE STUFF WE LIKE"™

RAWHIDE

TREAT YOUR DOG RIGHT

7-PAK

CONVENIENT SEVEN DAY MINI PAK

Be a small dog's best friend
every day of the week.

SEVEN 2.5" KNOTTED
SUN-DRIED RAWHIDE BONES

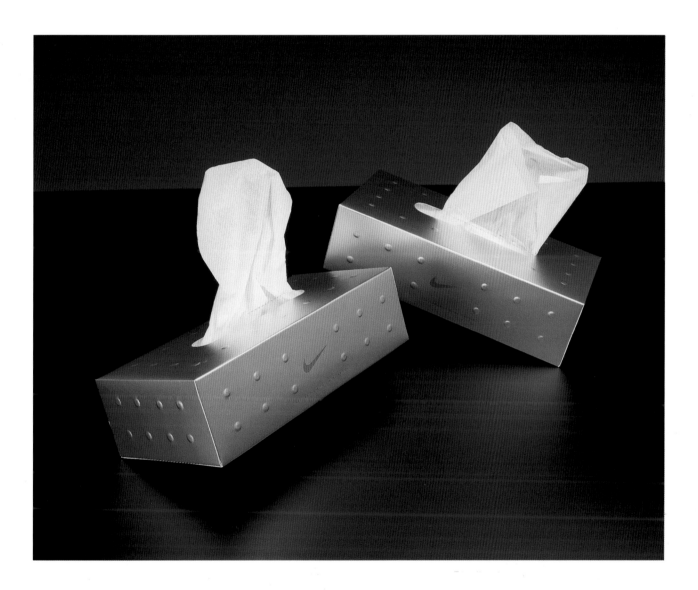

(this page) Package Land Co Ltd., (opposite) Shin Matsunaga Design Inc./Crecia Co. Ltd

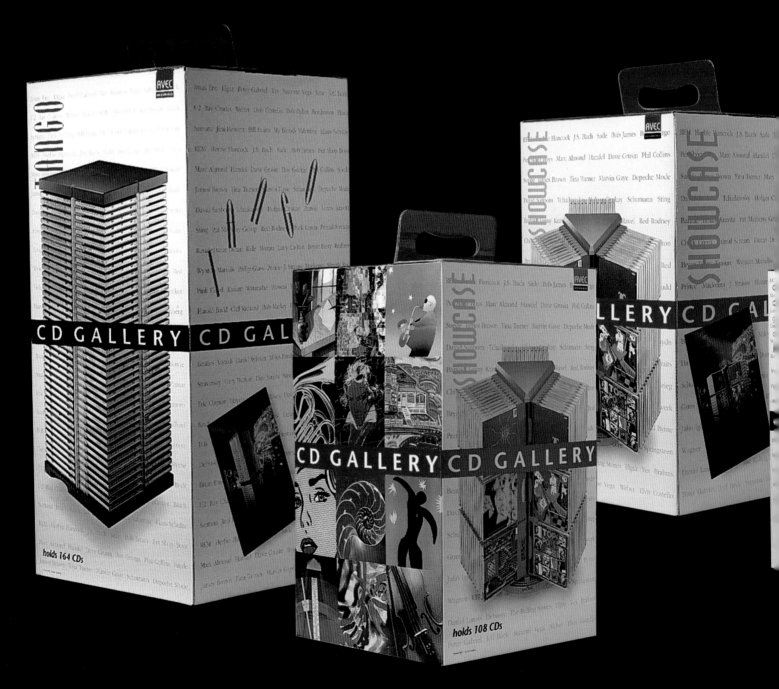

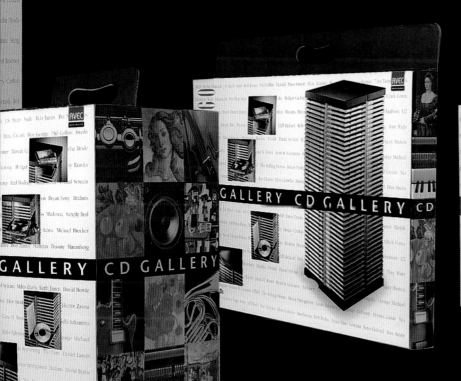

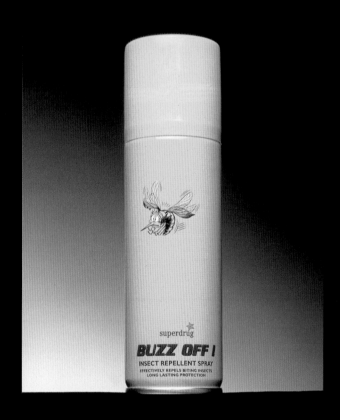

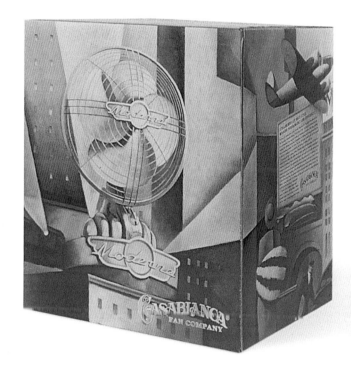

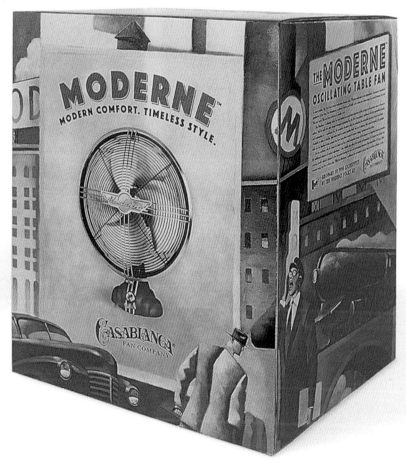

Brad Terres Design/Casablanca Fan Company

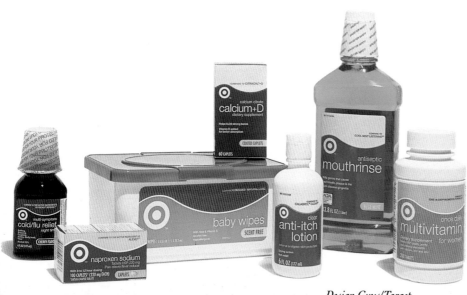

Design Guys/Target

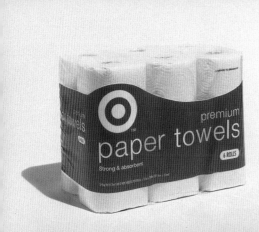

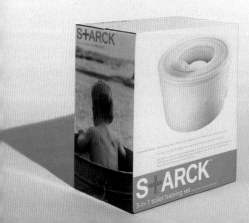

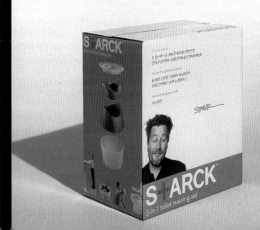

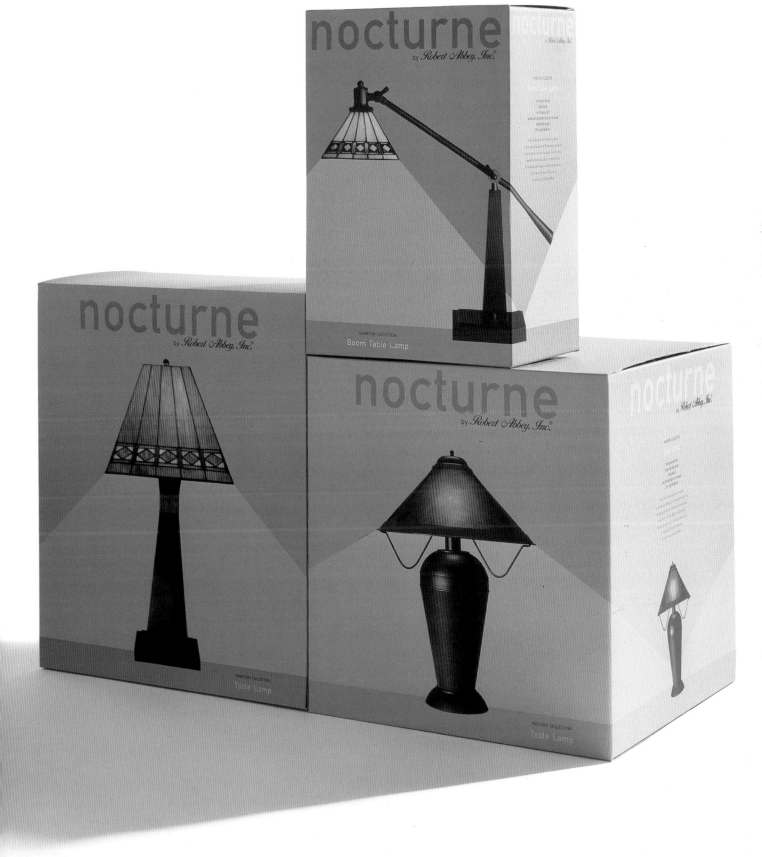

Robert Abbey/Nocturne

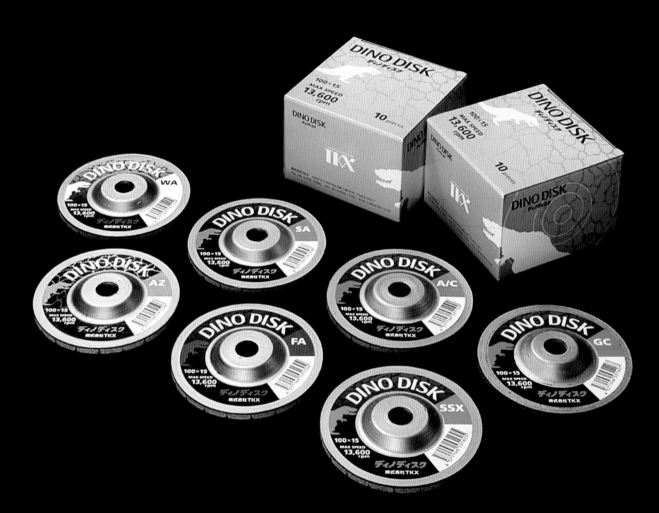

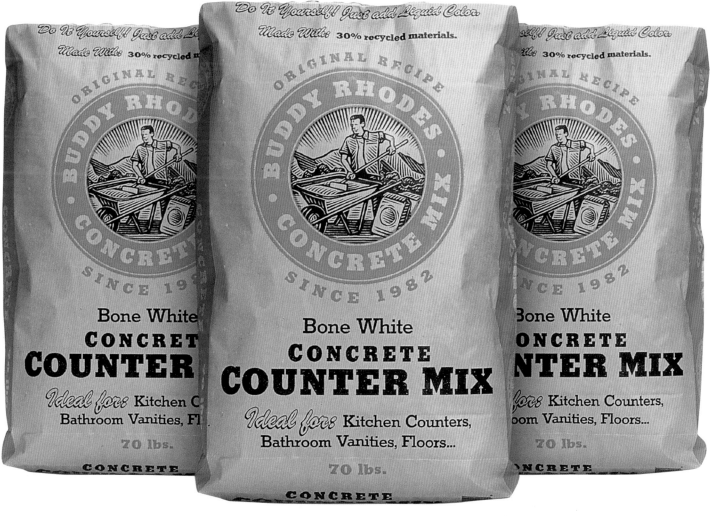

Philippe Becker Design/Buddy Rhodes Studio

Hornall Anderson Design Works, Inc./Stanley PMI (opposite), Custom Building Products (this page)

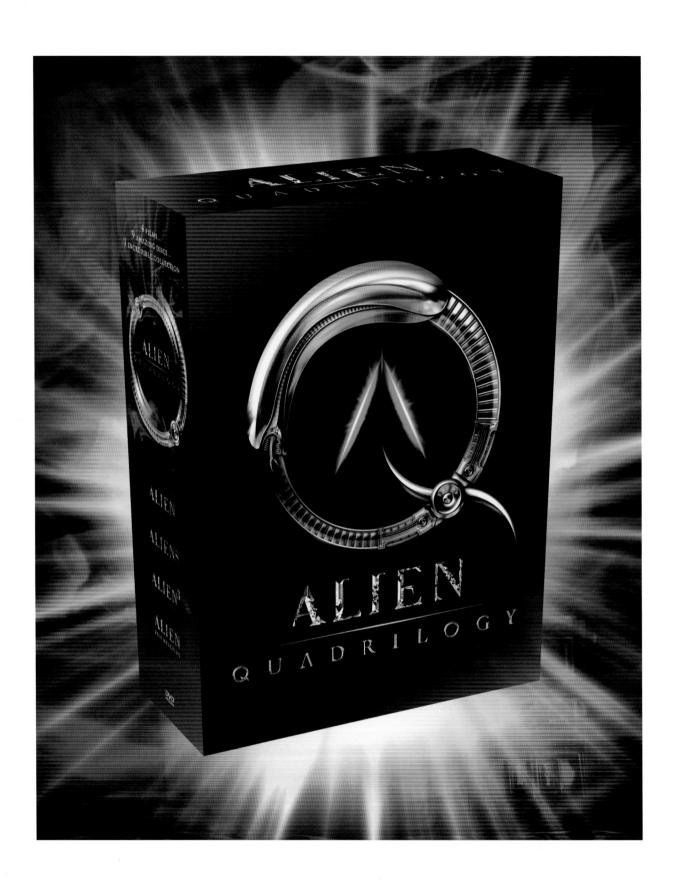

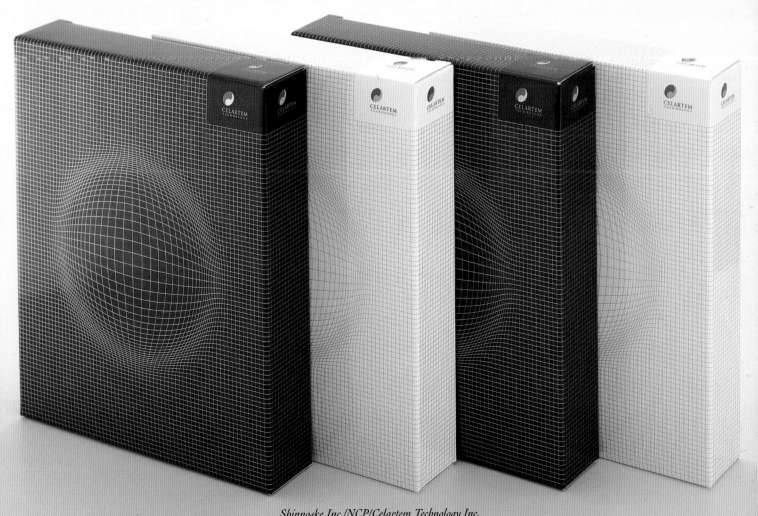

Shinnoske Inc./NCP/Celartem Technology Inc.

Mac OS X Panther

Version 10.3

Operating System Software

(this spread) Apple Computers

AppleWorks

Remote Desktop

Cinema Tools
for Final Cut Pro

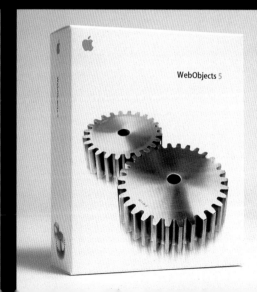

WebObjects 5

(this page) Sandstrom Design/Kink fm102, (opposite) Clemenger Design /Mikee Tucker/Loop Recordings

GOOD

SHIT HAPPENS

LOOP

LOOP Select 005

LOOP
SELECT 005
CREATIVE CONTENT INSPIRED
BY AOTEAROA (NZ)

LOOP
SELECT 005
CREATIVE CONTENT INSPIRED
BY AOTEAROA (NZ)

?regnancy test

1 test • 99% Accurate • Result in 4 minutes

superdrug

ONE
STEP
CONTACT
LENS SOLUTION

PEROXIDE SYSTEM

DISINFECTS & NEUTRALISES

FOR ALL TYPES OF CONTACT LENSES

superdrug

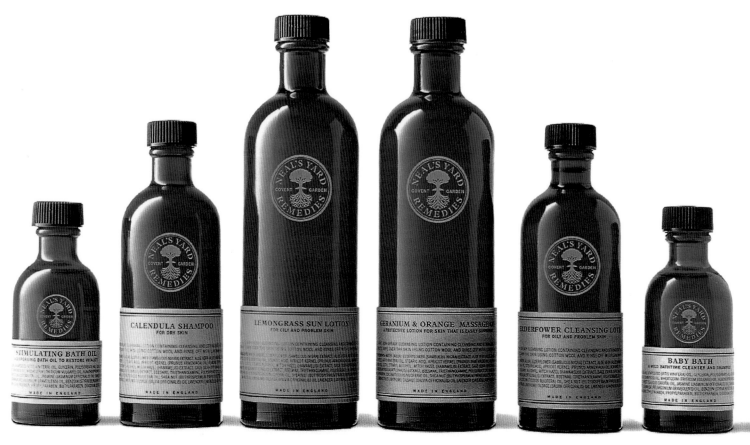

Turner Duckworth/Neal's Yard

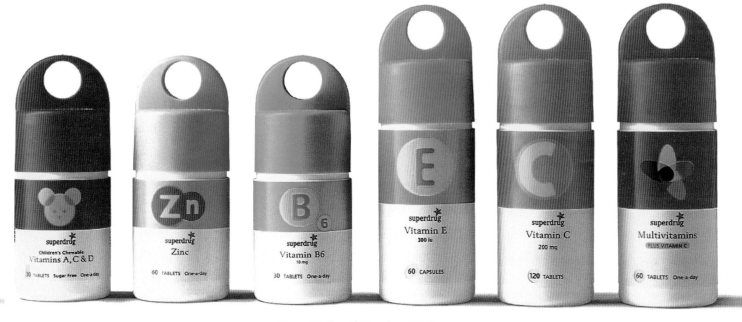

Turner Duckworth/Superdrug P.L.C.

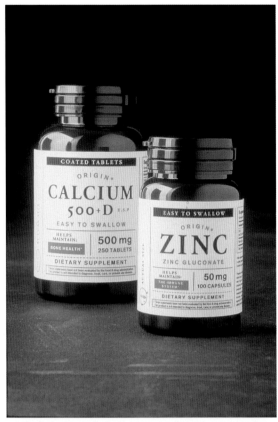

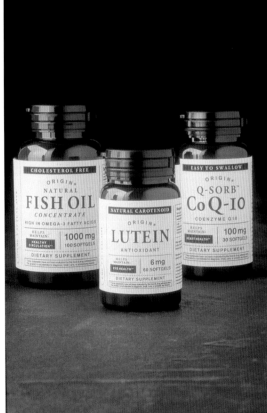

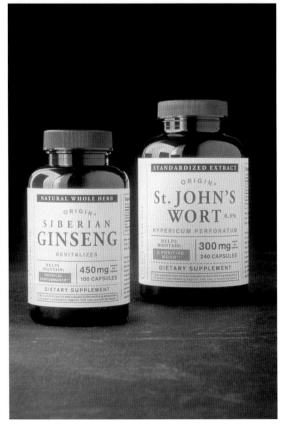

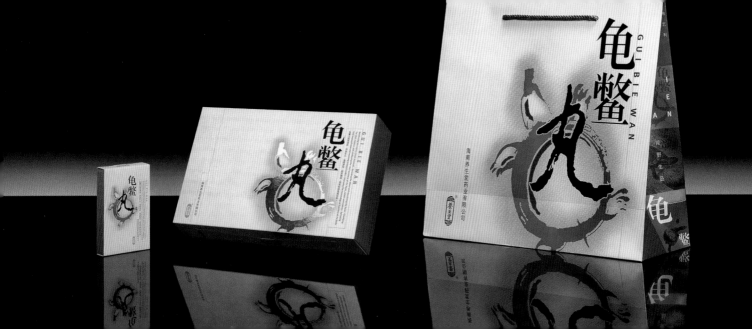

100 PERCENT
CIGARETTE-FREE

PACK™

THE NO B.S. TOOL
FOR BECOMING
AN EX-SMOKER

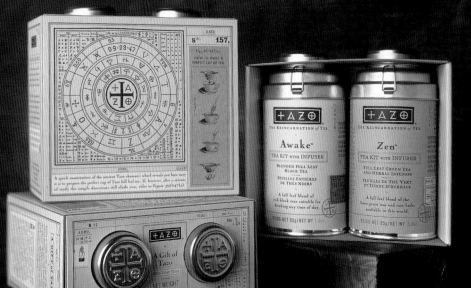

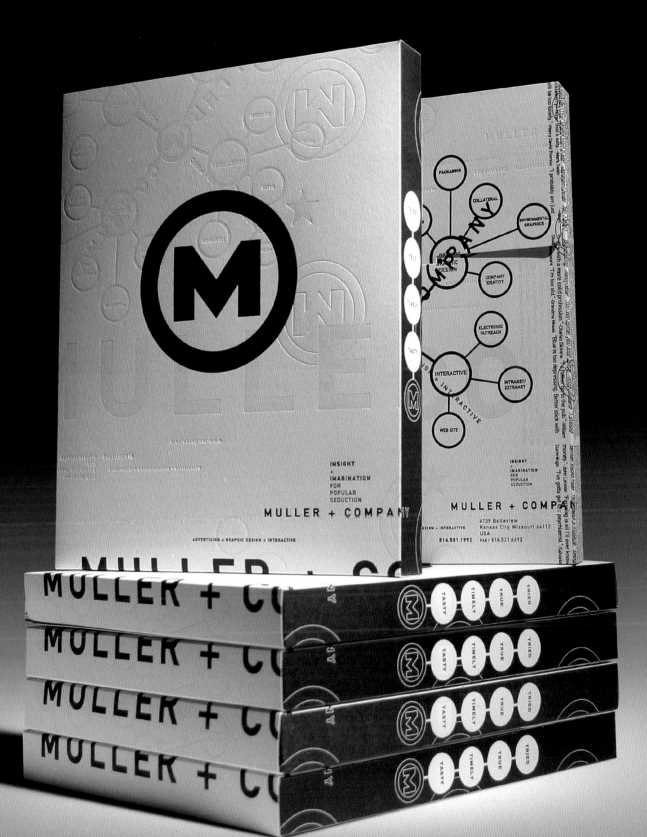

Muller + Company

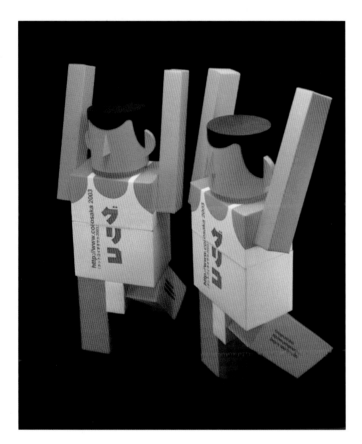

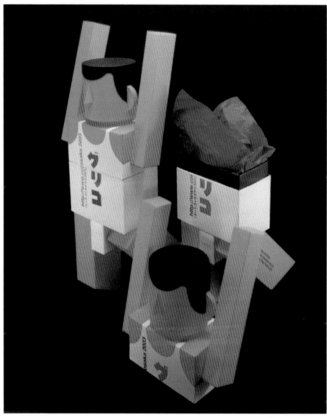

(this spread) Package Land Co Ltd.

YOU ARE CORDIALLY INVITED

TO AN EXCLUSIVE V.I.P OPEN HOUSE IN
CELEBRATION OF OUR BRAND NEW LOCATION.
THURSDAY, NOVEMBER 8 ☕ 2 PM TILL 4 PM

Ribbon cutting and Donor Wall unveiling at 3 p.m.
Refreshments include a chocolate buffet for your decadent enjoyment.
For more information, contact Cero's Candies at 316-264-5002.

Cero's
CANDIES
SINCE 1885

1108 E. DOUGLAS

IN OLD TOWN

EXCEPT OUR LOCATION.

WE'VE
MOVED

CERO'S OPERATED UNDER THE AUSPICES OF THE MENTAL HEALTH ASSOCIATION OF SOUTH CENTRAL KANSAS.

NOTHING
HAS CHANGED AT
CERO'S CANDIES
SINCE 1885.

Cero's
CANDIES

Taku Satoh Design Office Inc./Japan Graphic Designers Association Inc.

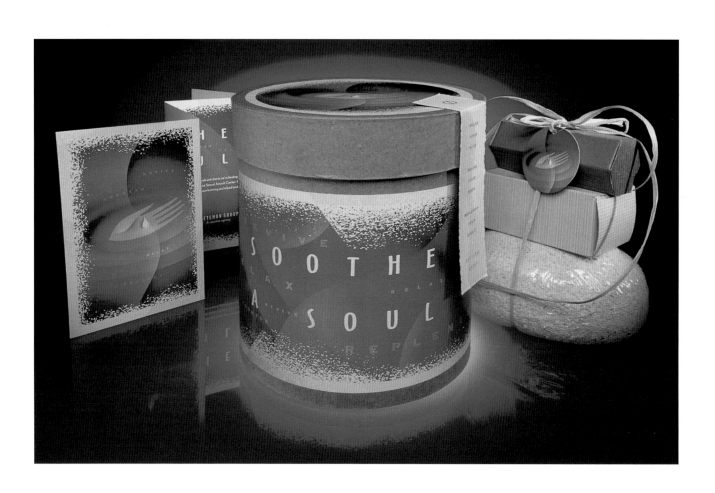

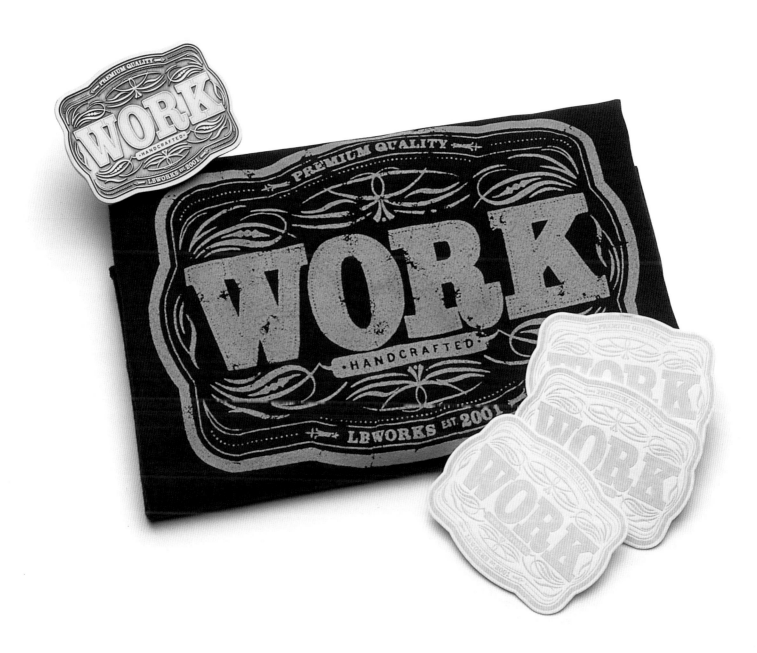

(opposite) Cornerstone/Winston (top), Bear Brook Design (bottom)
(this page) Leo Burnett/LBWorks

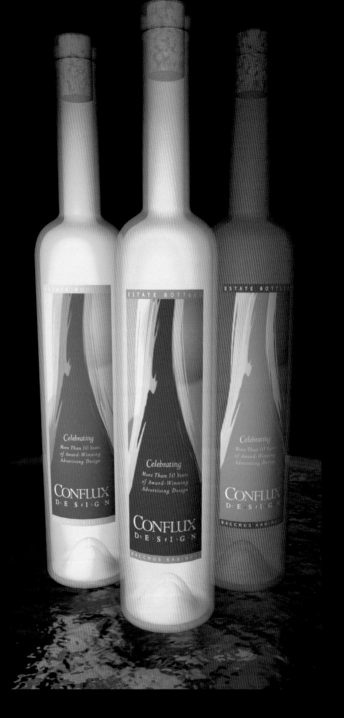

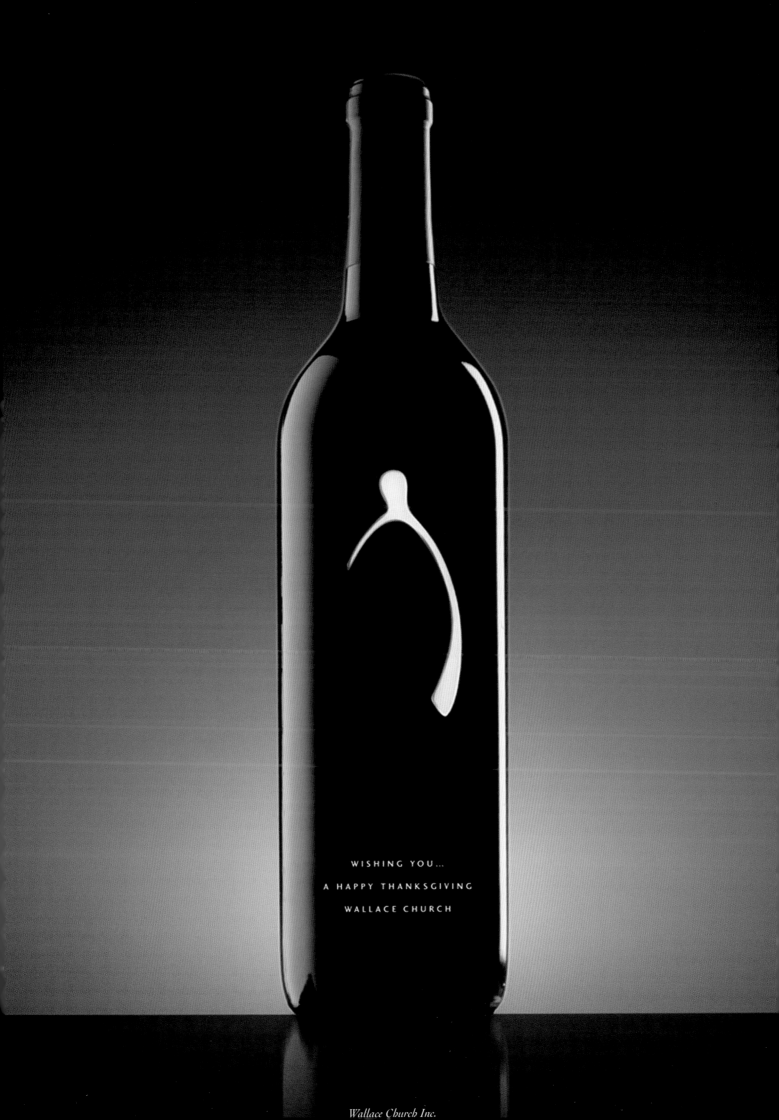

WISHING YOU...

A HAPPY THANKSGIVING

WALLACE CHURCH

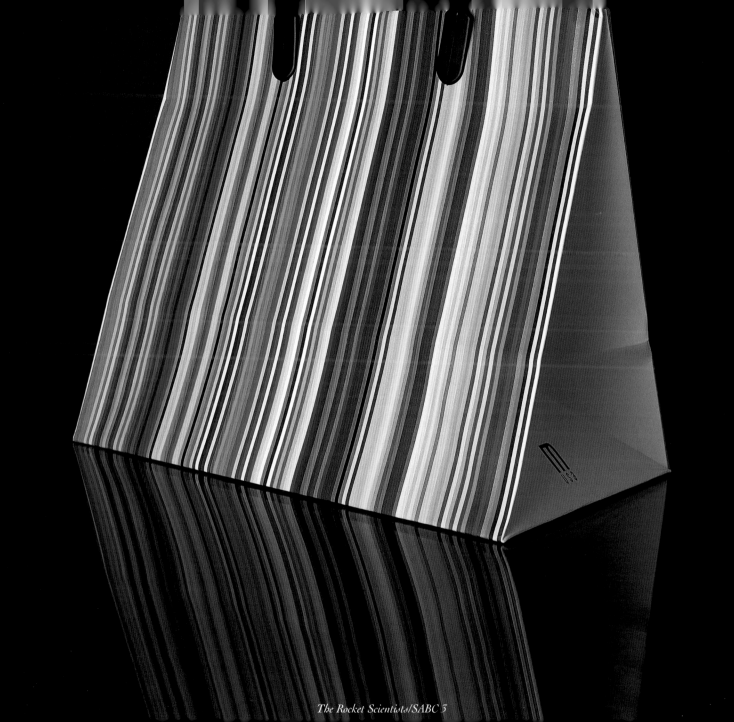

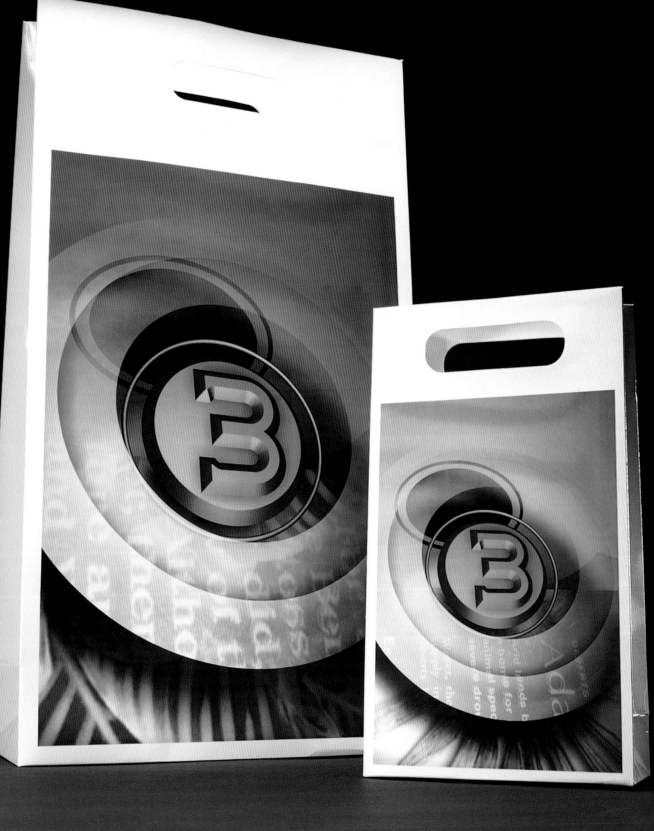

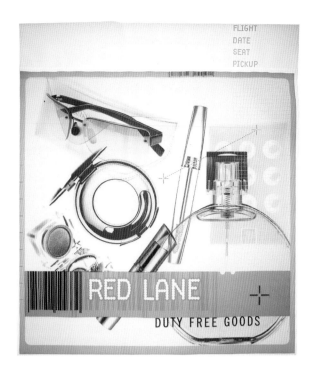

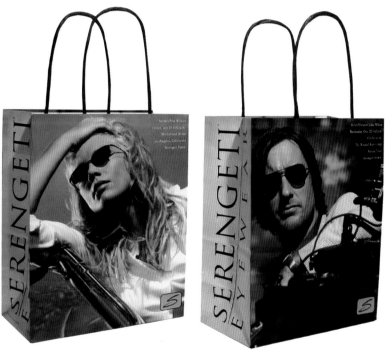

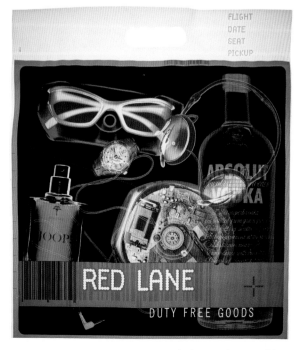

Clemenger Design/Duty Free Stores New Zealand Limited (top and bottom)
Muller + Company/Serengeti Eyewear (middle)

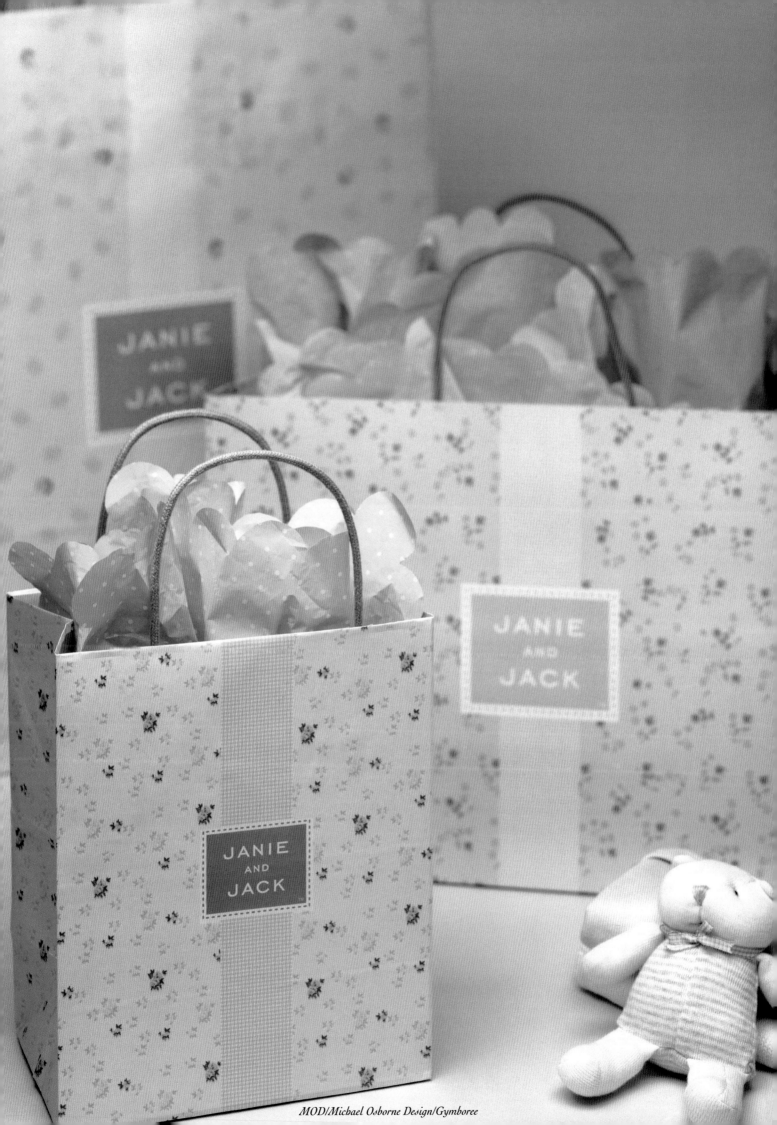

MOD/Michael Osborne Design/Gymboree

Igawa Design/Crank Brothers

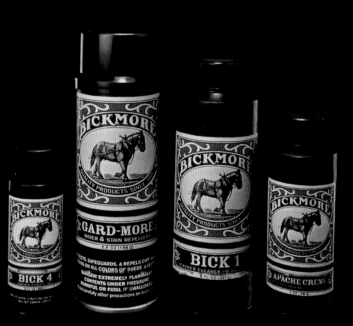

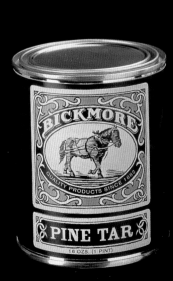

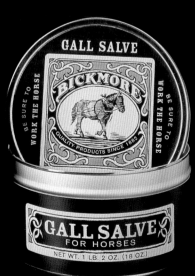

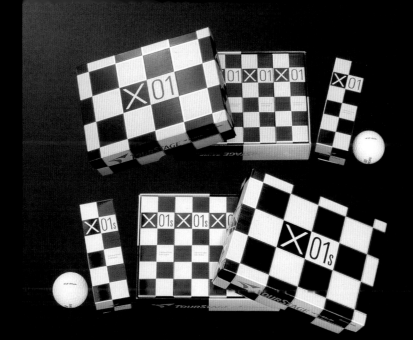

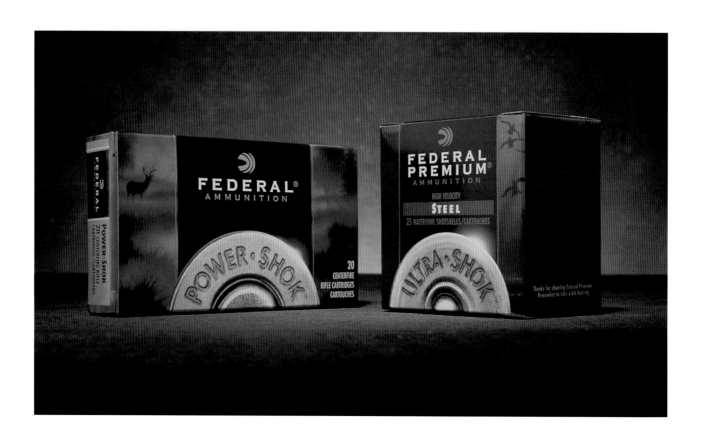

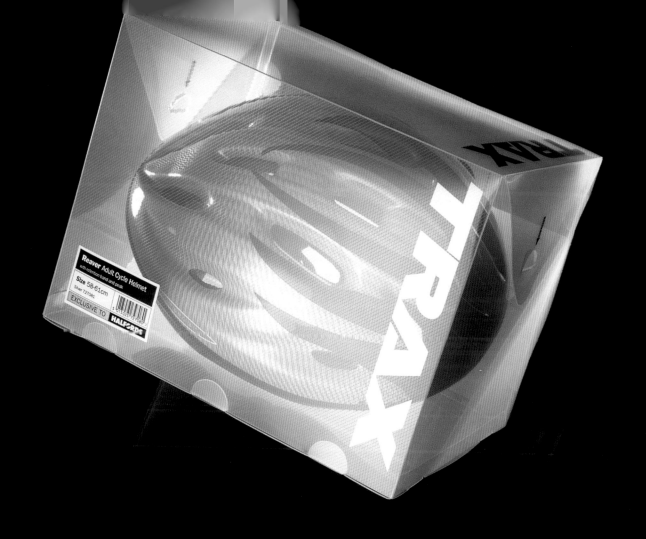

Reaver **Adult Cycle Helmet**
with retention band and peak

Size 58-61cm

Silver 727081

EXCLUSIVE TO HALFORDS

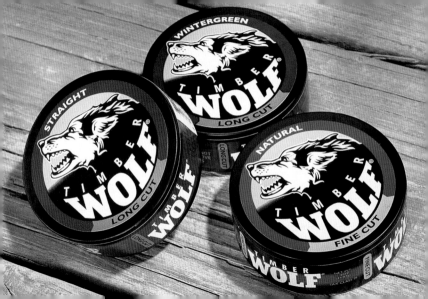

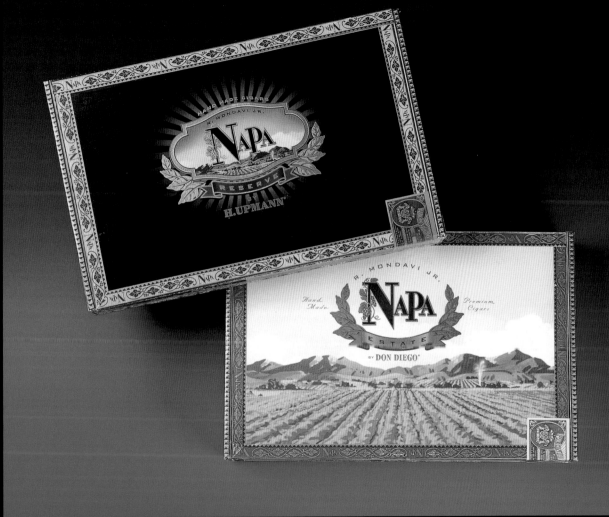

Aidalos Design
Worther Strasse #37
Berlin 10435 Germany
Tel +49 30 43 73 50 80
Fax +49 30 43 73 50 82

Alan Chan Design Co.
2/F Shiu Lam Bldg.
23 Luard Road, Wanchai Hong Kong
China
Tel 852 2527 8228
Fax 852 2865 6170

Apple Computers
1 Infinite Loop ms: 65–AD
Cupertino, CA 95014
Tel 408 974 1361
Fax 408 974 9836

Aramis
767 5th Avenue
New York, NY 10153
Tel 212 572 5710
Fax 212 527 7979

Be Design
1306 Third Street
San Rafael, CA 94901
Tel 415 451 3530
Fax 415 451 3532
www.bedesign.net

be_poles
17 rue de Lancry
75010 Paris France
Tel 33 1 4452 1150
Fax 33 1 4249 1220
www.be-poles.com

Bear Brook Design
Innovation Centre
1170 Route 17M
Chester, NY 10992
Tel 845 782 8292
Fax 845 782 2997
www.bearbrook.com

Brad Terres Design
4319 Railroad Avenue Suite B
Pleasanton, CA 94566
Tel 925 485 5441
Fax 925 485 5443
www.bradterres.com

Brand House
Bygdoy Allé 23
Oslo 0369 Norway
Tel +47 22 12 23 87
Fax +47 22 56 13 46
www.brandhouse.no

Brandhouse WTS
10A Frederick Close
London W2 2HD UK
Tel +44 20 7262 1707
www.brandhousewts.com

Bright Strategic Design
4223 Glencoe Avenue Suite A100
Marina Del Rey, CA 90292
Tel 310 305 2565
Fax 310 305 2566
www.brightdesign.com

Britton Design
724 First Street West
Sonoma, CA 95476

Tel 707 938 8378
Fax 707 938 5881
www.brittondesign.com

Cahan & Associates
171 Second Street, 5th Floor
San Francisco, CA 94105
Tel 415 621 0915
Fax 415 621 7642
www.cahanassociates.com

Campbell's Global Design Center
1 Campbell Place
Camden, NJ 08103
Tel 856 342 6299
Fax 856 342 4041
www.campbellsoup.com

Cave Design
3500 NW Boca Raton Blvd
Suite 808
Boca Raton, FL 33431
Tel 561 417 0780
Fax 561 417 0490
www.cavedesign.com

Chase Design Group
2255 Bancroft Avenue
Los Angeles, CA 90039
Tel 323 668 1055
Fax 323 668 2470
www.chasedesigngroup.com

Clemenger Design
Clemenger Bbdo House
8 Kent Terrace
Wellington Po Box 9440
New Zealand
Tel +64 4 802 3333
Fax +64 4 802 3318
www.clemengerbbdo.co.nz

Compass Design Inc.
510 First Avenue North
Minneapolis, MN 55403
Tel 612 339 1595
Fax 612 339 1596
www.compassdesigninc.com

Conflux Design
6758 Guilford Road
Rockford, IL 61107
Tel 815 226 4240
Fax 815 226 4239

Cornerstone
11 East 26th Street 20th Floor
New York, NY 10010
Tel 212 686 6046
Fax 212 686 8894
www.cornerstonebranding.com

CreationHouse
2/F Perfect Commercial Building
28 Sharp Street
West Wanchai Hong Kong China
Tel 852 90938703
Fax 852 28381375
www.creationhouse.com.hk

David Lancashire Design
17 William Street
Richmond, Melbourne VIC 3121
Australia
Tel +61 3 9421 4509
Fax +61 3 9421 4569
www.davidlancashiredesign.com.au

Design Bridge
18 Clerkenwell Close
London EC1R 0QN UK
Tel +44 (0) 20 7 814 9922
Fax +44 (0) 20 7 814 9024
www.designbridge.com

Design Guys
119 N. Fourth Street #400
Minneapolis, MN 55401
Tel 312 338 4462
Fax 312 338 1875
www.designguys.com

Design Mac
1-8-5 Toyama, Shinjuku
Tokyo 162-0052 Japan
Tel +81 3 3204 0951
Fax +81 3 3204 0965

Deutsch Design Works
10 Arkansas Street
San Francisco, CA 94107
Tel 415 487 8520
Fax 415 487 8529
www.ddw.com

Drews Design
Wielandstraße 6
Berlin 10625 Germany
Tel +49 30 312 81 08
Fax +49 30 312 86 77
www.drewsdesign.de

Époxy Communications
85 Saint-Paul Ouest Suite #120
Montréal, Québec H2Y 3V4 Canada
Tel 514 866 6900
Fax 514 866 6300
www.epoxy.ca

feldmann+schultchen design
Rehmstrasse 6
Hamburg 22299 Germany
Tel +49 40 510000
Fax +49 40 517000
www.fsdesign.de

Fossil
2280 N Greenville
Richardson, TX 75082
Tel 972 699 4984
Fax 972 699 2071
www.fossil.com

Futurebrand
Via Mazzini 4
Robecco sul Naviglio
20087 Milan Italy
Tel +39 02 9470181
Fax +39 02 94975908

GollingsPidgeon
147 Chapel Street
St. Kilda, Melbourne
Victoria 3182 Australia
Tel +61 3 9537 0733
Fax +61 3 9537 0187
www.gollingspidgeon.com

Graphème Branding & Design
2100 Drummond Street
Montréal, Québec H3G 1X1 Canada
Tel 514 282 4819
Fax 514 985 8350
www.cossette.com

Graphic Content
600 N. Bishop Avenue Suite 200
Dallas, TX 75208
Tel 214 948 6969
Fax 214 948 6950
www.graphicontent.com

Graphics & Designing Inc.
3-3-1 Shirokanedai Minato-ku
Tokyo 108-00071 Japan
Tel +81 3 3449 0651
Fax +81 3 3449 0653
www.gandd.co.jp

Greteman Group
1425 E. Douglas Avenue Ste. 200
Wichita, KS 67211
Tel 316 263 1004
Fax 316 263 1060
www.gretemangroup.com

Harcus Design
Level 3, 46 Foster Street
Surry Hills, Sydney NSW Australia
Tel +61 2 9212 2755
Fax +61 2 9212 2933
www.harcus.com.au

Hidemi Shingai
7F Ginza Bldg 1-3-11 Shintomi
Chuo-ku Tokyo 104-0041 Japan
Tel +81 3 3537 0845
Fax +81 3 3537 0846

Hookson
30 Annandale Street Lane
Edinburgh EH7 UK
Tel +41 131 524 7940
Fax +41 131 524 7941
www.hookson.com

Hornall Anderson Design Works
1008 Western Avenue, Suite 600
Seattle, WA 98104
Tel 206 826 2329
Fax 206 467 6411
www.hadw.com

I.VOX Design
709 NW Wall Street
Bend, Oregon 97701
Tel 541 317 5504
Fax 541 389 3531
www.ivoxdesign.com

Igawa Design
3726 Clark Avenue
Long Beach, CA 90808
Tel 562 209 5068
Fax 562 938 8779
www.igawadesign.com

IKD Design Solutions
173 Fullarton Road
Dulwich, Adelaide 5065 Australia
Tel +61 8 8332 0000
Fax +61 8 8364 0726
www.ikdesign.com.au

IM-LAB
1F, 1-1 Senri Banpaku-Koen Suita
Osaka 565-0826 Japan
Tel +81 6 4864 6380
Fax +81 6 4864 6570
www.okumura-akio.com

Intellecta Branding and Design
Abriksvägen 9, P.O. Box 3054,
SE-169 03 Solna
Tel: +46 8 506 288 50
Fax: +46 8 506 287 00
www.intellecta.se

Kan and Lau
28/F 230 Wanchai Road
Hong Kong China
Tel: +85 2574 8399
Fax: +85 22574 0199
www.kanandlau.com

Karim Rashid Inc.
357 West 17th Street
New York, NY 10011
Tel 212 929 8657
Fax 212 929 0247
www.karimrashid.com

Kendall Creative Shop, Inc.
3711 Parry Ave. #202
Dallas, TX 75226
Tel 214 827 6680
Fax 214 827 6019
www.kendallcreative.com

Klim Design Inc,
PO Box Y
Avon, CT 06001
Tel 860 678 1222
Fax 860 678 0591
www.klimdesign.com

KROG
Krakovski nasip 22
1000 Ljubljana, Slovenia
Tel +386 41 780880
Fax +386 1 4265761

Leo Burnett
35 W. Wacker Drive
Chicago, IL 60601
Tel 312 220 6627
Fax 312 220 1044
www.leoburnett.com

Leslie Evans Design Associates Inc.
133 Two Lights Road
Cape Elizabeth, ME 04107
Tel 207 874 0102
Fax 207 874 0058
www.ledadesign.com

Lewis Moberly
33 Gresse Street
London, W1T 1QU UK
Tel +44 20 7580 9252
Fax +44 20 7255 1671
www.lewismoberly.com

lg2d
3575 St. Laurent #800
Montreal, Quebec H2X 2T7 Canada
Tel 514 281 8901
Fax 514 281 0957
www.lg2.com

Lippa Pearce Design
358a Richmond Road
Twickenham
Middlesex, London TW1 2DU UK
Tel +44 20 8744 2100
Fax +44 20 8744 2770
www.lippapearce.com

Lloyd (+ co)
180 Varick Street
New York, NY 10014
Tel 212 414 3100
Fax 212 414 3113
www.lloydandco.com

Louise Fili Ltd.
156 Fifth Ave Suite 925
New York, NY10010
Tel 212 989 9153
Fax 212 989 9153
www.louisefili.com

Mark Oliver, Inc.
1984 Old Mission Drive
Solvang, CA 93463
Tel 805 686 5166 x14
Fax 805 686 5224
www.markoliverinc.com

MetaDesign
350 Pacific Avenue Ste 300
San Francisco, CA 94111
Tel 415 627 0790
Fax 415 627 0795
www.metadesign.com

Michael Schwab Studio
108 Tamalpais Avenue
San Anselmo, CA 94960
www.michaelschwab.com
Tel 415.257.5792
Fax 415.257.5793
www.michaelschwab.com

MOD/Michael Osborne Design
444 De Haro Street, Suite 207
San Francisco, CA 94107
Tel 415 255 0125
Fax 415 255 1312
www.modsf.com

Morla Design
463 Bryant Street
San Francisco, CA 94115
Tel 415 543 6548
Fax 415 543 7214
www.morladesign.com

Muller + Company
4739 Belleview
Kansas City MO, 64112
Tel 816 531 1992
Fax 816 531 6692
ww.mullerco.com

Nestor-Stermole VCG
121 West 27th Street #1104
New York, NY 1001
Tel 212 229 9377
Fax 212 229 9377
www.nestor-stermole.com

Neuron Syndicate Inc.
1617 Broadway 3rd Floor
Santa Monica, CA 90404
Tel 310 576 3656
Fax 310 401 6289
www.neuronsyndicate.com

Ogilvy (B.I.G.)
309 West 49th Street
New York, NY 10019
Tel 212 237 4547
Fax 212 237 7254
www.ogilvy.com

Olson and Company
1625 Hennepin Avenue
Minneapolis, MN 55403
Tel 612 215 7271
Fax 612 215 9801
www.oco.com

Optima Group
1899 Second Street
Highland Park, IL 60035 ,
Tel 847 681 4444
Fax 847 681 4445
www.optimagroup.net

Out Of The Box
215 Hanford Drive
Fairfield, CT 06430
Tel 203 254 2391
Fax 203 256 8055

Package Land Co Ltd.
201 Tezukayama Twr
1-3-2 Tezukayama-Naka
Sumiyoshi-Ku
Osaka 558-0053 Japan
Tel +81 6 6675 0138
Fax +81 6 6675 6466
www.package-land.com

Perks Design Partners
2ns Floor 333 Flinders Lane
Melbourne,Victoria 3000 Australia
Tel +61 3 9620 5911
Fax +61 3 9620 5922
www.perksdesignpartners.com

Peter Schmidt Studios
Feldbrunnen Strasse 27
Hamburg 20148 Germany
Tel +49 40 4418040
Fax +49 40 44180464
www.peter-schmidt-studios.de

Philippe Becker Design
612 Howard Street Suite 200
San Francisco, CA 94105
Tel 415 348 0054
Fax 415 348 0063
www.pbdsf.com

Piano & Piano
Duble Almeyda 2420
Nunoa, Santiago Region
Metropolitana 775-0059 Chile
Tel +56 2 4538684
Fax +56 2 4538247
www.pianoypiano.com

Poagi ®
81 Jeffcott Street
North Adelaide 5006 Australia
Tel +61 8 8239 1340
Fax +61 8 8239 1361

Priska-d
102-21 Nicolls Avenue 3C
Corona, NY 11368
Tel 718 899 7397
www.priska-d.com

RBMM
7007 Twin Hills Suite 200
Dallas, TX 75231
Tel 214 987 6500
Fax 214 987 3662
www.rbmm.com

Robilant & Assoc.
Via Mazzini 4
Robecco sul Naviglio
Milan 20087 Italy
Tel +39 02 9470181
Fax +39 02 94975908

Rod Dyer International
151 S. Camden Drive
Beverly Hills, CA 90212
Tel 310 860 9923
Fax 310 859 9538

Ross Creative + Strategy
305 S.W. Water Street 4th Floor
Peoria, IL 61602
Tel 309 690 4143
Fax 309 637 3051
www.rosscps.com

Sabingrafik, Inc.
7333 Seafarer Place
Carlsbad, CA 92009
Tel 760 431 0439
www.tracy.sabin.com

Sagmeister Inc.
222 West 14th Street Suite 15A
New York, NY 10011
Tel 212 647 1789
Fax 212 647 1788
www.sagmeister.com

Sandstrom Design
808 SW 3rd Avenue Ste 610
Portland, OR 97204
Tel 503 248 9466
Fax 503 227 5035
www.sandstromdesign.com

Sekine Design Office
7-12-9-303 Okamoto
Higashinada-Ku
Kobe 658-0072 Japan
Tel +81 7 8452 3469
Fax +81 7 8452 3469

Shin Matsunaga Design Inc.
98-4 Yarai-cho, Shinjuku-ku
Tokyo, 162-0805 Japan
Tel +81 3 5225 0777
Fax +81 3 3266 5600

Shinnnoske Inc.
2-1-8-602 Tsuriganecho Chuoku
Osaka 540-0035 Japan
Tel +81 6 6943 9077
Fax +81 6 6943 9078
www.shinn.co.jp

Shiseido Co., Ltd.
7-5-5, Ginza Chuo-ku
Tokyo, 104-8010, Japan
Tel +81 3 3572 5111
Fax +81 3 3289 4308

Sibley/Peteet Design, Dallas
3232 McKinney Avenue Suite 1200
Dallas, TX 75204
Tel 214 969 1050
Fax 214 969 7585
www.spddallas.com

Sibley/Peteet Design, Austin
522 E. 6th Street
Austin TX, 78701
Tel 512 473 2333

Fax 512 473-2431
www.spdaustin.com

Sieger Design
Schloss Harkotten
D-48336 Sassenberg
Germany
Tel +49 54 2694 920
Fax + 49 54 2694 9289
www.sieger-design.com

Squeeze, Inc.
16826 S 14th Drive
Phoenix, AZ 85045
Tel 480 706 1688
Fax 480 460 7309

Sterling Cross Creative
15 West MacArthur Street
Sonoma, CA 95476
Tel 707 939 8886
Fax 707 939 8986
www.sterlingcrosscreative.com

Strømme Throndsen Design
Holtegata 22
Oslo, Norway
Tel +47 22 96 39 00
Fax +47 22 96 39 01
www.stdesign.no

Studio GT&P
Via Ariosto 5
06034 Foligno, Italy
Tel +39 0742 320372
Fax +39 0742 329827
www.tobanelli.it

Studio Ignition
444 Hobron Lane Suite 315
Honolulu, HI 96813
Tel 808 383 2393
Fax 808 946 6556
www.studio-ignition.com

Taku Satoh Design Office Inc.
Ginsho Bldg-4F 1-14-11 Ginza
Tokyo 104-0061 Japan
Tel +81 3 3538 2051
Fax +81 3 3538 2054

Tangram Strategic Design
V. le Buonarroti 10/C
Novara, Italy
Tel +39 0321 35 662
Fax +39 0321 390 914

The Big Idea Inc.
116 South Fayette Street
Alexandria, VA 22314
Tel 703 838 0181
Fax 703 838 0183
www.tbiinc.com

The Rocket Scientists
South Africa

Travers Collins & Company
726 Exchange Street Suite 500
Buffalo, NY 14210
Tel 716 842 2222
Fax 716 842 2267
www.traverscollins.com

Turner Duckworth
831 Montgomery Street
San Francisco, CA 94133

Tel 415 675 7777
Fax 415 675 7778
www.turnerduckworth.com

Twist Inc.
9511 SW 264th Street
Vashon Island, WA 98070
Tel 206 443 7661
Fax 206 463 3506
www.twistdesign.biz

vitrorobertson
625 Broadway 4th Floor
San Diego, CA 92101
Tel 619 234 0408
Fax 619 234 4015
www.vitrorobertson.com

Wallace Church, Inc.
330 East 48th Street
New York, NY 10017
Tel 212 755 2903
www.wallacechurch.com

Wega Werbeagentur
Ludolf-Kerhl-Str. 13-17
Mannheim Germany
Tel +49 0621 3365 193
www.wega-werbeagentur.de

Williams Murray Hamm
The Heals Building, Alfred Mews
London W1P 9LB UK
Tel+44 0 20 7255 3232
www.creatingdifference.com

Wink
126 North Third Street No. 100
Minneapolis, MN 55401
Tel 612 455 2642
Fax 612 455 2645
www.wink-mpls.com

Work Advertising
2019 Monument Avenue
Richmond, VA 23220
Tel 804 358 4733
Fax 804 355 2784
www.worklabs.com

Wren & Rowe
4 Dengigh Mews
London SW1V 2HQ UK
Tel +44 207 828 5333
Fax +44 207 828 5444
www.wrenrowe.com

X-Ray Design
Schloss Gasse 9
Lorrach BW 76540 Germany
Tel +49 7621 4220 460
Fax +49 7621 4220 469

ZIBA Design
334 NW 11th Ave
Portland, OR 97209
Tel 503 223 9606
www.ziba.com

DesignersIllustratorsPhotographersWriters

Design Firms

Design Firms

Clients

Credits

Page 17
S&B Filters Packaging
Design Firm RBMM
**Art Director/Creative
Director/Designer** Luis Acevedo
Illustrator Gary Willmann
Client S&B Filters *Automotive filters*

Page 18
Kirin Ichiban 24 oz
Design Firm Bright Strategic Design
Art Director/Creative Director
Keith Bright
Designer Hiro Nakano
Client Kirin Brewery of American

Page 19
Widmer Brothers Spring Run Packaging
Design Firm Hornall Anderson
Design Works Inc.
Art Director Jack Anderson, Larry
Anderson
Designer(s) Larry Anderson, Elmer
dela Cruz, Bruce Stigler, Jay Hilburn,
Dorothee Soechting, Don Stayner
Illustrator Cathy Diefendorf
Copywriter Dylan Tomine
Client Widmer Brothers
*Oregon-based micro-brewery and distributor
The objective for the Spring Run branding
and packaging program was to redesign the
look and feel of their previous packaging and
ultimately apply that new look to the brand's
collateral materials. After initially changing the
name from Spring Fest to Spring Run
Hornall Anderson focused on rebuilding the
architectural graphics of the packaging to create
a bolder and more graphically appealing active*

*message. The client had felt that their original
packaging didn't show as well on the shelf
and needed to lose the softness it exuded.*

Widmer Bros. "Blonde Ale"
Design Firm Hornall Anderson
Design Works Inc.
Art Directors Jack Anderson, Larry
Anderson
Designer(s) Larry Anderson, Bruce
Stigler, Jay Hilburn, Henry Yiu, Kaye
Farmer, Don Stayner
Illustrator Jay Hilburn
Client Widmer Brothers
*Initially this particular flavor of beer was
named Sweet Betty but needed to be re-
branded to replace the original character who
as Sweet Betty was a 1940's-era woman.
Not only did the character not appeal as
much to the target audience but the name
Sweet Betty left consumers assuming it was a
sweet-tasting beer as well. To find a stronger
appeal in the marketplace Hornall Anderson
renamed the beer to Blonde Ale as well as
reintroduced the character as a svelte and hip
sophisticated woman. This new brand
appealed to both men and women consumers.
The idea of the new Blonde Ale brand was
based on the response originally received from
the Sweet Betty brand (Blonde Ale's first
brand). After the less than expected response
within the marketplace it was determined that
the character and name needed to better repre-
sent the brand than it already did. Not only
do the promotional collateral pieces incorporate
the look and feel of the brand but they also
do so in a creative way. For example the
drinking game cube is a memorable and*

*whimsical way to promote the brand by giving
the piece an actual humorous and fun pur-
pose. This enables it to be kept as opposed to
being just another flyer or card advertising the
brand. Additionally the tap handle incorpo-
rates the character of the brand including the
svelte curves of the woman on the shape of
the handle itself. This character becomes very
recognizable when lined up with numerous
other tap handles in a bar or pub. The blonde
character speaks for the brand through not
only its name but also visually.*

Page 20
Peroncino
Design Firm Futurebrand
Creative Director/Designer Drew
Smith
Designer Eduardo Murillo
Photographer Diego Decio
Client Peroni
*Creation of the identity and packaging of a
new beer for the Italian market. Positioned as
a fashionable alternative to traditional premi-
um beers and aperitifs.*

Page 21
Clydesdale Holiday Magnum
Design Firm Deutsch Design Works
Art Director John Marota-AB Image
Development
Creative Director Barry Deutsch
Designer Gregg Peri
Illustrator Matt Dineen
Client AB Image Development
*A beer manufacturer and marketer design.
Produce a promotional magnum of beer for
holiday and collectable purposes.*

Page 22
Duckstein Beer Crate
Design Firm feldmann+schultchen
design
Creative Director(s) André Feldmann
+ Arne Schultchen
Designer(s) f+s team, Stephan
Kremerskothen
Client Holsten-Brauerei AG
*International super premium beer brewery.
Duckstein is the German super premium beer
brand. The Duckstein Beer crate combines a
clever production strategy with a unique func-
tional and aesthetic design-concept.*

Page 23
Soft drink packaging
Design Firm Wega Werbeagentur
Client Welde

Page 24
Elmwood 6-pack carrier
Design Firm Ross Creative +
Strategy
Art Director Brian Brush
Creative Director Nick Jibben
Illustrator Mark Burckhardt
Client Elmwood Brewing Company

Page 25
Pete's Wicked Summer Sampler
Design Firm Sibley/Peteet Design,
Dallas
Art Director/Designer Brandon Kirk
Creative Director Don Sibley
Illustrator Ferruccio Sardella
(Summer), Gerald Bustamante
(Winter)

Client The Gambrinus Company
*Seasonal sampler 12-packs for Pete's Wicked
Brewing Company*

Page 26
Wild Brew
Design Firm Williams Murray
Hamm
**Creative Director/Designer/
Typographer** Garrick Hamm
Designer Simon Porteous
Photographer Phil Hurst
Client Interbrew UK

Page 27
Work Beer Bottles
Design Firm Work Advertising
Art Director Cabell Harris
Creative Director Cabell Harris
Designer Hailey Johnson
Client Work Beer

Page 28
Hydrade Sports Drink Pouches
Design Firm Sibley/Peteet Design,
Austin
Art Directors Matt Heck, Rex Peteet
Designer David Guillory
Client Hydrade Beverage Company
*Series of unique silver mylar pouches for
sports drink featuring everyday athletes*

Page 29
RINGNES TEEZER
Teezer Around The World
Design Firm Strømme Throndsen
Design
Art Director/Creative Director

Morten Throndsen
Designer Eia Grødal Ringnes AS
Client Ringnes Teezer
An alcoholic beverage and a new brand within the fab category (flavored alcoholic beverages), Teezer is positioned as an informal young and playful brand, highly innovative, colorful and new with exciting flavors. Experience is a keyword; and this resulted in the concept Teezer "Around The World." Every flavor is linked to a well known travel destination—a travel experience with the help of relevant product names, text, and picture collages. As an extra entertainment and experience 10 different back labels were designed with 100 different questions and answers from the relevant travel destination.

Page 30
KAZI Six-Pack Packaging
Design Firm Hornall Anderson Design Works Inc.
Art Directors Jack Anderson, Larry Anderson
Designers Larry Anderson, Jay Hilburn, Kaye Farmer, Henry Yiu, Bruce Stigler, Mary Chin Hutchison, Sonja Max, Dorothee Soechting
Photographer Angie Norwood Browne
Copywriter Tamara Paris
Client KAZI Beverage Company
Flavored alcoholic beverage distributor and bottler. When Portland OR-based KAZI Beverage Company realized there was an opportunity in the flavored alcoholic beverage market for something other than the typical hard lemonade and tea drinks they jumped at the chance to enter into a new category specifically what they call a cocktail in a glass. The strategy behind the brand identity graphics was to create a masculine and contemporary look with a slightly edgy feel to it. The filtered photography treatment adds to the classic cool positioning and suggests a melding of J. Crew meets Saturday Night Live. As a means of introducing a touch of humor to the packaging the inside of each bottle contains a pick-up line located on the backside of the label.

Page 31
Soft drink packaging
Design Firm Wega Werbeagentur
Client Oldenwald Quelle

Page 32
Zazz Beverages
Design Firm Wallace Church Inc.
Creative Director Stan Church
Art Director/Designer Wendy Church
Designer Jhomy Irrazaba
Client Ahold USA
Keeping in mind that Zazz is a private label brand with a restricted production budget, Wallace Church helped name and develop this line of beverages, creating a bold and easily adaptable design architecture.

Page 33
Zero Degrees
Design Firm Turner Duckworth Design
Creative Director David Turner and Bruce Duckworth
Designer/Illustrator Anthony Biles
Client McKenzie River

Page 34
Soft Drink Bottles
Design Firm Kan and Lau
Client Watson Distilled Water

Page 35
Batch Energy Juices
Design Firm Out Of The Box
Creative Director/Designer/Photographer Rick Schneider
Illustrator Sam Metro
Client Batch Beverage

Page 36
Sumwadda
Design Firm I.VOX Design
Art Director Esther Kang
Creative Director Paul Grignon
Designer Ether Kang
Client The Sweetwater Co.
This quality natural spring water is differentiated through naming and design that targets a contemporary mind-set. Sumwadda is simply playful and inviting without the traditional use of mountains/water imagery. (Limitation was that we could only design the label at a give size. The bottle itself could not be altered due to production/budget restraints.)

Page 37
Boomerang Packaging
Design Firm Epoxy Communications
Art Director Marie-Hélène Trottier
Creative Directors Daniel Fortin, Georges Fok
Designer Marie-Hélène Trottier
Client Interbrew France
Alcoholic beverage company

Page 38, 39
UV Vodka Packaging Design
Design Firm Olson and Company
Design Director Cindy Olson
Designers Robb Harskamp, Jarrod Riddle
Client Phillips Distilling
A 5-generation family-owned producer and bottler of over 70 different spirits. Inspiration in a bottle—even before you drink it. Instead of using a standard front-facing label, we put the bold UV logo—block letters radiating from energetic black rays—on clear acetate and applied it to the back of the bottle; you look through the vividly colored spirits to read the name.

Page 40
Spelling Vodka
Design Firm Chase Design Group
Creative Directors Rick Frey, Margo Chase
Designer Jonathan Sample
Photographer Jason Ware
Client The WB TV Network
Limited edition custom bottle for artisan-made vodka as gift from the network to producer Aaron Spelling.

Page 41
Effen Vodka Bottle and Black Cherry
Design Firm Cahan & Associates
Art Director Bill Cahan, Michael Braley
Creative Director Bill Cahan
Designer Michael Braley
Bottle Design Todd Simmons
Client jstar Brands
The creative objective here from the get-go was to throw a wrench into the typical alcoholic beverage packaging catagory. You see a lot of sameness out there. You know that look - products saturated with vintage and aged in look and feel. Each product tauting some historical relevance etc. etc. That works for Scotch. It can be abandoned for Vodka. Vodka is a mixer. It's pure. It's clean. What else? These days, it matters where you go out for a drink. Decisions are made by considering many different factors: importantly, what the scene is like, who else is going to be there, what you are wearing, what kind of music is being spun and overall, what vibe the physical space provides. People don't just simply need a drink anymore, they need an experience. That is the high-end Effen consumer does. All of that is to say that Effen was designed specifically with this in mind. If it matters so much how we accessorize our drinking experience, then why shouldn't it matter what beverage label you are attached to. On a physical level, the bottle (with it's spongy rubber sleeve) was designed for both practical and sensational reasons. The graphics were skimmed down to the most basic and simplistic level. It is a clear and clean manifestation of the product itself.

Page 42
Vikingfjord Vodka
Design Firm Design Bridge
Creative Director Graham Shearsby
Design Director Antonia Hayward
Client ARCUS
Arcus, Norway's leading wines and spirits producer first launched Vikingfjord in 1985 as a truly Norwegian vodka made from pure glacial water to compete alongside international brands such as Absolut and Smirnoff. Our brief was to exploit this positioning further enhancing the iconic fjord imagery and strengthening the brand logo. The creation of the graphic 'Viking ship' marque provides a strong off pack branding device. So far our design has won four international awards including a Norwegian Design Council award for 'Excellence in Design' and we have continued to work with Arcus on a whole range of other products.

Page 43
Dettling Kirsch
Design Firm Design Bridge
Creative Director Graham Shearsby
Design Director Antonia Hayward
Senior Designer Daniela Nunzi
Client Underberg
Dettling is one of those family-owned brands steeped in history which sometimes sadly disappears when absorbed within a global company's portfolio. However when major Swiss spirits producer Underberg acquired the brand in 1999, it recognised Dettling's qualities and was determined to preserve them, hence our brief to reinterpret its local heritage with sensitivity. A beautiful bespoke bottle—inspired by samples in the Dettling archives—is a canvas for crafted minimal graphics. The sophisticated steel presentation pack echoes the distinctive bottle shape. Our glass and display stand complete the brand presentation in-bar.

Page 44
Bertossi liqueur bottles
Design Firm Aidalos Design
Client Bertossi

Page 45
El Paso Margarita Mix
Design Firm Louise Fili Ltd.
Creative Director/Art Director Louis Fili
Designer Chad Roberts
Client El Paso Chile Co.

Page 46
Master Blend
Design Firm Hookson
Creative Director Bryan Hook and Jason Dobson
Designer Tim Bremner
Illustrator If
Client Whyte and MacKay
The label design celebrates the life of Andrew Usher, the founding Father of 'blended' scotch whisky. Whyte and Mackay, the scotch whisky industry and, in particular, the Blenders' still respectfully remember him and his contribution towards establishing this outstanding product. The design route reflects the event and the coming together of today's professionals to commemorate the life accomplishments of Master Blender Andrew Usher. As such the names of all the Master Blenders appear on the bottle itself and are printed in gold.

Page 47
Holy Grail Porto
Design Firm Poagi ®
Creative Director A. Musson
Designer Paul Dowell
Photographer Tom Roschi
Copywriter David Bland
Client Old Vines Co.

Page 48
Vodkice Packaging
Design Firm Epoxy Communications
Creative Directors Daniel Fortin, George Fok
Art Director/Designer Marie-Helene Trottier
Computer Graphic Designer André Renaud
Account Executive Marie-Geneviève Parent
Production Manager Hélène Joannette
Client Labatt Brewery

Page 49
Christiania Vodka
Design Firm Deutsch Design Works
Art Director Bruce Campbell
Creative Director Barry Deutsch
Designer Lori Wynn
Illustrator Mark Summers
Structural Designer KID
Client Nordic Beverages
Produce a new structure and graphic design for new Christiania premium vodka.

Page 50
Maestro Tequilero Tequila
Design Firm Klim Design Inc.
Art Director/Creative Director/Designer Matt Klim
Illustrator Peter Klimkiewicz
Photographer Greg Klim
Client Casa Cuervo S.A.
*Distilled spirits company.
Ultra Premium Tequila brand created to reflect the hand-made origin of the product as well as its Aztec roots with a unique label designed to work on a bottle with very little flat surface area. Hand-crafted wood presentation box designed to showcase the bottle while warp-a-round branding at base locks bottle securely.*

Page 51
Silver Tequila
Design Firm RBMM
Art Director Luis Acevedo
Art Director/Designer Lorie Ransom
Creative Director Luis Acevedo
Illustrator Greg King
Client Rio Bravo Spirits

Page 52
Simers Aquavit
Design Firm Strømme Throndsen Design
Art Director/Creative Director Morten Throndsen
Designer Dagheid Strømme
Illustrator Dave Hopkins
Client Arcus

Page 53
City Dry Gin
Design Firm lg2d
Art Director/Creative Director/Designer Christine Cook
Copywriter Sophie Bordes
Typography Christine Cook
Client Maison des Futailles
*Alcohol distributor
City Dry Gin was the brand name we developed for the launch of a new product. A typo graphic approach using "automatic writing" was used to create a layering of poetic confusion that was silkscreened directly on both front and back of the bottle. City Dry Gin reflects the nature of the contemporary metropolis: a continuum of sound movement images and typographic signs—all overlapping one another without an end or a beginning.*

Page 54
Xanath Vanilla Liqueur
Design Firm Graphic Content
Creative Director/Designer Art Garcia
Illustrator Jesus Nava
Photographer Lynn Sugarman
Client Sello Imports
*A spirits import company.
Xanath (pronouced sha-nath) is an all-natural vanilla liqueur from Mexico. The ancient Totonacs considered vanilla a gift from the gods and used in ritual drinks. With the exotic origins in mind this decanter was created specifically for the American market.*

Page 55
Cox Orange
Design Frim Heye & Partners
Client Ernst Kalff Obstbrennerei

Page 56
Ocho Dias Tequila
Design Firm Optima Group
Art Director Jim Pietruszynski
Creative Director Lyle Zimmerman
Illustrator Ann Werner
Photographer John Payne
Client Jim Beam
Ocho Dias is a tequila flavored liqueur that was developed by Jim Beam for restaurant usage. Ocho Dias is used as a substitute to traditional tequila for mixed drinks and margaritas. Optima created branding, packaging, on-premise promotional support and collateral.

Page 57
Shakers Vodka
Design Firm Deutsch Design Works
Creative Director Barry Deutsch
Designer Jess Giambroni
Illustrators Mike Kunisaki, Thahn Do
Structural Designer KID
Client Infinite Spirits

Page 58
True Wine Label
Design Firm Michael Schwab Studio
Client True

Page 59
Integrity
Design Firm IKD Design Solutions
Art Director/Creative Director/Designer Ian Kidd
Designer Damian Hamilton
Client Marquis Philips
*Wine making in Australia (Marquis) and importers, marketing in USA (Philips).
'Integrity' is an exceptional red wine made in limited quantity in Australia for the US market. Minimalism seemed logical. When put on display in California, the wine doubled its original retail price of $100 within months.*

Page 60
Warre's Otima Port
Design Firm Design Bridge
Creative Director Graham Shearsby
Designer Hui Wen Chan
Client Symington Family
Ports have traditionally used a similar design language—masculine, dark and heavy. Otima, a reinvention of an existing Warre's 10 year old tawny port, was conceived to break the rules and attract a younger, more female-biased audience. It has since been widely acclaimed as the perfect response to an emerging consumer need, instigating a growth rate of 27% in a previously static market. In fact, in the nine months following its launch in June 1999, sales rose by a factor of 37 solely as a result of its design—making Otima a worthy winner of the 2000 Design Effectiveness award for Branded Packaging—and still today the brand's growth continues to outstrip the market.

Page 61
Wavecrest
Design Firm Harcus Design
Art Director Annette Harcus
Designer/Illustrator Melonie Ryan
Illustrator Simon Fenton
Client Kreglinger Wine Estates
Creation of brand and wine label 'Wavecrest.' Illustration depicts the orbit of the moon around the earth creating tides and waves. Colorways in the illustration according to the different wine varieties.

Page 62
Bottles in Newspaper LeFigaro & Gaja
Designer Marina Drukman

Page 63
Sandeman 40 Year Old Tawny Port
Design Firm Wren & Rowe
Creative Director/Designer Michael Rowe
Hand-lettering Bob Stradling
Client Sandeman & Ca.
*Port and sherry shippers.
10 and 20-year old ports are relatively common but a Tawny Port that survives for 40 years is extremely rare and valuable, retailing for more than 100 dollars per bottle. Sandeman asked us for a presentation that would reflect its age and rarity, as well as the credentials of the Company, founded in 1790.*

Page 64
Cavit Arele
Design Firm Robilant & Assoc.
Creative Director/Designer Drew Smith
Designer Chiara Manin
Photographer Diego Decio
Client Cavit
Creation of brand and packaging for a premium vin santo wine.

Page 65
Black & White
Design Firm Germ
Client Black & White

Page 66
Di Stasio Wines Packaging
Design Firm GollingsPidgeon
Creative Director/Designer David Pidgeon
Designer Marianna Berek-Lewis
Illustrator Pasqulina and Prisco Di Stasio
Photographer John Gollings
Client Di Stasio Wines
A small Australian boutique vineyard owned by the son of migrant Italian parents. Each of the labels has been hand written by the parents referencing the traditional Italian farming values employed in the production of the wine.

Page 67
Design Firm Barbara Harkness Design
Client Limeburners

Page 68, 69
St. Leonard's Vineyard David Lancashire
Art Director David Lancashire, Luke Donovan
Creative Director/Designer David Lancashire
Designer Luke Donovan
Client St. Leonard's Vineyard
The St. Leonard's range features shadows of a wine glass in situations where you would enjoy wine, relax with wine, or contain an element of the vineyard. The elemental nature of the Shadow Series is reminiscent of the Australian Bush with uniquely Australian textures and shadows.

Page 70
Buena Vista Limited Release Carneros Zinfandel Rose 1998
Design Firm Sterling Cross Creative
Designer Peggy Cross
Client Buena Vista Winery
The objective was to create a unique, giftable package that shows off the color of this ultra premium Rosé.

Credits

Page 71
Frog Rock Premium
Design Firm Harcus Design
Designer Melonie Ryan
Art Director Annette Harcus
Photographer Keith Arnold
Client Frog Rock

Page 72
Winemaker's Lot
Design Firm Piano and Piano
Client Concha y Toro

Page 73
Sfida
Design Firm Louise Fili Ltd
Art Director/Creative Director/Designer Louise Fili
Designer Mary Jane Callister
Client Matt Brothers
Wine importer
A reasonably-priced Italian red wine with a lot of legal copy to contend with.

Page 74
Barsquare Winelabels
Design Firm Intellecta Branding and Design
Designer/Art Director Anders Schmidt
Client Intellecta Corporate

Page 75
Stepping Stone
Design Firm MOD/Michael Osborne Design
Art Director Michael Osborne
Designer Paul Kagiwada
Client Cornerstone Cellars *wine*

Page 76
Beer Brothers
Design Firm IKD Design Solutions
Art Director/Creative Director Ian Kidd
Designers Dinah Edwards, Ian Kidd
Photographer Catherine Gasmier
Client Beer Brothers
A grapegrowing and winemaking company. When we asked what made them unique two brothers entering the boutique wine market said Not much…oh we go crabbing most weekends have done so since we were kids. We decided to recreate a scene from the 1940s and a postcard label to further express the period and the concept of their point of difference.

Page 77
Placido wine packaging
Design Firm Britton Design
Art Director/Creative Director/Designer Patti Britton
Client Banfi Vintners
International wine marketer and wine importer.
The Italian wine depicts Count Placido riding his regal horse in the Middle Ages. The brand inherited its name from a famous Sienese family the Placidi on whose vast estate some of the Placido vines grow today. The land was awarded to the family back in the Middle Ages and remained in the possession of its descendents until modern times.

Page 78
Setanta
Design Firm IKD Design Solutions
Art Director/Creative Director Ian Kidd
Designers Dinah Edwards, Ian Kidd
Illustrator Anelia Pavlova
Client Talunga Ridge
Family with a vineyard in South Australia's Adelaide Hills wine district decided to launch their own label. Passionate about their Irish heritage we researched mythology from which we developed a suite of pictorial labels that can be endlessly added to.

Page 79
Marquis Philips 'Roogle' Wine Range
Design Firm IKD Design Solutions
Art Director/Creative Director/Designer Ian Kidd
Designer Matthew Remphrey
Illustrator Robert Marshall
Client Marquis Philips
A collaboration between award winning wine makers Sparky and Sarah Marquis in Australia and Californian importer Dan Philips led to a branding and packaging brief to launch a new product range in the USA. We responded with a hybrid image of a kangaroo and eagle illustrated in traditional zoological style. It enjoyed immediate success and became fondly known as the 'Roogle'.

Page 80
Canyon Road Packaging
Design Firm Michael Osborne Design
Art Director Michael Osborn
Designer Nicole Lembi
Photographer Jason Potts
Client Jim Beam Brands

Page 81
Rothbury Estate Regional Wines
Design Firm Perks Design Partners
Art Director/Designer Chris Perks
Client Beringer Blass
A series of labels designed to express the hands-on approach to wine-making in a way that could appeal to a young contemporary market.

Page 82
G5 Apple Computers
Design Firm Apple
Designers Hiroki Asai, Sam Davy, Peggy Jensen, Christine Finerty, Caelan Stack, Emma Webb, Jeff Zwerner
Production Dan Talbert
Client Apple Computers

Page 83
Powerbook G4-17 inch
Design Firm Apple Computers
Designers Hiroki Asai, Sam Davy, Peggy Jensen, Christine Finerty, Caelan Stack, Emma Webb, Jeff Zwerner
Production Dan Talbert
Client Apple Computers

Page 84
iBook G4 12-inch
Design Firm Apple Computers
Designers Hiroki Asai, Jeff Zwerner, Sam Davy, Peggy Jensen, Caelan Stack
Production Christine Finerty, Dan Talbert
Photographer Hunter Freeman
Client Apple Computers

Page 85
iSight
Design Firm Apple Computers
Designers Hiroki Asai, Jeff Zwerner, Sam Davy, Peggy Jensen, Caelan Stack, Josh Distler, Mike Abbink
Production Chritine Finerty, Dan Talbert
Photographer Doug Rosa
Client Apple Computers

Page 86, 87
iPod
Design Firm Apple Computers
Designers Hiroki Asai, Sam Davy, Peggy Jensen, Christine Finerty, Caelan Stack, Emma Webb
Production Dan Talbert
Photographer Davies & Starr
Client Apple Computers

Page 88
Kyocera Wireless Promotional Launch Kit
Design Firm vitrorobertson
Art Director Mike Brower
Creative Directors John Vitro, John Robertson, Mike Brower
Designer Mike Brower
Client Kyocera Wireless
Wireless phone manufacturer.
Launch Kit packaging for Kyocera Wireless' roll out of the Slider V5 MTV Edition wireless phone with Virgin Mobile and MTV. The package was designed to generate interest and buzz around the phone launch. Kits were seeded with key press celebs and launch party attendees.

Page 89
Motorola Packaging
Design Firm Ogilvy
Creative Directors Brian Collins, Dan Burrier
Designers Ed Chiquitucto, Jason Ring, Brian Collins, Dan Burrier
Client Motorola

Page 90, 91, 92
P.G.C.D Jour de Rêve
Design Firm Taku Satoh Design Office Inc.
Client Taku Satoh Design Office Inc.

Page 93
Guest & Me
Design Firm Taku Satoh Design Office Inc.

Page 94
Le Feu D'Issey
Design Firm Shin Matsunaga Design Inc.
Art Director/Designer Shin Matsunaga
Creative Director Issey Miyake
Client Beauté Prestige International

Page 95
Gucci Parfum
Design Firm Lloyd + Company
Art Director Alan Castro
Creative Director Doug Lloyd
Client Gucci
Gucci parfum is a modern signature fragrance steeped in Gucci heritage. It is a modern classic with an identity that is both captivating and seductive.

Page 96, 97
Shiseido The Makeup
Design Firm Shiseido Co. Ltd.
Creative Director/Art Director Tetsu Togasawa
Designer Aoshi Kudo
Director Shunsaku Sugiura
Client Shiseido Cosmetics

Page 98
Homme 2 in 1 Travel Kit
Design Firm Karim Rashid Inc.
Designer Karim Rashid Inc.
Client BPI Perfumes/Issey Miyake

Page 99
Aramis Life
Design Firm Aramis
Creative Director/Designer Gaemer Gutierrez
Designer Hirst Pacific
Designer Kristin Boone
Client Aramis
The Aramis Life package is a modern classic creation a further extension of the scent within. It's solid and tactile sculpted from cool fluted glass and shaped to fit comfortably in a man's hands. The unique metallic finish stands out and makes a statement of great power just like the fragrance and its inspiration Andre Agassi.

Page 100
Flacon & Packaging "Boss Woman"
Design Firm Peter Schmidt Studios
Art Director Camila Joedal
Creative Director Andrea Brandt
Client Proctor & Gamble

Page 101
IR Shine
Design Firm Nestor-Stermole VCG
Designers Mark Levitt, Okey Nestor
Client Rusk

A Man's Accessories Exhibition
Design Firm IM-LAB
Art Director Akio Okumura
Designer Naomi Hibata
Client DAS
A pin brooch can be displayed on the bottom of the tube. It becomes a package if you turn it upside down and close the upper part of the tube.

Page 103
Illusion
Design Firm Priska-d
Art Director/Creative Director Dominick Sarica
Designer/Illustrator Priska Diaz
Photographer(s) Priska Diaz, Dominick Sarica

Page 104, 105
Ginger
Design Firm Harcus Design
Art Director Annette Harcus
Designer Marianne Walter
Illustrator Sue Morris
Client The Trelivings Company
A body and beauty product line.
Buderim Valley Ginger Collection—a range of body and beauty products infused ginger and other exotic extracts.

Page 106, 107
Garden Territory Package Design
Design Firm Squeeze Inc.
Art Directors/Creative Directors/Designers Russ Wall, Ruth Wall
Illustrator Russ Wall
Client Garden Territory
Health/beauty & spa/garden lifestyle product line.
The brand was created with the mission statement in mind: "celebrate the pleasures of organic gardening, seasonal cooking, nutrition, homelife, and art. What life should be like.

Page 108
Pond's Double White System
Design Firm ZIBA Design
Client Nippon Lever

Page 109
Ethos
Design Firm Harcus Design
Art Director Annette Harcus
Designer Stephanie Martin
Client The Trelivings Company
A body and beauty product line.
Ethos—pure and natural beauty—a holistic brand creation from the name through to the physical shapes of the bottles for a new range of natural remedies for the skin using authentic botanical ingredients.

Page 109
David Jones Colour Enhancing
Design Firm Harcus Design
Art Director Annette Harcus
Designer Marianne Walter
Product Developer Daniella Napoli
Client Rauxel Pty Ltd
A cosmetic manufacturer.
Range of color-enhancing shampoos and conditioners.

Page 109
Dendera Body Bar
Design Firm Wallace Church Inc.
Creative Director Stan Church
Designer Allen Gaoiran
Client Bradford Soaps
Bradford Soaps came to Wallace Church for a premium design for their new line of Dendera Soaps evoking the quality and luxury of a spa. Wallace Church was engaged as their exclusive branding resource to help shape and reflect the brand experience. We determined that promoting the brand's organic ingredients was both relevant and unique. Our final design achieves an elegance that reflects both the premium and organic qualities of Dendera.

Page 110
Aramis Cool
Design Firm Aramis
Creative Director Gaemer Gutierrez
Designer Kristin Boone
Client Aramis

Page 111
Tommy
Design Firm Aramis
Creative Director Gaemer Gutierrez
Designers Gaemer Gutierrez, Kristin Boone
Illustrator Andrea Selby
Client Tommy Hilfiger
Tommy And Tommy Girl Fragrance Brands have traditionally been red white and blue. Summer fragrances were a great opportunity to transform traditional design elements. It allowed us to be more playful and keep the core of the brand intact. It also created some excitement and newness at counter.

Page 112
L'eau dIssey Pour Homme Shok proof Travel Case
Design Firm Karim Rashid Inc.
Designer Karim Rashid Inc.
Client BPI Perfumes/Issey Miyake

Page 113
Heals Bath Essence
Design Firm Williams Murray Hamm
Creative Director Garrick Hamm
Designer Clare Sheffield
Typographer Clare Sheffield
Client Heal & Son

Page 114
Terra Bella
Design Firm MOD/Michael Osborne Design
Art Director Michael Osborne
Creative Director Michelle Regenbogen
Designer Alice Koswara
Client Terra Bella

Page 115
Design Packaging for Cliniderm
Design Firm Brand House
Designer Anders Torris Christensen
Client Nycomed
Pharmaceutical company.
Modernize the design of Cliniderm and add sun lotion and after-sun lotion.

Page 116
Bolty
Design Firm Taku Satoh Design Office Inc.

Art Director Taku Satoh
Creative Director Minoru Shiokawa
Designers Taku Satoh, Kazutoshi Amano
Client FT Shiseido Co Ltd.

Page 118
Express Jeans Hangtag
Design Firm Morla Design
Creative Director Jennifer Morla
Designers Jennifer Morla, Brian Singer
Client Express Jeans
The leading fashion brand of Limited. Express invited Morla Design to participate in an exclusive designer-series hangtag collection for their Fall 2003 Men's and Women's line. We created a fanbook style hangtag with six double-sided cards. Provocative images and type are sandwiched between two sheets of frosted polypropylene fastened with an industrial eyelet and attached to the jeans with a ball chain.

Page 119
Dockers® Recode
Design Firm Turner Duckworth Design
Creative Directors David Turner, Bruce Duckworth
Designers Allen Raulet, Jonathan Warner
Client Levi Strauss & Co.

Page 120
Jewels Bliss
Design Firm Tangram Strategic Design
Art Director Enrico Sempi
Designers Enrico Sempi, Enrico Anzani

Page 121
Nike Watch in Case
Design Firm Nike

Page 122
Watch packaging for birthdays
Design Firm Fossil
Art Director David Eden
Creative Director Stephen Zhang
Designer David Parsons
Client Fossil
Fashion brand specializing in watches. These packages were designed for consumers who purchase a Fossil watch specifically for gift purposes.

Page 122
Surf packaging for watches
Design Firm Fossil
Art Director Jon Kirk
Creative Director Stephen Zhang
Designers David Parsons, David Eden
Client Fossil
Fashion brand specializing in watches. These watch tins were designed to compliment a fashion trend that was derived from 60's surf culture.

Page 123
Truly Inspired Pattern Tins
Design Firm Fossil
Art Director David Eden, Shay Ometz, Steven Zhang
Designer Bhavini Kalidas
Client Fossil

Sound tin series
Design Firm Fossil
Art Director David Eden
Creative Director Stephen Zhang, Tim Hale
Designer/Illustrator David Eden
Client FOSSIL

Valentine Tins
Design Firm Fossil
Art Director Stephen Zhang, Shay Ometz
Designer Sarah Nantze-Turner
Client Fossil
Watch and jewelry tin packaging for Valentine's Day 2004.

Surf packaging for watches
Design Firm Fossil
Art Director Jon Kirk
Creative Director Stephen Zhang
Designers David Parsons, David Eden
Client Fossil

Packaging for watches
Design Firm Fossil
Art Director David Eden
Creative Director Stephen Zhang
Designer David Parsons
Client Fossil
These watch tins were designed with a retro

Credits

arcade game theme.

Speedway Tins
Design Firm FOSSIL
Art Director David Eden
Creative Director Stephen Zhang
Designer Jun Park
Client FOSSIL

Page 124, 125
Converse Shoe Boxes
Design Firm Sandstrom Design
Art Director/Creative Director
Designer Steve Sandstrom
Designer David Creech
Client Converse
The new Converse shoeboxes provide a visual link to the history of the brand. Each has a graphic band and stripe that replicate the rubber sole of the iconic Chuck Taylor All Star and a pair of silver eyelet "vents"—a recognized feature around the world.

Page 126
Janie & Jack
Design Firm MOD/Michael Osborne Design
Art Director Michael Osborne
Designer Michelle Regenbogen
Client Gymboree
A children retail store/line.

Page 127
Diva
Design Firm Lewis Moberly
Art Director/Creative Director Mary Lewis
Designers Suse Klingholz, Mary Lewis, Ann Marshall, Lewis Moberly

Page 128
Poppets
Design Firm Turner Duckworth Design
Creative Director David Turner and Bruce Duckworth
Designers/Illustrators Mark Waters, Christian Eager, Anthony Biles
Client Fox's Confectionery

Page 129
Big Island Chocolates
Design Firm Hornall Anderson Design Works Inc.
Client Big Island Candies

Page 130
Biscotti Packages
Design Firm Studio Ignition
Art Director/Creative Director Stephen Goss
Illustrator Michael Furuya
Production Designers Noah Tom, Donald Cheung
Client Clara Confectioners
Attractively package the client's new line of Biscotti in a manner and image consistent with earlier package treatments.

Page 131
Christmas tin
Design Firm Sabingrafik Inc.
Art Director Jason Virchis
Creative Director Dan Blanchard
Designer/Illustrator Tracy Sabin
Client Tamansari Beverage
Promotional holiday tins filled with candy. Limited edition "Night Before Christmas" tin filled with Nestlé Crunch.

Page 131
Panforte Label
Design Firm Sabingrafik Inc.
Art Director Bridget Sabin
Designer/Illustrator Tracy Sabin
Client Seafarer Baking Company
Panforte is a fruit nut and chocolate confection originating from Siena, Italy and traditionally served during the Christmas season.

Page 131
Springerle Package
Design Firm Sabingrafik Inc.
Art Director Bridget Sabin
Designer/Illustrator Tracy Sabin
Client Seafarer Baking Company
Springerle are traditional holiday cookies from Germany with a stamped picture on the surface.

Page 132
LL Bean Country Packaging
Design Firm Leslie Evans Design Associates Inc.
Creative Director/Designer Leslie Evans
Designer Tom Hubbard
Illustrator Bruce Hutchison
Client LL Bean Homewares

Food division of LL Bean.
Project Goal: To develop a line of packaging for food items that portrays the look of an old dry goods store.

Page 133
Jaffa
Design Firm Williams Murray Hamm
Creative Director Garrick Hamm
Designer/Typographer Gareth Beeson
Client United Biscuits

Page 134
Tokyo Azuki Glaces
Design Firm Taku Satoh Design Office Inc.

Page 135
Lotte Xylitol Gum Pink Mint
Lotte Bergamot Mint Gum
Design Firm Taku Satoh Design Office Inc.
Creative Directors Yoshiharu Obata, Tokihiko Kimata
Art Director/Designer Taku Satoh
Client Lotte Co. Ltd.

Page 136
Kashi Medley Cereal
Design Firm Mark Oliver Inc.
Art Director/Creative Director Mark Oliver
Designer Patty Devlin-Driskel
Photographer Burke/Triolo Food Pix
Client Kellogg Company Cereal
We were asked to breathe new life into an old product that mixed different types of cereal. We positioned the product as the cereal lover's cereal, added a downpour of cereal to allow easy content identification and create a sense of playfulness, and put in a blue sky with puffy white clouds to complete the fantasy.

Page 137
CAVIAR BAR
Design Firm Graphics & Designing Inc.
Art Director/Creative Director Toshihiro Onimaru
Designer Hiroki Ariyoshi
Photographer Kazuo Suzuki
Client Will Planning Inc.
Foods management company. The dining restaurant and bar specializing in original caviar dishes.

Page 138
Chocolate Packaging
Design Firm X-Ray Design
Creative Directors/Designers Markus Schone, Cornelia Glanzmann
Photographer Claudia Albisser
Client COOP

Page 139
La Tempesta Biscotti
Design Firm Turner Duckworth Design
Creative Directors David Turner, Bruce Duckworth
Designer Anthony Biles
Photographer Lloyd Hryciw
Client La Tempesta

Page 140
Lake Champlain Chocolates
Design Firm Optima Group
Designer Carol Grabowski-Davis
Client Lake Champlain Chocolates
Optima Group helped Lake Champlain reintroduce this premium line of chocolates emphasizing its handcrafted quality in a more upscale giftable package.

Page 141
Borgovivo Aromatic Extra Virgin Olive Oil
Design Firm Studio GT&P
Art Director/Illustrator Gianluigi Tobanelli
Client Diva International Trading
S.r.l. Airline in-flight supplies Borgovivo extra virgin olive oil Italian dressing and various condiments packagings; a bottle contains 13 ml of product mainly used for airlines in-flight service.

Page 142
Salsa Loca Package
Design Firm RBMM
Art Director/Creative Director/Designer/Illustrator Tom Nynas
Client El Paso Chile Co.

Page 143
El Paso Chile Co. Cuban Black Bean
Design Firm RBMM

Art Director/Creative Director/Illustrator Gary Willmann
Client El Paso Chile Co.

Salsas
Design Firm RBMM
Art Director/Creative Director/Designer Luis Acevedo
Illustrator Gary Willmann
Client El Paso Chile Co.

Page 144
Salsa Borracho
Stubbs BBQ Sauce
Design Firm RBMM
Art Director/Creative Director/Designer Luis Acevedo
Illustrator Gary Willmann
Client El Paso Chile Co.

Page 145
Mouse Odille Salad Dressing
Design Firm Mark Oliver Inc.
Art Director/Creative Director Mark Oliver
Designer Patty Devlin-Driskel
Illustrator MeiloSo
Client Chanteclere Foods
A salad dressing manufacturer. The venerable Santa Barbara restaurant was out of business but demand for its salad dressing continued unabated. We positioned the dressing as French country commissioned a witty and iconic illustration of a Citroen 2CV puttering through the countryside restored the restaurant's old lettering and an irreverent (and pricey) product was born.

Page 146
Royal Botanic Gardens
Design Firm David Lancashire Design
Art Director/Creative Director/Designer David Lancashire
Art Director/Designer Tony Gilevski
Client The Gardens Shop Royal Botanic Gardens
Retail outlet situated in Royal Botanic Gardens. Preserves, chutneys, and sauces were packaged exclusively for the Royal Botanic Gardens Shop. Archival botanic illustrations were the focus of the labels.

Page 147
Fischer Weiser
Design Firm RBMM
Creative Director Tom Nynas
Designer/Illustrator Kevin Bailey
Client Fischer Wieser
*Specialty gourmet sauces.
Fischer Wieser wanted a promotional package "with an attitude" for special in-store display during the holidays.*

Page 148
Tate's
Design Firm Louise Fili Ltd
Art Director/Creative Director/Designer Louise Fili
Designer Mary Jane Callister
Client Tate's specialty baked goods
Artisan-baked cookies for an upscale market.

Page 149
Bella Late July
Design Firm Louise Fili Ltd
Art Director/Creative Director/Designer Louise Fili
Designer Chad Roberts
Illustrator Graham Evernden
Client Late July organic snacks
A new line of organic crackers designed to evoke vintage packaging.

Page 150
Big Island Candies Olive Oil Cookies Packaging
Design Firm Hornall Anderson Design Works Inc.
Art Directors Jack Anderson, Kathy Saito
Designers Kathy Saito, Sonja Max, Alan Copeland
Photographers EJ Armstrong, Joan Teasdale
Client Big Island Candies
Confections retailer based in Hawaii. Unlike the packaging Hornall Anderson designed for the Big Island Candies regular line of chocolates and cookies, the packaging for the new Olive Oil-flavored cookies needed to reflect the heritage and culture behind the style of cookie. Hornall Anderson looked to the more earthy and organic color palette with respect to an Italian flavor. Snippets of photos depicting cultural lifestyle vignettes of the Italian countryside were also incorporated into the packaging graphics.

Page 151
Di Camillo Gift Tin
Design Firm Travers Collins & Company
Art Directors Jeffrey Herberger, Michael Di Camillo
Creative Director/Designer Jeffrey Herberger
Illustrators Larry Grohman, Jeffrey Herberger
Client Di Camillo Bakery
Retail and wholesale specialty foods bakery. A holiday food gift tin. An annual marketing tool of this 84-year old Italian/American family bakery. The visual imagery was meant to convey the holiday celebration the classic traditions and the flavor of the food inside. The illustration although it has a very classical look has an extremely complex printing technique. The use of an opaque white ink in various screens laid down under the other colors varies the reflective quality of the metal. This look gives the image an added dimension as light passes across it.

Page 152
Cobble Creek Preserves Packaging
Design Firm Kendall Creative Shop Inc.
Art Director/Designer Mark K. Platt
Client People Gotta Eat *Gourmet foods
The goal was to create a package that had an all-american country feel to it without covering up the delicious preserves that were contained inside.*

Page 153
Royal Botanic Gardens
Design Firm David Lancashire Design
Art Director/Creative Director/Designer David Lancashire
Art Director/Designer Tony Gilevski
Client The Gardens Shop

Page 154
Victorian Olive Groves
Design Firm David Lancashire Design
Art Director/Creative Director/Designer David Lancashire
Art Director/Designer Luke Donovan
Client Victorian Olive Groves
An olive-growing collective.

Page 155
Bellagio Gourmet Series - Olive Oil
Design Firm Sibley Peteet Design
Art Director Tom Hough
Creative Director Don Sibley
Art Director Joy Price
Client The Bellagio Resort
*Las Vegas Hotel, Casino, and Resort.
Part of a series of gourmet food products created for The Bellagio gift store.*

Page 156
Pane e Vino
Design Firm Rod Dyer International
Art Director/Creative Director/Designer/Illustrator Rod Dyer
Client Pane e Vino

The Stinking Rose Gift Packaging
Design Firm Be Design
Art Director Eric Read
Creative Director Will Burke
Designer Lisa Brussel, Coralie Russo
Photographer Waldo Bascom
Client The Stinking Rose Restaurant
The Stinking Rose, a garlic restaurant, approached Be Design to redesign their existing logo for their restaurant and food business. The harlequin background pattern was inspired by the interiors of the Stinking Rose restaurant in San Francisco's North Beach Italian neighborhood. The pattern was echoed in the single diamond inside the O of the logotype Rose. A fun retro style type treatment finished the look. The holiday packaging used purple tissue and gold ribbon to enhance the harlequin pattern.

Page 157
Mustpha's Argan Oil
Design Firm Twist Inc.
Art Director/Creative Director/Designer Kristine Anderson Dahms
Photographer Rick Dahms
Client Haddouch Gourmet Imports
Importer of high-end Moroccan foods. This is was one of the first introductions of culinary argan oil to the US. It is prized (& priced) like truffle oil and is sometimes referred to as liquid gold. The goal was to design a package that was worthy of this

expensive little number and to help get it into retailers such as Wiilliams-Sonoma and Sur La Table.

Page 158
Heal's Balsamic Vinegar
Design Firm Williams Murray Hamm
Creative Director/Designer/Typographer Garrick Hamm
Client Heal & Son

Page 159
Heals Oils
Design Firm Williams Murray Hamm
Creative Director Garrick Hamm
Designer/Illustrator/Typographer Fiona Curran
Client Heal & Son

Page 160
California Grape Seed Oil
Design Firm Louise Fili Ltd
Art Director/Creative Director/Designer Louise Fili
Designer Mary Jane Callister
Client California Grape Seed Company *specialty foods
A line of grape seed oils from a world-renowned chef.*

Page 161
Bella Cucina Aromatic Oils
Design Firm Louise Fili Ltd
Art Director/Creative Director/Designer Louise Fili
Client Bella Cucina
A line of aromatic oils imported from Italy.

Page 162
Balsamic Vinegar
Design Firm Williams Murray Hamm
Creative Director/Designer/Typographer Garrick Hamm
Client Heal & Son

Page 163
Acetum
Design Firm KROG
Art Director/Designer Edi Berk
Photographer Dragan Arrigler
Client Klansek d.o.o. Brezje
Juices, vinegar, and spirits company. ACETUM means vinegar in latin.

Page 164, 165
Hollywood Video Nuts
Design Firm Sandstrom Design
Art Director Jon Olsen
Creative Director Steve Sandstrom
Associate Creative Director and Designer Jon Olsen
Illustrator Jeff Foster
Copywriter Leslee Dillon
Designer Greg Parra
Client Hollywood Video *Video Rental*

Page 166
Stahmann's Gift Pack
Design Firm Mark Oliver Inc.
Art Director/Creative Director Mark Oliver
Designer Patty Devlin-Driskel
Illustrator Jeremy Sancha
Client Stahmann's
Established on the banks of the Rio Grande river in 1932, the country's largest private grower of pecans sought to produce 20 gift boxed pecan products. Rich with the company's old west lore we created an illustrated narrative of significant events complemented by an elegant classic treatment of type and color and captured the essence of old New Mexico.

Page 167
The Stinking Rose Packaging
Design Firm Be Design
Art Director Eric Read
Creative Director Will Burke
Designer Lisa Brussel
Photographer Bill Turner
Designer Coralie Russo
Client The Stinking Rose

Page 168
Atlantis Fresh Soup
Design Firm Cave Design
Art Directors/Creative Directors/Designers David Edmundson, Matt Cave
Illustrator Don McLean
Client Atlantis Foods
Atlantis Fresh Soups were created to satisfy the needs of today's busy quality-conscious consumers. The main objective for this project was to communicate the freshness of the soup. Since most soup in the grocery store is

canned, it was important that the container and label system revealed the chunky nature of the soup. We designed the packaging system to be a balance between something you might see at a country fair and a big brand feel. We accomplished this by using a line art illustration instead of a typical photo and unique color combinations. In addition we designed the typography to portray an authentic premium brand.

Page 169
Campbell's Condensed Tomato Soup
Design Firm Design Center
Art Director Jami Hogan
Director Darralyn Rieth
Client Campbell Soup Company
Warhol celebrated Campbell's Tomato Soup by turning our iconic red and white cansinto a colorful art form.

Page 170
Tazo Coasters
Design Firm Sandstrom Design
Art Director/Creative Director/Designer Steve Sandstrom
Designer Andrew Randall
Client Tazo tea company

Tazo Full Leaf Tea Tins
Design Firm Sandstrom Design
Art Director/Creative Director/Designer Steve Sandstrom
Copywriter Steve Sandoz
Designer Andrew Randall
Client Tazo

Page 171
Tazo 3 Stacker Tins
Design Firm Sandstrom Design
Art Director/Creative Director/Designer Steve Sandstrom
Copywriter Steve Sandoz
Production Designer Sarah Cook
Copywriter Palmer Pettersen
Client Tazo
A sample stacked version of the original patented Tazo full leaf tea tin with infuser lid. It isn't always easy to commit to purchasing a large tin of tea or an herbal infusion that you are not familiar with. This set allows one to try a few different varieties or blends without a big investment. Each set includes a stainless steel infuser built into the lid.

Page 172
Tazo Holiday 3 Stacker Tins
Design Firm Sandstrom Design
Art Director/Creative Director/Designer Steve Sandstrom
Copywriter Steve Sandoz
Production Designer Sarah Cook
Copywriter Palmer Pettersen
Client Tazo

Page 173
Tazo NY Promo
Design Firm Sandstrom Design Art
Art Director/Creative Director/Designer Steve Sandstrom
Copywriter Palmer Pettersen
Designer Andrew Randall
Client Tazo
Gift package sent to select list of influential New Yorkers to encourage trial of Tazo products.

Tazo Tea Latte Carton campaign
Design Firm Sandstrom Design
Art Director/Creative Director/Designer Steve Sandstrom
Copywriter Palmer Pettersen
Designer Kristin Anderson
Client Tazo
Packaging for a line of "tea lattes" with distinctive international flavors. Asian African Indian and European touches were designed into an overall concept that was consistent across the line. Packages need to work on grocery shelves.

Page 174
Tazo 24ct Filterbag Cartons
Design Firm Sandstrom Design
Art Director/Creative Director/Designer Steve Sandstrom
Copywriter Steve Sandoz
Designer Andrew Randall
Client Tazo
Tazo filterbag tea products are packaged in paperboard cartons with markings and glyphs that render up ancient beginnings. They look involving and sophisticated with little codes and lack of color but the text which covers the cartons is humorous and entertaining. Nothing is left un-touched or unconsidered.

Tazo Full Leaf Tea Sample Envelopes
Design Firm Sandstrom Design

Art Director/Creative Director/Designer Steve Sandstrom
Copywriter Steve Sandoz
Designer Andrew Randall
Client Tazo

Page 175
Tazo Travel Tin
Design Firm Sandstrom Design
Art Director/Creative Director/Designer Steve Sandstrom
Creative Director Steve Smith (Tazo)
Copywriter Palmer Pettersen
Client Tazo
The original concept for the travel tin came from Tazo's desire to create a container that could hold a few filterbags and slip into a purse briefcase or pocket. We decided to modify the shape of a typical rectangular tin with a slide lid. With the help of the tin supplier Tin Scape of Aurora IL we created a radiused top for the flat bottomed tin and slightly rounded the corners for a very sophisticated look and feel which created a perfect fit for four filterbags. We then incorporated the logo and characters on the top and the elements were blind embossed. The travel tin and tea assortment carton with the envelopes displayed on angle showing through the acetate window was also designed by us.

Page 176, 177
Best of Mickey
Design Firm Sieger Design
Client Sieger Design

Page 178, 179
Gerber Blades
Design Firm Sandstrom Design
Art Director/Creative Director/Designer Jon Olsen
Photographer Michael Jones
Copy Writers Peter Favilla, Jim Carey
Team Designer Brad Engle
Client Gerber
*Knives, tools, and gear.
Plastic packaging of Gerber's products was a given. The product had to be viewable and secure. We set out to design a better plastic "clamshell" style package that both compliments and showcases the product. We took Gerber's existing 1400 clamshell shapes and consolidated them into 6. The clamshell design integrated feet on the bottom that fit into notches on the top preventing scratching and scuffing during shipping.*

Page 180, 181
W. R. Case & Sons Limited Edition Packaging
Design Firm RBMM
Creative Director Tom Nynas
Designers Matt Staab, Dan Birlew
Computer Retouching Ratchet
Client W. R. Case & Sons Cutlery
*Manufacturers of collectible cutlery and knives
Clamshell Packaging.*

Page 182, 183
Castor & Pollux Pet Products
Design Firm Sandstrom Design
Art Director/Associate Creative Director/Designer Jon Olsen
Creative Director Steve Sandstrom
Illustrator Larry Jost
Copywriter Leslee Dillon
Designer Starlee Matz
Client Castor & Pollux
*Premium pet products
The personality of this identity was based upon 2 fictional friends Castor the dog & Pollux the cat who started their own brand in response to the poor quality of current pet products.*

Page 184
Scottie Shin
Design Firm Matsunaga Design Inc.
Art Director/Creative Director/Designer Shin Matsunaga
Client Crecia Co. Ltd
Paper manufacturing company.

Page 185
Tissues Paper/Japan Traditional Figurer/Walking Man's Gift
Design Firm Package Land Co Ltd.
Art Director/Creative Director/Designer Yasuo Tanaka
Client Package Land Co. Ltd

Page 186, 187
CD Gallery
Design Firm CreationHouse
Art Director/Creative Director/Designer Michael Miller Yu
Illustrator Various
Photographer Holly Lee
Client Sun Hing Group
Manufacturer of audio accessories.

To design a series of display box for one product range of CD Containers. Some of the containers are flat-packed and to be assembled by the end-users.

Page 188
Buzz Off
Design Firm Brandhouse WTS
Creative Director David Beard
Illustrator Clem Haldin
Copywriter Mike Brownfield, Clem Haldin
Client Superdrug
High Street retailer

Page 189
Casablanca Moderne Packaging
Design Firm Brad Terres Design
Creative Director/Designer Brad Terres
Illustrator Murray Kimber
Photographer Rick Chou
Digital Production David Brix
Copywriter Alexa Chigounis
Client Casablanca Fan Company
When Casablanca approached us to develop packaging for its Moderne Fan the challenge was clear: to communicate the unique nature of the product in a way that would set it apart at retail. The resulting packaging solution pays tribute to the Moderne's nostalgic design influences while communicating the technological innovation and quality craftsmanship that are cornerstones of the Casablanca brand.

Page 190, 191
Target brand
Design Firm Design Guys
Art Director Steve Sikora
Designers Wendy Bonnstetter, Katie Kirk
Client Target

Stark packaging
Design Firm Design Guys
Art Director Steve Sikora
Creative Director Maureen White
Designer John Moes
Photographers Mark Lavor, JB Mondino
Structural Design Gary Patch
Copywriter Eric Lumba
Client Target

Page 192
Sony Atom Batteries
Design Firm DESIGN MAC
Art Director Yoshihiko Suzuki
Creative Director Tetsuro Sano
Designers Kumi Kiso, Eiji Hiruma
Illustrator Osamu Tezuka
Client Sony
The design appointed national famous character "Tetsuwan Atom" as an eye catcher.

Page 193
Nocturne Lamps
Design Firm Robert Abbey
Client Nocturne

Page 194
Dino Disk
Design Firm Sekine Design Office
Client Grindstone

Page 195
Buddy Rhodes Concrete Counter Mix
Design Firm Philippe Becker Design
Creative Director Philippe Becker
Designer Jay Cabalquinto
Illustrator Scott Sawyer
Client Buddy Rhodes Studio
*Manufacturer of high-end concrete counter products for upscale lofts, Pottery Barn stores, restaurants, and retail.
The objective was to develop a brand and packaging system that could extend Buddy Rhodes' initial product offering to a line of retail concrete mixes, tints, sealers, and custom molds targeted at contractors and sophisticated "do-it-yourselfers."
Solution: A brand and packaging system using only two colors and incorporating a bold recognizable look that brings personality to Buddy Rhodes and stands out in the concrete category. The graphics were designed to be very easily reproducible and look good using the lowest quality flexo printing on low-grade craft paper.*

Page 196
Stanley Packaging
Design Firm Hornall Anderson Design Works Inc.
Art Director/Designer Jack Anderson
Illustrator John Anderle
Copywriter Hugh Saffel
Designers Andrew Wicklund, Henry

Yiu, Andrew Smith, Bruce Branson-Meyer, John Anderle
Client PMI
*Manufacturer of vacuum sealed thermal containers.
Pacific Marketing Incorporated was planning to launch a new line of Stanley products but first needed to revitalize their original packaging design. The HADW design team researched a typical retail aisle where similar products were displayed. They compared color schemes to determine which were over-used and which would stand out among the competition. Based on their findings and due to similarities to other brands the team dismissed the colors blue yellow and black and red. After much deliberation burnt orange was chosen as Stanley's new core color with the strategy of drawing attention from the other products. New packaging structure was created to best display the actual product; as well clearly convey the necessary technical information.*

Page 197
Custom Building "SuperiorBilt" Tools Packaging
Design Firm Hornall Anderson Design Works Inc.
Art Director Jack Anderson
Art Director/Designer Lisa Cerveny
Designers Bruce Branson-Meyer, Don Stayner, Belinda Bowling
Naming Pamela Mason Davey
Client Custom Building Products
*Manufacturer of tools and tile care products
Since there was such a wide range of shapes and sizes in the client's new line of tools designing packaging to fit them all while staying congruent to each other was the largest obstacle to overcome. We had to take into consideration the unique packaging to fit the tools from clamshells to wraps as well as incorporate different printing processes depending on the type of packaging in question. The packaging solution included structural architecture that allowed for the most exposure and display of each individual tool regardless of its size. Each category within the line retains a similar look and feel to keep the entire line integrated as a family. The packaging doesn't distract the buyer from the product itself but rather accents the tool while still providing the essential copy information and necessary stats. Clear see-through clamshells were used for the saw blades while cardboard wraps were used for the larger more oddly shaped tools. The appearance of the packaging enhances the product by making it appealing and providing the necessary product information without concealing the actual product.*

Page 198
Alien Quadrilogy
Design Firm Neuron Syndicate Inc.
Art Directors/Creative Directors/Designers Sean Alatorre, Ryan Cramer
Designer Lee Parent
Client 20th Century Fox
All 4 Alien films released onto DVD. The Packaging holds 9 DVD Discs and is 5 feet long. When opened Alien Quadrilogy is the largest package produced for home entertainment that has ever been designed and released.

Page 199
Softimage XSI Packaging
Design Firm Graphème Branding & Design
Art Director/Designer David Drummond
Creative Director Pierre Léonard
Illustrator Denis Riverin
Photographer Tilt
Print Producer Sylvie Ouzilleau
Client Softimage Software
*Company for cinematographic industry
Softimage XSI is a new generation of animation software allowing for greater creative freedom and fluid process.*

Page 200
Creative Pro Packaging
Design Firm MetaDesign
Creative Director Brett Wickens
Designers Conor Mangat, Kihwan Oh, Brett Wickens
Illustrator Jonathan Caponi
Photographers Steven Underwood, Brett Wickens
Design Director Conor Mangat
Image Manipulation Jamie Welsh, Jeff Allison
Client Adobe Systems Inc.
To help Adobe 'emotionally reconnect' with its creative professional customers, we reinvented the packaging of their flagship products to convey the attributes of precision (through sil-

houettes), beauty (through textures), and aspiration (through white space and more streamlined typography). We used the theme of nature as a metaphor for the process of working with creative software. Since there are formulas and patterns that govern such things as how a leaf grows or the shape of a snowflake or the logarithmic spiral of a nautilus shell. And although nature can be described in these common mathematical terms, a wondrous variety of forms results. Similarly Adobe's engineering and 'code' provides the solid technological foundation for the ability of their customers to realize an infinite variety of creations.

Page 201
Celartem Technology
Design Firm Shinnoske Inc./NCP
Art Director Shinnoske Sugisaki
Creative Directors Satoshi Horiba, Shigeki Takegahana
Designers Chiaki Okuno, Jun Itadani
Client Celartem Technology Inc.
Image-processing software company

Page 202
Panther
Design Firm Apple Computers
Designers Hiroki Asai, Meng Mantasoot, Mike Abbink, Michael Tompert, Peggy Jensen, Christine Finerty
Production Dan Talbert, Kris Sutherland
Client Apple Computers

Page 203
Apple Works
Design Firm Apple Computers
Designers Hiroki Asai, Meng Mantasoot, Peggy Jensen, Kris Sutherland, Caelan Stack
Production Dan Talbert, Christine Finerty
Copywriter David Begler
Photographer Hunter Freeman
Client Apple Computers

Page 204
Kink Live V
Design Firm Sandstrom Design
Art Director/Creative Director/Designer Steve Sandstrom
Copywriter Dave Scott
Designer Greg Parra
Client Kink fm102
*Radio station.
A collection of songs performed live at a radio station to benefit a community program to teach kids how to read.*

Page 205
LOOP Select 005
Design Firm Clemenger Design
Art Director Peter Montgomery
Creative Director Rod Schofield
Designer Mikee Tucker
Client Loop Recordings
*Independent New Zealand music label.
Create a delivery system for LOOP Select 005 Art book, CD, and their first DVD for retail sale and presentation to VIP guests at Lord of the Rings: Return of the King Premieres in Wellington New York and London.
Idea: The brief to contributing artists was 'The State of this World' we looked on the brighter side of this and wanted to tie the various elements together thematically.
Solution: A retort on the media driven perception that the state of this world is dire was visually communicated through the use and mechanics of the slip case. The elements are simply titled 'Good'. When they are brought together in the vessel... 'Good Shit Happens'.*

Page 206
Beethoven
Design Firm be_poles
Creative Director Patrice Lourme
Art Director Antoine Ricardou
Designer Clementine de Mesties
Illustrator Don Coley
Client Andante

Page 207
The distance to here - LIVE
Design Firm Sagmeister Inc.
Art Director Stefan Sagmeister
Designer/Illustrator Motoko Hada
Photographer Dan Winters, Danny Clinch
Client Radioactive Records
We designed a contemporary version of a Hindu mandala on the cover of the album and 2 singles reflecting the eastern influences of the lyrics.

Page 208
Pregnancy Test
Design Firm Williams Murray Hamm
Creative Director Garrick Hamm
Designer/Typographer Clare Sheffield
Client Superdrug

Page 209
One Step Contact Lens Solution
Design Firm Williams Murray Hamm
Creative Director Garrick Hamm
Designer/Typographer Fiona Curran
Client Superdrug

Page 210
Neal's Yard
Design Firm Turner Duckworth
Creative Directors David Turner, Bruce Duckworth
Designers Bruce Duckworth, Bob Celiz
Client Neal's Yard

Page 211
Superdrug Vitamins
Design Firm Turner Duckworth
Creative Directors David Turner, Bruce Duckworth
Designer Bruce Duckworth
Structural Design David Scothron
Illustrator Justin De Lavison
Client Superdrug P.L.C.

Page 212
Origin Dietary Supplements Packaging
Design Firm Wink
Creative Director Richard Boynton, Scott Thares (Wink), Karen Lokensgard (Target)
Designer Richard Boynton
Client Target
Create a packaging system for a Target owned-brand product line of dietary supplements. The tone and feel needed to reflect the current big-picture direction of the Target pharmacy (in which the supplements are to be sold) which was leaning more towards an organic/holistic approach to pharmaceuticals and health maintenance. By nature vitamins need to communicate a lot of information (and in multiple layers) with limited real estate. The solution was to strip away any and all pretense (decoration) in favor of a straightforward organizational structure. With the emphasis isolated on content and hierarchy the typography is therefore forced to carry the load evoking a sense of traditional apothecary mixed with a hint of modernity within its bright (retail) color palette of accents.

Page 213
Packaging for Gui Bie Wan
Design Firm Alan Chan Design Co.
Creative Director Alan Chan
Designers Alan Chan, Peter Lo
Client Yangshengtang Co. Ltd.

Page 214, 215
Smoking Cessation Kit & 100 Percent Cigarette-Free X Pack
Design Firm Sandstrom Design
Art Director/Creative Director/Designers Jon Olsen, Shanin Andrew
Illustrator Ward Schumaker
Copywriter Ginger Robinson
Client Population Services International
A nonprofit organization that provides low-cost health and family planning products and services to lower income people primarily in developing countries.
A smoking cessation kit created for the 17-22 year old. Straightforward full of attitude without an ounce of preachiness. The pack is designed to help the consumer break the habit and find new rituals to get through the day. It includes a guide for preparing to quit tips and tricks inspiration stories and several self-distracters such as stress putty and chewing gum.

Page 216
A Gift of Tazo
Design Firm Sandstrom Design
Art Director/Creative Director/Designer Steve Sandstrom
Copywriter Palmer Pettersen
Client Tazo

A custom designed two-pack of Tazo Full Leaf Teas in tins with infuser lids. A black tea and a green tea are included.

Page 217
Muller + Company box
Design Firm Muller + Company
Art Director Jeff Miller
Creative Director John Muller
Designer Jeff Miller
Client Muller + Company
Business advertising, graphic design interactive
We had a need for a package that would be used to hold proposals and samples of our work to new clients. We designed a box out of 140# paper and letterpressed out identity and information in three passes using black ink and clear varnishes which gave the piece a tactile surface.

Page 218, 219
Hand In Mobile
Design Firm Package Land Co Ltd.
Art Director/Creative Director/Designer Yasuo Tanaka
Client Package Land Co. Ltd

Page 220, 221
Japan Traditional Figure
Design Firm Package Land Co Ltd.
Art Director/Creative Director/Designer Yasuo Tanaka
Client Package Land Co. Ltd

Page 222
Direct Mail Invite
Design Firm Greteman Group
Creative Director Sonia Greteman
Art Director James Strange
Copywriter Raleigh Drennon
Client Cero's Candies

Page 223
"Hanahanahana" Card Case
Design Firm Taku Satoh Design Office Inc.
Client Japan Graphic Designers Association

Page 224
Soothe A Soul
Design Firm Greteman Group
Art Directors Sonia Greteman, James Strange, Craig Tomson
Designers/Illustrators James Strange, Craig Tomson
Client Greteman Group
Branding agency.
Annual Christmas gift to clients along with a monetary donation in the client's name to the Wichita Area Sexual Assault Center.

Page 225
Design Firm The Big Idea Inc.
Art Director Peter Byer
Creative Director Mary Duncan
Designer/Illustrator Peter Byer
Art Director/Designer Margo Scavone
Client The Big Idea Inc.
Graphic desig business.
This self-promotional packaging series was designed to highlight core strengths of our company and reflect our brand of clear messaging using strong clean design. Each box contained a brochure describing the core strength and a fun give-away: "Focused" included a ViewMaster containing a reel of samples; "Responsive" contained a yo-yo; and "Flexible" contained a slinky.

Page 226, 227
Haus Bellevue
Design Firm Drews Design
Art Director/Creative Director Burglind Drews
Designer Andreas Meier
Photographer Andreas Suess
Client Huehne Immobilien GmbH
A real estate developer.
This cassette contains brochures and floor plans specifying the exclusive residential building. What made the idea exceptional was the addition of samples in order to provide a sensory element. With the samples the client was given the opportunity to envision the superior quality of the building prior to its completion.

Dorotheenhoefe
Design Firm Drews Design
Art Director/Creative Director Burglind Drews
Designer Andreas Meier
Photographer Andreas Suess
Client Huehne Immobilien GmbH
A real estate developer.
The invitations for the cornerstone laying ceremony were mailed in this tinplate box. The addressees were asked to fill the boxes with the best of wishes and to take the boxes with them to the festivities—as an addition to the cornerstone. With pleasure the guest followed suit.

Page 228
Winston 1st Cut CD
Design Firm Cornerstone
Creative Director Keith Steimel
Design Director Sally Clarke
Illustrator David O'Neil Winston
Client Winston

Bear Brook Holiday Gift
Design Firm Bear Brook Design
Art Director Eileen MacAvery Kane
Creative Director Tom Trapp
Designers Amanda Whelen, Niko Niarhos
Client Bear Brook Design
We sent out this gift along with a donation to American Forests to clients as our annual holiday gift.

Page 229
LBWorks Employee Gift
Design Firm Leo Burnett
Designer/Art Director Marian Williams
Client LBWorks Advertising
These pieces were created as an employee gift to be handed out at an agency outing. They represent the spirit, tone, and attitude of the workplace.

Page 230
Annual Wine Promotion
Design Firm Conflux Design
Designer Greg Fedorev
Client Conflux Design
Advertising design
Each year Conflux Design produces it's annual wine promotion as holiday gifts for each client. The packaging usually carries some kind of theme ranging from illustrating major events in our lives such as the birth of our children to creating imagery inspired by trips to exciting locations to just being inspired by a bottle or desire to try to see if we can create an unusual package. The projects not only serve as a way to show our appreciation to our clients; they serve as a way to mark each year in business and to continually challenge ourselves with what can be done in the packaging industry.

Page 231
Thanksgiving Wine: "Wishbone"
Design Firm Wallace Church Inc.
Creative Director Stan Church
Art Director Wendy Church
Designer Nereeida Lopez
Illustrator Teri Klass
Client Wallace Church Inc.
International strategic brand imagery and design consultants.
Each year we design a Thanksgiving wine bottle for our clients. This year everyone was thankful to receive the winning half of the wishbone etched on our elegant bottle of wine.

Page 232
Tazo Shopping Bag
Design Firm Sandstrom Design
Art Director/Creative Director/Designer Steve Sandstrom
Client Tazo
Paper bag developed for select retailers and marketing promotions.

Page 233
Design Firm The Rocket Scientists
Creative Director Charl Ritter
Designer/Illustrator/Art Director Eduard Claassen
Client SABC 3

Page 234
MUSA Shopping Bags
Design Firm IM-LAB
Art Director/Designer Akio Okumura
Client MUSA
A shopping bag that simply has 131 colored lines using 131 kinds of colored paper.

Page 235
Serengeti Shopping Bag
Design Firm Muller + Company
Creative Director John Muller
Designers Scott Chapman, Christina Modlin
Photographer Greg Gorman
Client Serengeti Eyewear

Red Lane Shopping Bag
Design Firm Clemenger Design
Art Directors Dianne Fuller, Rod Schofield
Creative Director Rod Schofield
Designer Dianne Fuller
Photographer Ross Brown
Retouch artist Simon Redwood
Client Duty Free Stores New Zealand
We used the language of the airport, customs and the duty free shopping experience. To create a new name—'Red Lane'—the path you take when you have purchased something to declare. This was visually supported with imagery of luxury and fashion goods shown as x-rays. We used the shopping bag as a 'branded badge' that customers wear with pride long beyond their journey.

Page 236
Shoe Bazar
Client Shoe Bazar

Page 237
Janie & Jack
Design Firm MOD/Michael Osborne Design
Art Director Michael Osborne
Designer Michelle Regenbogen
Client Gymboree

Page 238
Crank Brothers Candy
Design Firm igawa design
Creative Director/Designer Sven Igawa
Photographer Marc Tule
Client Crank Brothers
Mountain bike component manufacturer.
Creating a packaging system that reflected the personality and style of this new line of pedals required a little detour from the existing Crank Brothers' brand. We thought it was important that the packaging conveyed the company's philosophy as well as its innovative products so we tailored the packaging system to fit a specific market segment. By using bold colors minimal copy and stylized photography we created a system that would be easily recognized by the consumer.

Page 239
Bickmore Products
Design Firm Leslie Evans Design Associates Inc.
Art Directors Melany Kuhn, Leslie Evans
Creative Director/Designer Leslie Evans
Designer Melany Kuhn
Illustrator Bruce Hutchison
Client Bickmore

Page 240
LA 2012 Olympic Bid Package
Design Firm Bright Strategic Design
Designers Keith Bright, Denis Parkhurst
Client LA 2012 Olympic

Page 241
Golf ball packages
Design Firm Hidemi Shingai
Designer Hidemi Shingai
Client Tourstage

Page 242
Federal Premium Ammunition
Design Firm Compass Design Inc.
Creative Director Mitchell Lindgren
Designers Tom Arthur, Bill Collins, Rich McGowen
Illustrator John Schreiner
Client Federal Premium Ammunition
ReBrand and redesign the entire product line of Federals consumer ammunition products. The goal was to separate Federal from the competition with a brand and look that represented the specialty category of ammunition.

Page 243
Cycle Helmets
Design Firm Lippa Pearce Design
Art Director/Designer Harry Pearce
Structural packaging Jeremy Roots, Harry Pearce, and in collaboration with AM Associates
Client Halfords Ltd
One of the largest auto retailers in the UK
Using transparent casing the design creates strong shelf stand out and allows the consumer to see exactly what they are buying even try the various helmets out for size before purchasing. With reference to the helmets the transparent packaging encourages the item to be removed from the casing by use of graphic instruction on the box. There are bold arrows directing the removal of the item from the box and a small built in sliding shelf to assist in the task. There is also a 3D feel to the new design and allows the actual product to be seen from all angles. The fitments for each individual helmet are all hidden under a central compartment in the main case giving the finished product a clean sharp holistic feel.

Page 244
Timberwolf chewing tobacco packaging
Design Firm Cornerstone
Creative Director Keith Steimel
Design Director Sally Clarke
Illustrator David O'Neil
Client Timberwolf

Page 245
Napa Cigar Estate and Reserve Cigars
Design Firm Deutsch Design Works
Creative Director Barry Deutsch
Designers Jacques Rossouw, Lori Wynn
Client Napa Cigar Company
Design and produce two new graphic designs for two cobranded premium cigars.

Page 246
Thinkum Tins
Design Firm Sandstrom Design
Art Director/Creative Director/Designer Steve Sandstrom
Designer David Creech
Illustrator Steve Sandstrom
Copywriter Palmer Pettersen
Client Blue Dash
Specialty products.
Two different formulations of putty are offered in one package. There is a more firm and dense version which requires a little more effort to manipulate. These globs of putty are great for keeping your hands busy while thinking – hence the name "Thinkum". The packaging is light-hearted and entertaining – a bit more mature however than store Silly Putty. The tin makes for a great office gift.